BENDING
THE
FUTURE

BENDING
THE
FUTURE

Fifty Ideas for the Next Fifty Years

of Historic Preservation in the

United States

Edited by

Max Page
and
Marla R. Miller

UNIVERSITY OF MASSACHUSETTS PRESS

Amherst and Boston

Copyright © 2016 by University of Massachusetts Press
All rights reserved
Printed in the United States of America

ISBN 978-1-62534-215-7 (paper); 214-0 (hardcover)

Designed by Sally Nichols
Set in ITC New Baskerville
Printed and bound by Sheridan Books, Inc.

Library of Congress Cataloging-in-Publication Data

Names: Page, Max, editor of compilation. | Miller, Marla R., editor of compilation.
Title: Bending the future : fifty ideas for the next fifty years of historic
preservation in the United States / edited by Max Page and Marla R. Miller.
Description: Amherst : University of Massachusetts Press, [2016] | Includes
bibliographical references and index.
Identifiers: LCCN 2016012903| ISBN 9781625342157 (paperback : alkaline paper)
| ISBN 9781625342140 (hardcover : alkaline paper)
Subjects: LCSH: Historic preservation—United States. | Historic
preservation—United States—Forecasting. | Historic preservation—Social
aspects—United States. | Historic sites—Conservation and
restoration—United States. | Historic buildings—Conservation and
restoration—United States. | Cultural property—Protection—United
States. | United States. National Historic Preservation Act of 1966. |
United States—Cultural policy.
Classification: LCC E159 .B415 2016 | DDC 973–dc23 LC record available at
https://lccn.loc.gov/2016012903

British Library Cataloguing-in-Publication Data
A catalogue record for this book is available from the British Library.

Contents

CONTENTS

CONTENTS

Acknowledgments

We begin by expressing our gratitude to the anonymous reviewers engaged by the Press; their astute comments and criticisms, as well as enthusiasm and support, helped us sharpen our thinking and buoyed us forward. We are deeply indebted, too, for the friends and colleagues—David Brown, David Lowenthal, Bonnie Parsons, Chris Skelly, John Sprinkle, Andrew Hurley, and Bob Weyeneth—who generously contributed their time, expertise, insights, and experience to the book, looking over our draft introduction and pointing out places we missed connections, overstated evidence, and other missteps, while helping us to deepen analyses that resonated most clearly.

A project involving more than fifty authors, and entangled in the immovable deadline of a national anniversary, is a sizeable challenge for any press; we are so very grateful to the whole staff of University of Massachusetts Press for taking this project on and helping it reach fruition. In particular, we thank Mary Dougherty for her enthusiasm and support, and Kerrie Maynes for taking up the administrative baton and bringing the project to such a successful conclusion. Kathy Kottaridis of Historic Boston Incorporated and Molly Garfinkel of Place Matters provided some great illustrations of preservation in action. Lastly, Rebekkah Rubin and Jennifer Cavanaugh provided essential research and editorial assistance.

As always, we thank our colleagues, friends, and families for their support. Max would like to especially thank Richard Rabinowitz and Tom Mayes for many walks and talks about preservation and life; Marla for her remarkable leadership in the field of public history and for again, on our second book, being such a great collaborator; and Eve Weinbaum for quietly insisting that beauty and history must always be tied to the fight for justice. Marla is grateful to Max for bringing her into this bold and provocative work, and for generally being such a generous and inspiring colleague and all-around good egg. She also thanks the incredible team that is UMass Public

History—and particularly director of outreach Jessica Johnson—for making it possible to put our most ambitious aims into action. Lastly, she is unendingly grateful to her husband Steve Peck for his constant support, and for his help getting up the big hills.

Rem Koolhaas's essay "Cronocaos" originally appeared in the catalogue to OMA/AMO's exhibition *Cronocaos* at the 12th International Architecture Exhibition at the Venice Biennale and was published in *Log* (Winter 2011): 119–23. The essay herein is a revised version of that piece.

ACKNOWLEDGMENTS

BENDING
THE
FUTURE

Introduction

If you have ever waited for a train at Pennsylvania Station in New York City—by far the busiest station in the nation—you may have been struck by photographs on the walls around the main timetable board, images of a massive classical building that seems to take up an entire Manhattan block. Photographs capture a grand hall, with soaring columns and Roman arches. Carved iron railings lead down to railroad tracks. As you struggle to find a square foot to call your own in this windowless space, you may start to resent that someone thought it a good idea to taunt riders with images of what was once one of the greatest railroad stations in the world. The architectural historian Vincent Scully memorably said about the loss of the 1910 Pennsylvania Station that one once "entered the city like a god; one scuttles in now like a rat."[1]

The 1963 demolition of Pennsylvania Station, designed by the celebrated firm McKim, Mead, and White, was part of what sparked the creation of both the New York City Landmarks Preservation Commission in 1965 and the National Historic Preservation Act (NHPA) in 1966. Although birth is not destiny, there is no doubt that the image of that building succumbing to the wrecking ball, its pieces being dispersed around the country, reinforced the culture of the modern preservation movement. But you didn't have to have mourned Penn Station to embrace this emerging ethic: as urban renewal efforts reshaped communities everywhere, cities and towns across the country witnessed their own tragedies, from the 1962 loss of India Wharf in Boston, Massachusetts, to the razing of much of San Francisco's Fillmore District. By the time of the publication of the growing preservation movement's

manifesto, *With Heritage So Rich*, in January 1966, "almost half of the twelve thousand structures listed in the Historic American Buildings Survey of the National Park Service had been destroyed."[2] Churches were razed for parking lots. Pittsburgh lost its Wabash Terminal, Denver its Grand Opera House. For many then and since, this sense of loss was the foundation of modern historic preservation work. As the *New York Times* architectural critic Ada Louise Huxtable wrote at the time, the National Historic Preservation Act marked "the culmination of a growing national concern with architectural and natural beauty and the physical environment."[3]

As national law signed by Lyndon Baines Johnson on October 15, 1966, the National Historic Preservation Act established the Advisory Council on Historic Preservation, created a network of State Historic Preservation Offices, formalized the National Register of Historic Places (managed by the National Park Service), and established the "Section 106" review process, which required the evaluation of federally funded projects for their impact on cultural resources.[4] Within a year of the Act's passage, all fifty states had appointed state preservation officers (or "liaisons," as they were called at that time).[5] A new era in preservation had begun.

But if the NHPA seemed revolutionary at the time, as historian John H. Sprinkle, Jr., has shown, many of its intellectual underpinnings had been articulated over the full course of the twentieth century, beginning with the federal Antiquities Act of 1906.[6] In late 1933, the federal effort to put people back to work resulted in the Historic American Buildings Survey. These efforts were expanded two years later by the Historic Sites Act, which led to the creation of the National Historic Landmarks program. As Sprinkle contends, that initial implementation was not as narrow as often believed, and looked well beyond "the houses of great white men and their battlefields."[7] Nevertheless, as Diane Lea notes, the shift in priorities and practices was "palpable"; *With Heritage So Rich* called for a preservation practice that would provide a "sense of orientation to our society, using structures and objects of the past to establish values of time and place."[8]

We were both born in 1966, the year the modern historic preservation movement was created with the passage of the National Historic

Preservation Act. We grew up, and became scholars and practitioners of preservation and public history, in the shadow of the preservation act, which fundamentally changed how American cities and towns, and state and national government, shaped their environment. We have both served on local historical commissions, the heart of the U.S. system of preservation, where most discussions about what is important to save begin. And we both teach at a university—on a campus just a short drive from Deerfield, Massachusetts, scene of the first (though failed) U.S. attempt to preserve a historic house—introducing students to the history, present, and possible futures of preservation.[9]

We invited "provocations."

In his 2014 account of the evolution of preservation criteria, John Sprinkle posits that "from time to time—say every fifty years or so—it is prudent and reasonable to take a look backward; to try to understand 'why we do what we do' in historic preservation."[10] We agree, and this introduction, as well as many of the essays that follow, draws quite consciously on the past to understand how we got to this present and to envision possible futures. But we also wanted to "think forward," with a desire to shape the future of preservation in some small way. We asked a wide range of people involved in preservation to think "prudently and reasonably"—but also argumentatively and radically—about the history of preservation in the fifty years since the 1966 Act, and to offer significant proposals for the next fifty years.[11]

In these pages, some of the nation's leading preservation professionals, historians, scholars, activists, and journalists offer fifty distinct visions for the future. We urged them to avoid essays that were overly theoretical or technical. Instead, we invited "provocations," editorial-like essays that would prompt readers to reconsider received wisdom about historic preservation. We asked our contributors to consider the following questions: What's working, what's not, and where can we do better? What are the unintended consequences and indirect effects of past practices? How has our vision of what's possible changed? Who does, and who should, decide which places to save, and how to save them? How can preservation contribute to the financial, environmental, social, and cultural well-being of our communities? Some of the essays overlap in agreement on a particular issue; at other

times readers will find the authors disagree dramatically. We ourselves, as coeditors and as individuals, don't always agree with the proposals, but will consider our job done if some sparks fly off these pages.

Today social justice is a priority for many practitioners.

With humility, we take our title from a phrase first invoked by the Massachusetts abolitionist Theodore Parker in the 1850s and made famous by Dr. Martin Luther King Jr. a century later. "I do not pretend to understand the moral universe," said Parker; "the arc is a long one, my eye reaches but little ways; I cannot calculate the curve and complete the figure by the experience of sight; I can divine it by conscience. And from what I see I am sure it bends towards justice."[12] Social justice was not an overt aim of the preservation community in 1966. But today, as the essays here show, it is a priority for many practitioners, who desperately hope to connect preservation practice with the broader work of building a more just society. This volume was conceived at a time when citizen outrage at class inequality was erupting across the country in the form of minimum wage struggles and progressive tax campaigns, and took shape in the wake of racial unrest and uprisings in Ferguson, Missouri, and Baltimore, Maryland; the first draft was finished in the weeks following the shooting of nine churchgoers in Charleston, South Carolina, in June 2015. Our contributors also watched those events unfold, and urged us to see preservation's role both in creating those conditions and as a means to address them. Ana Edwards, a founding member of the Sacred Ground Historical Reclamation Project, a Richmond-based activist organization working to preserve and interpret the hidden former slave market in Shockoe Bottom (in size second only to that of New Orleans), writes in her essay that her organization has "insisted that Richmond's invisible and devalued black history must now be understood, made public, understood, and honored." How can we understand our present-day society if we don't know all that it took to create it? How can we know what not to repeat? And remember that which had to be overcome?

We have gathered a diverse group of some of the most compelling voices in preservation today. It is our hope that readers will find their views as inspiring and provocative as we do, and that audiences find

INTRODUCTION

in them specific ideas that they can use to advance their work, as well as new ways of looking at preservation's goals and methods. In other words, we have created this collection with the notion that these essays can actively shape both preservation theory and practice in the coming decades. We hope that at the one hundredth anniversary of the 1966 Act, schools and practitioners will seek out this volume as an encapsulation of some of the core concerns and dreams of preservationists in 2016, and as a measure of how far we have come.

Let us begin by marking where we are "in the flow of time."

In the pages that follow we show how, in the five decades since its passage, the National Historic Preservation Act has evolved, matured, and expanded, and how the effects of that tremendous growth can sometimes be surprising. As contributor Erica Avrami writes here, "Through legislation at the national, state, and local levels, tax incentives, zoning overlays, listing mechanisms, and other tools, preservation has matured from a grassroots movement [or, as the National Trust's David Brown likewise observes, an "outsider movement"] to an integral part of governance structures for the built environment." Today, the preservation field shaped by the NHPA encompasses a massive infrastructure of local, state, and federal offices employing thousands of historians, preservation professionals, landscape architects, archaeologists, attorneys, and administrators—not to mention developers and investors who have found ways to profit from the uniquely American system whereby most preservation is undertaken by property owners. But how well has that past, robust as it certainly is, equipped us for preservation's future? Along with Brown, we too wonder, "Could preservationists be too attached to tools designed to fight the last war? Have we 'won' and yet do not know how to build on our success?" With Max van Balgooy we consider whether "we've confused the ends with the means and are chasing the wrong goals."

Taking stock

Borrowing a phrase from our contributor Richard Rabinowitz, let us begin by marking where we are "in the flow of time." Anniversary

moments like this one often offer an occasion for celebration and reflection, but more importantly they can be catalysts for change. An earlier milestone in the history of the NHPA—the twenty-fifth anniversary in 1991—proved to be such a moment, as the preservation community seized the opportunity to take a good hard look at where they had been and where they were going.[13] In the Act's first two and a half decades, 56,350 individual entries had entered the National Register, and another 802,157 buildings were documented in historic districts.[14] Observers at that time (who remembered well the painful losses occasioned by urban renewal initiatives) lauded the Act's ability, especially via Section 106, to compel federal agencies to consult with the Advisory Council on Historic Preservation, noting that the initial scope of the legislation had widened well beyond the Department of Transportation and other early targets of concern. But they also raised questions and concerns about the future. The National Preservation Conference in that year articulated many of these concerns. The most pressing issues at that time were in many ways not unlike those we face today: how best to serve the United States' multicultural population; how best to tap emerging technologies; how to locate intersections between preservation and land-use decision making; and how preservation practice might intervene in the "increasing abandonment of the central cities."[15]

The report that emerged from the 1991 conference—*Held in Trust: Preserving America's Historic Places*—saw at the anniversary both "room for pride and room for improvement."[16] The report lauded preservation's contributions to sustainable housing (noting that preservation tax incentives had produced fifty-five thousand rehabilitated housing units and twenty-four thousand new housing units), community revitalization (especially in the National Trust's Main Street program), rural preservation, job growth (citing in particular the 1983 Emergency Jobs Act, a $25 million appropriation that funded one thousand preservation projects generating fourteen thousand jobs), education, heritage tourism, and the recognition and preservation of cultural diversity. The report also identified a series of "future needs." Key lines of argument here included the need to "expand efforts to identify our national patrimony" (that is, to educate the public on preservation principles and practice, and to expand the National

INTRODUCTION

and State Registers, particularly "underrepresented historic property types"), expand participation in preservation planning at every level, strengthen the federal government's role, increase funding (through tax incentives and partnerships), heighten public awareness, and improve the dissemination of new "techniques and technologies."[17] Other goals aimed to expand international conversations and to address challenges raised by shifting demographics at home, both of which demanded new efforts to "involve recent immigrant groups in the national historic preservation program."[18]

The Act's fortieth anniversary in 2006 saw another flurry of activity. Advocates once again celebrated the legislation's impact to that date: $19 billion of private sector monies generated through federal tax credits to rehabilitate neglected historic properties; $8.6 billion in private sector investment in 1,400 urban downtown areas; 16,000 new jobs and 43,800 new businesses created by the National Main Street program; 48,800 rehabilitated historic structures; more than 2,500 new historic districts; and overall increases in both heritage tourism and property values. In addition, the "revitalization of previously decaying neighborhoods" had lowered the crime rate.[19]

More significantly, the Preserve America Summit, held in New Orleans in October 2006, observed the Act's fortieth anniversary—and actively prepared for the fiftieth—with conversations about how to build on past achievements and plan for the future (our contributor Theresa Pasqual was a member of the ten-person expert panel charged with reviewing current conditions and making recommendations). The following summer, the Advisory Council on Historic Preservation (ACHP) issued thirteen recommendations based on discussions at the summit, describing "actions the federal government should take to enhance the effectiveness of the national historic preservation program as it moves toward 2016, the 50th anniversary of the NHPA."[20] Priorities articulated included the need for stronger leadership at the federal level (e.g., the ACHP chairperson should be appointed by the president with the advice and consent of the Senate and should serve on the Domestic Policy Council), better coordination among preservation programs in the Department of the Interior (i.e., a "new Office of Preservation Policy and Procedure (OPPP) should be established to oversee implementation of the

NHPA throughout the entire Department of the Interior's bureaus and offices"), more integration across programs focused on natural and cultural resources, more support for tribal preservation offices, and—unsurprisingly—more federal funding.

..

For many, the preserva-
tion movement's successes
have masked some of its
weaknesses.

..

Complaints that had surfaced by that time included a sense that the National Register, despite its massive size and ongoing efforts to expand the themes addressed, was still failing to document the full sweep of American life; conversely, many said that it was too easy to obtain a register listing.[21] Declining federal, state, and local funding, uneven support for tax incentives, and persistent tensions between cultural and economic agendas were identified as among the next century's most pressing challenges, alongside basic issues common to maturing organizations, including a general reluctance to embrace change, the difficulties inherent in partnership, and an inability, in the crush of the day to day, to look to the future.[22]

Now another decade has passed, and another important anniversary is upon us. In the short time since the Act's fortieth birthday, new challenges have joined older ones as at the forefront of preservationists' concerns. For many of the contributors in this volume and for many preservationists around the country, the preservation movement's successes have masked some of its weaknesses. For some, the question is how to modify existing laws and practices to open up the umbrella of what preservation is concerned with and who it involves. But others in this volume believe that the fiftieth anniversary offers the opportunity to confront fundamental problems inherent in the governmental structures and regulations that have become part of the DNA of preservation practice, largely due to the NHPA and its ensuing implementation.

Drawing on their diverse experiences and pointing to specific proposals for advancing historic preservation, the contributors to this volume offer responses to a series of core questions, and their responses will shape preservation practice for the next five decades.

Who is a preservationist?

Is preservation a movement? A profession? A discipline? A state of mind? For many of our contributors, the question of what is being stewarded is inextricably linked with who is doing the stewarding. How can the preservation establishment become more diverse and the preservation community more inclusive? In many ways, there is already great diversity within the preservation movement. Community organizers, activists, church and youth groups, businesspeople, and others often engage in heritage work as a tool in advancing their goals. But it's often the case that these actors don't think of themselves as preservationists. As Robert Weyeneth has phrased it, "The lingo of labels gets in the way."[23] Now that preservation has been so soundly established as a profession and an academic discipline, do we need once more to nourish preservation as a grassroots movement?

Do we need once more to nourish preservation as a grassroots movement?

Our contributors say yes.

The demographics of professional preservation practice is fully interwoven—as several contributors observe—with the histories that preservation recognizes, documents, and values.[24] A look at the gender history of preservation practice offers one perspective. As the field professionalized, early generations of pioneering women—from the energetic members of the Mount Vernon Ladies Association to the much-maligned "little old ladies in tennis shoes" (a tired trope we sincerely hope the preservation community will at last retire)—were displaced.[25] In the twentieth century, new leaders such as William Sumner Appleton, Charles E. Peterson, Ronald Lee, and Fiske Kimball came to define an increasingly professionalized, masculine arena. By mid-century, with the proliferation of graduate programs and government positions, the field had become dominated by white male architects and architectural historians.[26] Women, having in many ways founded preservation in the nineteenth century, spent much of the twentieth century fighting their way back to the table.[27] The NHPA and the women's movement, as Michelle McClellan notes, are generational peers, having arrived and come of age together. The same year the preservation legislation passed, Betty Friedan, whose book *The Feminine*

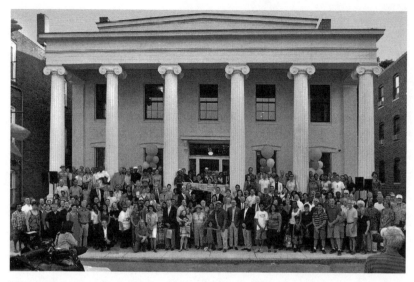

Historic Boston Inc.'s August 2014 ribbon-cutting celebration at the Alvah Kittredge House (1834) in Boston's Roxbury neighborhood, with Mayor Martin J. Walsh. In the work of Historic Boston Inc., a nonprofit developer of historic buildings, preservationists include architectural historians, contractors, small business owners, community members, nonprofit partners, public officials, and others. PHOTO COURTESY OF HISTORIC BOSTON, INC.

Mystique had appeared three years earlier, cofounded and was elected the first president of the National Organization for Women (NOW), which aimed to bring women "into the mainstream of American society now [in] fully equal partnership with men." But the preservation profession proved slow to respond; while women remained active at local levels, and in time gained purchase among the community of consultants doing the foundational spadework, women's imprint on cultural landscapes remained underdocumented. While efforts have been made to "add women and stir" (to use a common phrase), women's history as it intersects with historic preservation can struggle to incorporate the findings of the most sophisticated scholarship, something especially true when we turn to social constructs of gender and sexuality. The preservation field now contains many women in professional positions—including the first woman president of the National Trust for Historic Preservation, Stephanie Meeks, a contributor to this volume—though whether parity has been achieved in leadership roles remains an open question.[28]

INTRODUCTION

Those new professionals who emerged in the third quarter of the twentieth century interacted in particular ways with preservation's volunteer workforce. In the mid 1960s, community preservation was in the hands of local or state historical societies and community volunteers, "devotees of local history," whose values often reflected traditional ideas about historical significance. Initially, the new procedures were meant to be democratizing: where the Historic Sites Survey implemented formal, federal criteria, the NHPA (which allowed anyone to submit nominations) opened up the process. James Marston Fitch believed that the net effect was to greatly "increase the expertise and precision of the preservation and physical conservation of buildings," while using more sophisticated methods of interpreting them for the public, and elevating the role of laypersons in the community.[29] But in the decades that followed, as James Glass has explained, "thanks to the funds funneled to the states, the number of professional preservationists increased substantially. The states and many Federal agencies hired professional architects, architectural historians, archeologists, and historians to meet the dictates of the Historic Preservation Act," a cadre of new professionals who spread "preservation values" through state and local offices nationwide.[30]

The 1970s would see crucial developments that continue to shape contemporary practice in essential ways, in part due simply to generational change, but also prompted by opportunities offered by the United States bicentennial, which engaged broad public interest and enthusiasm in preserving the past.[31] State programs, for instance, shifted away from the pursuit of individual historic landmarks toward the documentation of historic districts "and other broadened environmental concepts of heritage."[32] New types of preservation nonprofits sprang up as a rising generation of preservation activists labored to protect local resources, create affordable housing, and pursue other goals.[33] But as state offices hired more and more architectural historians to meet Park Service staffing standards, "survey and registration efforts in each state came to be dominated by evaluations for architectural significance and aesthetic merits. (By late 1990, 78% of the listings in the National Register of Historic Places included architecture as an area of significance and 81% of all listings claimed significance in architecture or engineering.)"[34]

This surge of professionalization, welcome in its day, has had long-lasting effects, as several of our contributors here observe, both directly and indirectly. To be sure, it has created thousands of jobs in preservation offices and entities nationwide; many people who work in the field today hold positions that date from this time. Our counterparts at the twenty-fifth anniversary saw professionalization as a good thing, a welcome infusion of scholarship and training in place of sentiment and idiosyncrasy.[35] But it has sometimes meant confining laypersons—who often bring sophisticated understandings of their community's history and preservation needs—to particular roles as rising expectations made it difficult for untrained efforts to meet the standards of professional staff reviewers. And, certainly, the community of trained professionals, as contributors here observe, remains all too homogeneous. The good news is that in recent years there has been a serious and sustained effort to engage local expertise in preservation work; furthermore, local preservation activists have increasingly been undertaking rigorous research and driving the expansion of the circle of what is considered significant and worthy of preservation.

The twenty-fifth anniversary proved to be a wake-up call on a number of fronts but most powerfully in trying to increase the historic preservation movement's racial and ethnic diversity. The movement for civil rights for African Americans, and subsequent movements for greater recognition of the place of other groups in the American story, all began to take hold in tangible ways in the wake of that milestone. As early as 1971 an effort emerged, with support from the Afro American Bicentennial Commission, to recognize sites associated with African American history.[36] At the NHPA's quarter-century mark, attention also turned then toward diversity, or the lack thereof. At the National Trust's 1991 gathering in San Francisco, which marked their observance of the anniversary year, "the mainstream preservation movement took a hard look at itself."[37] Peter Brink, vice president for programs, information, and services, would later muse, "I recall standing at the podium that year and looking out at a sea of white faces."[38] The National Trust's Diversity Scholarship Program was also launched at this time.[39]

In that atmosphere, changes to the NHPA in 1992 also aimed to give Native American tribes greater control and influence over the preservation and interpretation of their historic resources. The

Tribal Preservation Program emerged from a 1990 National Park Service (NPS) report, "Keepers of the Treasures: Protecting Historic Properties and Cultural Traditions on Indian Land."[40] In 1992 Congress amended the NHPA to transfer to federally recognized Indian tribes more formal responsibility for significant historic properties on tribal lands, creating Tribal Historic Preservation Offices (THPO).[41]

These and other substantive efforts aimed to include a greater range of people, groups, and histories in the world of preservation. But how much progress has been made? our contributors ask. Not enough, as suggested in essays in this volume by Everett Fly, Sarah Gould, Franklin Odo, and others. And the effects, these authors assert, are tangible. In a 2012 report for the California Cultural and Historical Endowment, our contributor Donna Graves wrote "The overwhelming majority (ninety-three percent) of 'preservation leaders' are white, with two percent identifying as either African American and Asian / Pacific Islander American, and one percent as Latino."[42] If the community of preservation professionals does not reflect the American public, the field's ability to remain relevant to that public is severely compromised.

If the community of preservation professionals does not reflect the American public, the ability to remain relevant to that public is severely compromised.

How can we broaden the preservation community? In part, our contributors suggest, we must simply expand our idea of who is already a preservationist. Susan West Montgomery, for instance, suggests that in our rush to "celebrate the big win" we have overlooked the everyday work of those who steward properties on a day-to-day basis and have "failed to notice the steady and true efforts that preserve buildings over time without the need for massive investments." Homeowners, building maintenance crews, commercial property owners—every day these people make decisions that extend the lives of buildings and landscapes.

Gail Dubrow advises us of the urgent need to make preservation a more "democratic and inclusive sphere of cultural activity," while David Brown argues that a necessary "democratization of preservation suggests we must move the protection and reuse of older and historic environments from the purview of the few to work that all of our citizens can embrace." His call to leverage technologies, to

invite the new audiences into documentation efforts, to rethink the fifty-year rule, to reenvision how we think about building types, and to work "preemptively and collaboratively" with marginalized communities resonates across these pages, most particularly in essays by Sarah Gould, Julianne Polanco, and Brian Joyner, among others.

We must ensure that the community of practitioners who most actively shape preservation practice is fully inclusive. Amber Wiley's vision here includes a "New WPA" aimed at engaging "a working middle class, and developing new creative projects that put unemployed and underemployed citizens to work" in the field. Bernice Radle urges readers (especially younger activists) to "be at the table"—to run for office, serve on local zoning boards and housing courts, and otherwise seize roles that affect change in their communities. Everett Fly makes a strong call to ensure that the preservation workforce includes more people of color (and that preservation training exposes all students to more diverse histories).

In 2003, Antoinette Lee described what were to that date comparatively modest efforts to engage Latinos and Asian Americans, efforts that have expanded significantly in more recent years with the comparatively robust Latino Heritage (2013) and the Asian American Pacific Islander Heritage projects.[43] Franklin Odo's essay applauds Asian and Pacific Islander Americans in Historic Preservation (APIAHiP), a national network formed in 2007 of "preservationists, historians, planners, and advocates focused on historic and cultural preservation in Asian and Pacific Islander American communities," while Sarah Gould describes the first national summit of Latinos in Heritage Conservation, which took place in May 2015.[44] Gould's essay captures the sense of urgency that permeates this work, asserting that Latino Heritage sites "have been devalued by the powers that be for too long, and yet within these communities we know and value our past and understand the need to preserve places that matter."[45]

Yet Donna Graves cautions that "merely enlarging the number and range of sites listed by these programs in itself will not create a more inclusive and relevant preservation movement," and Gail Dubrow adds, "While identity-based politics have resulted in a more inclusive agenda for what we preserve, the democratic future of how we preserve depends on bringing their experience, insights, and

perspectives to bear on redefining the scope, policies, practices, and priorities of the preservation movement as a whole."

In his contribution to the volume, Jeremy Wells constructs an imaginary interview in a future preservation world where a far greater range of people, not to mention a far greater range of disciplines, are engaged in the work of saving and interpreting the past. His invented dialogue can serve as a response to National

What is the fundamental purpose of preservation?

Trust president Stephanie Meeks's concern that we continue to have the "unfortunate perception of preservationists as the 'paint police.'" As she writes, "We need to work with communities to reconceptualize historic places, so they meet the needs of neighborhoods and reflect the energy and diversity of their environment."

What should be preserved, and why?

The question of *who* is closely aligned with that of *what*—what of local, state and national history deserves to be preserved? And *what* is of course inextricable from *why*.

On the opening page of Gabriel Garcia Marquez's classic novel *One Hundred Years of Solitude*, the gypsy Melquíades, who has come to the village of Macondo to show off the power of magnets, declares, "Things have a life of their own. It's simply a matter of waking up their souls."[46] Substitute "buildings" for "things" and you have a neat summary of one of the animating ideas of historic preservation under the NHPA regime: buildings are alive; they have souls, and can communicate with us; the best of them must be saved so that future generations might experience those "souls." Contributor Michelle McClellan has come at this another way in her writing and thinking elsewhere about "place-based epistemology"—the "faith," she explains, "that being in a particular location brings us closer to events that happened there, that we can know and understand experiences from the past better if we can go to the places where they occurred. We hear this in our language: 'It made me feel like I was really there,' a heritage tourist will often say. Because you are there—and there may be the closest you can get to then."[47]

What is the fundamental purpose of preservation? Is it an essentially

archival effort to document the history of the built environment? A tool to achieve environmental and economic sustainability? An ultimately humanist effort to bridge divides between the living and the dead?[48] In his essay, Randy Mason urges us to get back to basics and ask "What effects do we want preservation to have on society? What will be our social impact? How do we measure and monitor effects?" Several of our contributors argue forcefully against the centrality architecture has assumed in historic preservation. This may seem like a bizarre notion, but in fact, historic preservation was, in its nineteenth-century incarnation in the United States, as much if not more about saving sites of historic meaning than about preserving great works of architecture. Indeed, the 1966 Act gave equal emphasis to buildings and places of historic importance and examples of architectural achievement. It is only over the last fifty years—with the rise of preservation professionals mentioned above—that the values of "criterion C" of the NHPA, focusing on preserving architecture, has come to dominate our local, state, and federal preservation work.[49] According to this standard, a "property must embody the distinctive characteristics of a type, period, or method of construction, represent the work of a master, possess high artistic values, or represent a significant and distinguishable entity whose components may lack individual distinction." Today, Criterion C is cited on more than half of buildings listed on the National Register.[50]

One of our contributors, Richard Longstreth, in the twenty-fifth anniversary year of the National Historic Preservation Act, cautioned against this drift in the preservation field, declaring that "among the most fundamental changes for which there is an urgent need is the expunging of taste, or current aesthetic predilections, as a force in decision making. While taste is not an official criterion for listing historic properties, anyone who has worked in the preservation field knows that it is an underlying factor and may surface openly to influence the debate."[51]

Daniel Bluestone argues in this volume that the issue is neither simply taste nor changing the "extent" of our emphasis but rather "dislodging," once and for all, the central notion—articulated by one of the founders of modern, professionalized preservation, James Marston Fitch—that preservation is about the "curatorial management of the

INTRODUCTION

built environment." Is it not finally time, Bluestone asks, to focus first and foremost on places of great meaning to our communities, regardless of architectural merit? Bluestone challenges us to consider setting aside "the fastidious, precious descriptions of architectural and landscape resources demanded by the National Park Service for completing Section 7 of the National Register of Historic Places," where the building's architecture is described, and focus instead on Section 8, where a case is made for why a given resource matters.

Tom King is even more direct: "Fifty years is long enough." As a professional who has built a career around the compliance policy and the procedural requirements of the existing law, he nonetheless argues that the emphasis on the built environment and the "elitism" of the National Register has ended up skewing what we save. We should get rid of the entire edifice, says King, and replace it with something far more expansive and open-ended, allowing for the full acknowledgement of what Berkeley professor Randolph Hester has called the unique "sacred structure" of a community's environment.[52]

An unlikely and unplanned dialogue between an eminent American historian and a world-famous architect—Neil Harris and Rem Koolhaas—poses one of the most troublesome issues for preservationists: When do we let buildings die? Harris posits the simple question: Shouldn't we have a living will for buildings, as many of us do for our own bodies? Shouldn't we have an idea, either at the birth of a building, or in its maturity, a clear sense of how it might end its days? Isn't it irresponsible to ignore the inevitable, no matter how far in the future it might be? Rem Koolhaas, who is best known for his visionary buildings of the past quarter century across the globe, has repeatedly returned to the theme of preservation, offering sharp challenges to reigning practices. He provocatively argues in these pages that we should throw out complicated systems that identify the best or most representative places of a particular time, and replace them with approaches that simply keep an entire swath of a city— good, bad, ugly, exceptional, ordinary—preserved for a time before allowing it to be redeveloped, while moving on to preserve another section of the city. Koolhaas proposes here that "the march of preservation necessitates the development of a theory of its opposite: not what to keep, but what to give up, what to erase and abandon. A

system of phased demolition, for instance, would drop the unconvincing pretense of permanence for contemporary architecture, built under different economic and material assumptions."

Tom Mayes of the National Trust for Historic Preservation offers another viewpoint: he sees the problem being not that we save too much, but that our society assumes and grants extensive freedom of demolition to property owners. Mayes proposes a novel local ordinance that starts with the premise that in the service of energy conservation and fighting climate change we must upend our current approach, which allows demolition by right of ownership to virtually all buildings and requires preservationists to fight the tide through historic districting and demolition delays. Shouldn't developers have to jump over at least a small regulatory obstacle and publicly explain why they cannot adapt an older building and must instead start anew?

Much of the discussion around what to save and how much to focus on architecture, has hinged on two key—and controversial and highly charged—concepts: integrity and significance. "The quality of significance in American history, architecture, archeology, engineering, and culture," the National Register's criteria for evaluation reads, "is present in districts, sites, buildings, structures, and objects that possess integrity of location, design, setting, materials, workmanship, feeling, and association, and: That are associated with events that have made a significant contribution to the broad patterns of our history; or that are associated with the lives of persons significant in our past; or that embody the a) distinctive characteristics of a type, period, or method of construction, or b) that represent the work of a master, or c) that possess high artistic values, or d) that represent a significant and distinguishable entity whose components may lack individual distinction; or that have yielded or may be likely to yield, information important in prehistory or history."[53]

In this formulation, significance hinges on integrity, that is, the ability of the historic resource to convey its significance. Students of historic preservation practice learn early on those seven elements that the federal government has determined comprise physical integrity: materials, workmanship, setting, design, location, feeling, and association.[54] Most of the elements of this formulation (the emphasis on materials, workmanship, and location, as well as the more

INTRODUCTION

subjective assessments of feeling and association) predate the NHPA.[55] Historian John Sprinkle argues that in the three decades prior to the NHPA, "practitioners came to understand that the concept of integrity" as well as "the changing nature of historical significance" were "best viewed on a sliding scale." In other words, there should be no hard-and-fast rules about how much original material must remain of a building, for example, for it to be deemed to have "integrity."[56] Unfortunately, the flexibility of the concept can easily be lost on state and local preservation commissions: examples are legion of the (presumed) dictates of integrity undermining efforts to gain recognition for sites of great historical or cultural importance.

The set of chronologically based, thematic frameworks articulated in 1936 by pioneering NPS historian Verne Chatelain guided the agency's historic site selection for the next five decades. The frameworks—an outline or checklist of historical themes and subjects that helped NPS track the degree to which the agency was interpreting what was understood to be the full sweep of U.S. history—initially "focused on relatively few broad themes, such as the development of the English colonies and the westward expansion, that stemmed from a view of American history as a 'march of progress.'"[57] By the 1980s, that conception of history had been laid to rest by generations of social and cultural historians; in their wake, the frameworks were revamped in 1987, and thoroughly overhauled again in 1993, to respond to a range of emerging fields, as well as to rising interest in the construction of public and collective memory.[58] "The new framework," proponents observed, "encourages a more thorough examination of cultural and social processes. It invites interdisciplinary consideration of larger trends. It fosters discussion of fundamental social and economic structures and an analysis of change over time. In using the revised thematic framework, NPS staff will recognize more readily the larger implications and research possibilities of a site and better answer such key questions as 'Why does this place really matter?'"[59]

That question—why do places matter, and to whom?—drives many of the essays in this volume.

Given that the NHPA was enacted in part in response to the devastating effects of urban renewal in the 1950s and '60s, with whole neighborhoods lost to the wrecking ball, it is no accident that the

Act's provisions greatly elevated the role of local history in preservation practice.[60] In time, nominating historic districts, as opposed to individual structures, to the National Register became the focus of preservation energy, a development that had implications for the preservation of neighborhoods.[61] But preservationists have continued to press for tools that respect and capture meanings that are increasingly intangible. For instance, in the wake of Hurricane Katrina, assert David Morgan, Nancy Morgan and Brenda Barrett, "there simply was no record of many of the common places whose loss people mourned, whose loss threatened that most intangible and critical sense of place tying people to their community and to the landscape."[62] These authors join many who contend that "community concepts of place diverge widely from the way place is considered in the legal framework of historic preservation in the United States."[63]

Our contributors concur. Na Li proposes a "culturally sensitive narrative approach" that prioritizes oral history as a tool to understand neighborhood preservation values; in order to cultivate a practice that respects community values, we need to spend "a substantial amount of time in the field, with humility and diligence." Julianne Polanco likewise sees a much more expansive possibility for intangible heritage. How, she asks, can we document, preserve and interpret the "layers of culture" that accumulate over time as new peoples inhabit old places in ways that "enliven" sites for future generations? Sarah Gould, Brian Joyner, and others note disconnects between what preservationists have traditionally deemed significant and the places a community values for its own reasons.

Erica Avrami may agree with all of these goals but offers an important caution and challenge: whatever our goals, we must take the time to rigorously measure and evaluate our work, in order to convincingly prove the successes we claim. The preservation field is fully mature, she argues, save for our ways of actually measuring how well we are accomplishing what we set out to do. Of course, there is a caution about metrics woven throughout some of the other essays. Metrics can have a force of their own, and it has been easy for the preservation field to drift toward easily measurable, quantifiable objectives. As Russell Keune has noted, in many preservation offices, "success is measured by the number of projects reviewed and processed, the

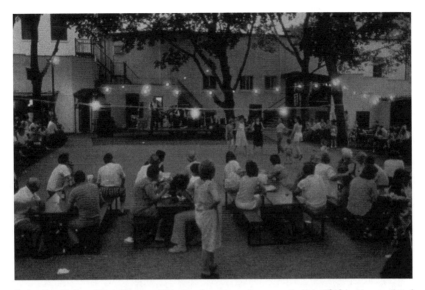

Bohemian Hall and Park, Queens. This Czech community center, built in 1910, makes no list of outstanding works of architecture. But as a home away from home for immigrant communities in New York City it is of profound importance. It has served as a center for the Czech community for a hundred years, and the setting of important communal events for Hungarian, Croatian, Cypriot, Greek, and South American groups. PHOTO COURTESY OF MARTHA COOPER.

number of approvals or rejections issued, and the number of statistics compiled into reports."[64] But simply counting the amount of money invested in Main Streets or the number of buildings saved by our efforts is not enough, especially as preservation has expanded its hopes to shaping the environment and improving communities. Avrami insists that we should not shy away from less easily measured goals but rather work to find new tools to track them.

What stories should we be telling?

If previous generations focused on tools and instruments for attracting financial investment, many preservationists today are committed to expanding the range of stories we tell through historic places as a means of promoting a more diverse understanding of the nation's history.

This body of essays suggests that we need to rethink how we discover, assess, and interpret the stories we tell. For instance, James Lindgren observes the special challenges inherent in maritime

preservation, but also the pressing need to direct attention toward our nation's maritime heritage, a largely neglected subject but essential to understanding our longer-term role as a global power.[65] Meanwhile Michael Allen and Brian Joyner take on the "fifty-year rule"—a.k.a. Consideration G of the National Register Criteria—which is, according to historian John Sprinkle, the "best-known, yet also the most misunderstood preservation principle in America."[66] Consideration G holds that "properties that achieved significance within the past fifty years" should not be considered eligible for the National Register "unless they are of exceptional importance."[67] The logic here is that "fifty years is a general estimate of the time needed to develop historical perspective and to evaluate significance. This consideration guards against the listing of properties of passing contemporary interest and ensures that the National Register is a list of truly historic places."[68] Over decades of practice, this guideline has accumulated force, calcifying into a "rule." Our contributors worry about what's lost when we accept too-rigid an interpretation of this principle. Joyner in particular urges us to see how, today, "history, its effect on or how it is affected by the built environment . . . unfolds with such velocity and ferocity that today it seems to occur in between breaths, not eras." Michael Allen offers us a specific example: the struggle to remember the site of Michael Brown's death at the hands of police officer Darren Wilson in 2014 in Ferguson, Missouri. "We lose too many sites of struggle and social change," he cautions, "before their stories are recognized, let alone understood."[69]

Too often, preservationists bring a flattened approach to the past

Too often, preservationists bring a flattened approach to the past, slotting people and places into anticipated boxes rather than allowing full expression of complex and diverse histories. For instance, Kurt Dongoske and Theresa Pasqual explain the consequences inherent in the long-standing application of preservation criteria that limits recognition of native sites to their archaeological potential. "By not recognizing the tribal associative values to archaeological sites under Criteria A and B," they observe, "the federal agency unwittingly contributes to a nefarious three-hundred-plus-year history of colonial oppression in which science, legislation, and regulations

were often employed to diminish and explain away Native peoples' primacy rights and claims to the landscape in favor of colonial land taking and imperialistic and capitalistic enterprise." Also, they point out, existing policies and procedures have no place for emotional or affective meaning. Everett Fly likewise considers what's at stake when preservationists assume that sites associated with African Americans have only one story to tell, and one associated with slavery or civil rights rather than with the numerous other places in which black lives intersect with the larger currents of American history. What's more, we have far too often rushed to preserve sites of interracial cooperation—such as the Rosenwald Schools—and shied away from the most troublesome sites in American race relations.[70]

In another provocative essay, Michelle McClellan tackles how women's and gender history have fared among preservationists.[71] The career of women's history in historic preservation practice is especially complex, given the importance of women to the field's origins and the ways in which that history has and has not shaped the field. The National Register has never tracked the documentation of women's history; in fact, when the first automated index to the register was developed, Carol Shull (longtime keeper of the National Register) explains, "after considerable discussion," NPS "decided not to include a data field for significance in women's history [since] the places associated with women were being nominated not because of the gender of the women associated with them, but because these individuals made contributions in areas of significance, such as architecture, art, education, literature, law, medicine, or science—regardless of their sex. Gender was not a factor in their selection."[72] "There was concern," Shull later recalled, "that to list a property in any area of significance just because it was associated with a woman was patronizing."[73]

Complicating matters is the sense that today, despite increased attention to women as historical actors, the fundamental premises underlying formal determinations of significance—which tend to prioritize individuals and events over networks and long-term processes—mitigate against the application of the scholarly discipline's findings and insights, which has emphasized the intersection of women's multiple identities (race, gender, and class, for example), relational differences between women, the mutual construction of sexual

and gender norms, and the constructed nature of gendered identity and biological sex.[74] As McClellan further observes, "Historic sites and interpretive practices still implicitly tend to favor a 'great man' theory of history, even as historical scholarship has been transformed as it relates to the histories of women, gender, sexuality, and the family. The codification of standards of 'significance' at the federal level represented a critical success for preservationists. But fifty years on, those criteria have had unintended consequences in determining what counts as important, even as preservation has become more inclusive."

Expanding the range of the stories being told expands the realm of the possible

In May 2012, Secretary of Interior Ken Salazar introduced a new secretarial initiative focusing on women's history, "Telling the Whole Story: Women and the Making of the United States," which aims to redirect attention to the preservation of women's history.[75] This is a needed and welcome initiative. But meanwhile, the field of women's history has itself evolved in new directions, launching the related (and sometimes overlapping but not identical) field of gender studies, as well as the history of sexuality. This too is gaining important attention. In 2014, secretary Sally Jewell announced the Lesbian, Gay, Bisexual, Transgender, and Queer (LGBTQ) Heritage Initiative outside the Stonewall Inn in New York City, the site of a 1969 riot that is widely recognized as a catalyst for the modern civil rights movement in the LGBTQ community (and currently the only LGBTQ-associated site designated a National Historic Landmark).[76]

Expanding the range of the stories being documented and told expands the realm of the possible as preservationists seek to engage new questions about the past and address present-day policy issues. Franklin Odo, for instance, urges us to see in historic sites the opportunity and responsibility to raise critical questions, such as "How did our current immigration policies emerge and evolve?" or "What does the historical record say about our nation's ability to adhere to constitutional principles in, say, the Bill of Rights, when questions of national security become preeminent?" But he also concedes, "But before we can ask such sites to address such complex questions, we need to know where these places are."

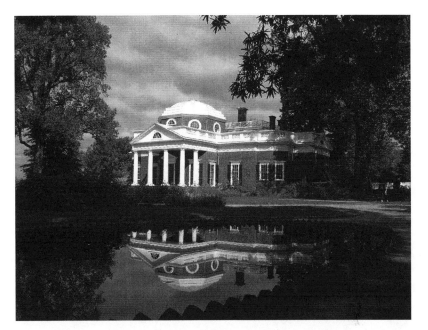

Monticello, reflected in the fish pond. Monticello has long been revered for its architectural beauty as well as for being the home President Thomas Jefferson, designed by and for himself. But the meaning of the place has changed through historic research and advocacy. Now the site is understood as the home not only of Jefferson but of his enslaved woman Sally Hemings, her children (six by Jefferson), and a host of free and unfree workers as well. PHOTO BY MATT KOZLOWSKI, THROUGH WIKICOMMONS.

How do we, and should we, tell the histories of significant places?

Many contributors call attention to the need to harness new interpretive techniques and put fresh emphasis on using historic places as sites of dialogue about our multiple pasts. A tremendous amount of information gathered in preservation practice languishes in formats that very few people ever see. Buried in reports and forms rarely seen outside professional pipelines, the community knowledge cultivated by these processes cannot make meaningful contributions to public historical understanding. What's more, the tools we do use to share that information may not meet the needs of twenty-first-century audiences. It is unsurprising that that most familiar of preservation genres, the historic marker, gets its share of attention here. Stephanie Meeks

warns us that "working to cordon off historic places behind plaques and velvet ropes 'because they're there' will only ensure these buildings remain sterile, desiccated, shut off from communities." Steven Lubar notes how much harder historic markers could work; why not make physical markers more compelling, while also harnessing emerging technologies to make interpretive data accessible, constantly and at its most fulsome, at our fingertips? Richard Rabinowitz imagines landscapes teeming with interpretive information—on bus stops, bike racks, and lampposts—that "enliven the cityscape with the memories of the artistry, voices, and struggles of the past, rather than pretend that they sit in a tabula rasa."

John Sprinkle reminds us that the "documentation reflects the time and administrative context in which nominations were prepared and processed, and thus it is often out-of-date or incomplete." He offers what, in the wake of the murder of nine churchgoers in Charleston, South Carolina, and the ensuing removal of the Confederate battle flag from the statehouse grounds, is a chilling example: "Thomas Jefferson's Virginia State Capitol building's official name is the 'Confederate Capitol' because it was designated as a National Historic Landmark in 1961 during the centennial of the American Civil War." "The "fact is," Sprinkle continues, "only 3 percent of the ninety thousand listings on the National Register have ever been updated for content," a dire state of affairs for which no obvious remedy, given the enormity of the problem, is available. But perhaps this "maintenance backlog" could be addressed by "an interactive, widely accessible, authoritative, and crowd-sourced guide to our historic places and their stewards."

More boldly, Tiya Miles and Rachel Miller propose using "critical place-based storytelling" to engage audiences, an approach especially valuable when no extant built environment survives. Historical fiction, "read dialogically to illuminate the complex histories of preserved (as well as unmarked) places," offers one fresh interpretive strategy since, "with an empathetic ear to the past," fiction writers "have already forged pathways through fragmented evidence and lost memories." Miles and Miller are not alone in contemplating the need to document and interpret not just what survives but what has disappeared. Steve Lubar urges us to "interpret our entire history, moving our focus beyond just those lucky buildings that survive. Indeed, it may be even

more important to tell the stories of those buildings that, demolished because they were no longer of value, speak directly of change over time." Meanwhile, Angel David Nieves shows us what that could look like as he explores how graphic information systems and computer- generated imagery of buildings and landscapes can be used to digitally reconstruct "vanished landscapes."

The field is only now beginning to undergo rigorous self-reflection.

Nieves believes that this approach will be especially valuable as we seek to recover, preserve, and interpret places with difficult stories to tell. Jamie Kalven writes, "The practice of historic preservation should directly engage the ways structural inequalities in our society are expressed, reinforced, and hidden by the built environment." How can preservation better attend to the full array of "spatial strategies of white supremacy" (to borrow a phrase from Robert Weyeneth) and address the "serial displacement" that unfolds as public housing complexes, predominantly black neighborhoods, and African American schools, churches, and other public buildings give way to new landscapes that reflect the preferences of the powerful?[77] Having watched the dismantling of Chicago's high-rise public housing and its many unwelcome consequences, Kalven asks, "What form would a redevelopment process that honored residents' identities, memories, and sense of place take?" Observing that a "shadow preservation movement has stolen across the world," Liz Ševčenko describes the growing "populist, urgent" global effort, as part of broader social and political movements, to mark difficult places, particularly sites of state terrorism, efforts that sit alongside the more official, "elite," and "static" state-sponsored preservation programs. Ševčenko encourages us not only to help document and mark such sites but also to seek out those emotionally charged spaces, and learn how to engage in those sensitive dialogues.

Lastly, several authors—following developments in related fields that urge public historians to "pull back the curtain" and assume responsibility for interpreting their own role in shaping change—see a special need to expand the kinds of stories we tell to include the history of historic preservation itself.[78] Thus, Jack Tchen calls for a frank narration of New York's Fifth Avenue Association, while Suleiman Osman seeks greater acknowledgment of preservation's

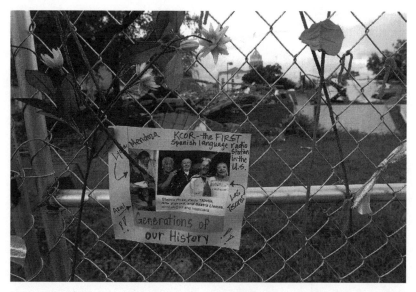

In November 2013, protests erupted in San Antonio, Texas, concerning the demolition of the 1955 Univision building, the last home of KWEX-TV. The San Antonio Conservation Society, together with the Westside Preservation Alliance, had been fighting for months to get the midcentury building—the "birthplace of Spanish-language broadcasting in the nation," according to activists working on the building's behalf—designated a historic resource. PHOTO BY TOM REEL/SA EXPRESS-NEWS, THROUGH ZUMA PRESS.

role in nourishing gentrification. Richard Rabinowitz's critique of landmark signs—which are often virtually unreadable and largely irrelevant to people other than architectural historians—reminds us that preservationists need to thoughtfully acknowledge their role in creating some of the problems we now critique. Preservation is the way so many Americans encounter history. And yet, the field is only now beginning to undergo the rigorous self-reflection—histories of the movement, analyses of foundational laws and ideas, evaluations of practices—that other built environment fields have experienced.

Can preservation help create more economically vibrant and just communities?

The 1966 Act declares in its opening lines that preservation will have economic benefits for the nation. Many advocates—and detractors—speak primarily about preservation's economic impacts, and much of

contemporary preservation policy revolves around how preservation projects will make a profit while promoting economic development. This transformation was primarily the product of changes to the 1966 Act in the ensuing decades. Due to the significant 1976 Tax Reform Act, which "provided Federal income tax incentives for the rehabilitation of registered properties, local preservationists and new converts to historic preservation, local developers and business investors, nominated additional historic properties to the Register. A boom in the rehabilitation of income-producing historic buildings occurred after the Economic Recovery Tax Act of 1981 afforded generous tax credits for rehabilitation of National Register properties."[79] The result was to bring "large numbers of developers and investors into the preservation movement for the first time." Around the same time, in 1977, the National Trust launched the Main Street Project (which led to the creation in 1980 of the National Main Street Center), designed to make preservation a core strategy of downtown redevelopment for city leaders and small-businesspeople alike. The program "converted small town business people into preservationists."[80]

For many in the field, the creation of tax credits (which have in the intervening years been weakened at the federal level but augmented unevenly at the state level) was as monumental a development as the NHPA itself. Tax credits made preservation projects economically viable, launching thousands of projects around the country. For supporters, tax credits are what made preservation a part of mainstream economic development strategy, and dramatically accelerated the core mission of the movement to save the significant places of the nation. For others—including a number of contributors to this volume—the focus on tax credits, and on luring wealthier individuals back to stage-set neighborhoods, has turned preservation away from its concern with places of architectural and historical significance and toward gentrification as economic development. It has meant, as Suleiman Osman writes herein, "striking a Faustian bargain with developers." Donovan Rypkema has been perhaps the central figure arguing the case for preservation as a valuable tool for promoting economic development.[81] He has insisted, with equal fervor, that other purposes of preservation—history, beauty, identity—are more important. And yet, in many places the bulk of preservation work is organized around the

needs of private real estate, making preservation seem at times simply a handmaiden to market-based economic development.[82]

Osman and Japonica Brown-Saracino try to disentangle some of the arguments about preservation and its role in gentrification. While historic neighborhood preservation in places such as New York, Philadelphia, and San Francisco has lured wealthier people back to the city, pushing up rents and at times displacing local businesses and long-time residents, there is also a strong case to be made that in many cities there is no threat of gentrification. Indeed, many places are desperate for the inflow of capital whose pathway is often paved by historic preservation. Preservation is, in some places, a true force for displacement and encouraging the segregation of cities by class. But preservation also has an image problem, whereby it has become the scapegoat for neighborhood change that has been fueled by far more fundamental, structural economic shifts. The Lower East Side Tenement Museum did not cause the Lower East Side rents to soar to the level of the rest of Manhattan, but you would not know this from the condemnation it has received as the institution has grown alongside the transformation of the neighborhood. And yet, in the end, Brown-Saracino urges that we embrace the efforts of "social preservationists" who are aware of the dangers of gentrification and are working, however imperfectly, to "preserve the social fabric of neighborhoods."

One answer, several contributors suggest, is for the preservation movement to be much more vocally and actively engaged in creating more economically just communities. Graciela Sánchez, a long-time organizer for Esperanza Peace and Justice Center in San Antonio's predominately Mexican American West Side, argues pointedly that preservationists must become "anti-gentrification activists." In the 1970s, her house and that of her grandparents fell to urban renewal; by 2011, when Sánchez helped organize an effort to rescue Casa Maldonado—birthplace of civic leader and union organizer William Maldonado and over time housing a tavern, fruit store, thrift store, and office building—from demolition, fifty-one of seventy-one West Side buildings deemed by a 1986 study to be contributing historic structures had been demolished.[83] Sánchez's work has led her "to believe that if historic preservationists are serious about the desire to preserve the history and culture of communities of color, they must

INTRODUCTION

find ways to prevent the gentrification of inner-city communities." This will require, she writes, that preservationists be willing "to take on some of the most formidable economic interests in the city because inner-city redevelopment promises huge profits and historic preservation is at risk of becoming mere 'value added' for the developers."[84]

Andrew Hurley, who has been active in writing about the use of historic preservation in the revitalization of St. Louis, one of the most devastated of cities in the postwar era, argues that the regulations and standards have left the preservation movement with limited tools to truly help regenerate the poorest parts of our cities. Hurley makes the uncomfortable point that the market-based approach to preservation—encouraging developers through tax credits, for example—has left most of the poorest areas of the country untouched. The market reflects the ongoing segregation, racism, and gross class inequity that leave developers far from the areas that might benefit the most from capital. "To reassert its relevance as a tool for revitalization, the preservation movement must find ways to accommodate and reward a wider range of heritage-based revitalization strategies."

Architect and author Michael Sorkin argues that if we want to look for New York's most important preservation act—its "human preservation" act, that is—we might look back further than the creation in 1965 of the Landmarks Preservation Commission to the 1942 rent control law, the anchor for the preservation of communities in the face of market-driven displacement. The next fifty years, Sorkin writes, should be about building very clear links between architectural preservation and human preservation. Larry Vale, a historian of public housing in the United States, praises the planned National Public Housing Museum in Chicago as a tool for changing public opinion about one of the most—unfairly—loathed building types in the country: "In the case of public housing, preservation of a stigmatized place may, paradoxically, contribute to the easing of that very same stigma."[85]

Even as some urge that we defend public housing as part of preservation's goal, Randy Mason suggests that we be creative in supporting new forms of ownership, given that the most direct pathway to preserving an important place is to own it. In the rest of the world—and increasingly in the United States—there are alternative forms of

ownership and alternative types of organizations to manage property, such as land trusts, conservancies, nonprofit corporations. "Looking ahead fifty years from now," Mason writes, "the preservation field will hopefully have pioneered new models of ownership mixing the most effective and resonant aspects of historical private and public ownership models, innovated new institutions to manage ownership and stewardship processes (and fiscal and public accountability), and created new cultures of heritage ownership in the broad and progressive sense."

> *Preservation has a role to play in transforming our society so as to slow the transformation of the planet.*

Modifying preservation rules, defending public housing, and promoting new forms of ownership are all powerful ideas. But Daniel Vivian and Gabriela Sánchez offer deeper critiques. Rather than softening the impact of the market, Vivian thinks that preservation can and should be a tool for challenging the edifice of neoliberalism that has been the dominant political economy of our time. And Sánchez ends her essay with a different but sympathetic challenge to the culture of activism in the preservation movement. Essentially, she argues that if preservation means to call upon the name of those movements of the last half century that have transformed and continue to transform our society—the African American civil rights movement, the feminist movement, the gay rights movement—then it must be prepared to use the full range of tools those movement employed.[86] "To do this work," Sánchez writes, "we must be passionate. Remember: when we get dismissed, demonized, or jailed, we are preservationists, as well as activists. We are people who do the research, think and analyze, and follow the rules. Yet when all else fails, we take to the streets and, if necessary, disobey civil authorities."

Can preservation help save the planet?

Section 1 of the 1966 National Historic Preservation Act declares that preservation "is in the public interest" in part because of the "energy benefits."[87] The link between preservation and the environment, which has been a subject of growing discussion within the

555 Hudson Street in Manhattan's West Village section, the home of the urbanist Jane Jacobs when she wrote *The Death and Life of Great American Cities*. The urban density she championed is the source of the environmental sustainability of big cities. PHOTO COURTESY OF MAX PAGE.

preservation field, was there from the beginning. But it is fair to say, as do several of our contributors, that climate change (and not just the need to conserve energy) is one of the central crises of our day, and that preservation has a role to play in transforming our society and world so as to slow the transformation of the planet. Indeed, if preservationists can show and then convincingly argue for the key role played by preserving old places and conserving the cultural landscapes in which they sit, and cultivate the interactions between people and natural places, then this might be the moment preservation gains its widest influence.

Strong arguments have been made over the past decade by the National Trust's Preservation Green Lab and other groups, following the long-held dictum, attributed to architect and preservationist Carl Elefante, "The greenest building is one that is already built."[88] With close to half of all carbon in the atmosphere created by the demolition, construction, and operation of buildings, preservationists have argued a simple truth: there is no building ourselves out of the climate disaster we are creating and starting to experience.

Even the most "green" building—given, say, a "platinum" evaluation by the U.S. Green Building Council's rating system, will take decades to make up for the energy and carbon produced in the demolition of the previous building and construction of the new. Tom Mayes's local ordinance proposal is built from this foundational idea: we must start with the assumption, in a world threatened by climate change, that we should reuse buildings because reuse is almost always better for the environment than building new.

Our contributors look beyond the immediate technical proof of preservation's importance to the climate change struggle and propose a deeper reunion between preservationists and conservationists, and call for a far more nuanced understanding of the relationship between human and natural environments, over a far longer time span.[89] Richard Longstreth argues that we need strong leaders in preservation and conservation advocacy fields who will take a "holistic approach to conservation that encompasses all scales—from moldings and hardware to general matters of form and space—and embrace continuity while allowing for needed change." Long-time *New Yorker* staff writer Tony Hiss similarly proposes that we need a "grand coalition—a coming together of preservationists and conservationists."

In a way, the rise in awareness among preservationists, and, more slowly, the general public, that saving old places, building traditional neighborhoods, and understanding the functioning of the natural world in ongoing dialogue with human beings mirrors the general sentiment proposed by many of the essays in this volume: that we broaden the range of people who call themselves preservationists, that we think holistically about the world, its places, and its stories that we seek to steward. Writing about the need for a new dialogue between preservation and conservation groups, Hiss may have captured the essence of what our contributors hope for: that they ultimately "see themselves as forming a single constellation of protection. They can acknowledge that at the deepest level they both draw from the same well. . . . How fortunate that a train station and a tree . . . can shake us out of the lonely daydream that the present moment is isolated from all the lives that preceded and will follow us, and all the life around us."

The future beyond the bend: Toward 2066

There are no simple solutions, no magic bullets, and no detailed blueprints in these pages. There are, instead, ideas that we hope will energize the next half-century of preservation practice for those who call themselves preservationists as well as those who don't but who in fact do the lion's share of the work of saving and telling the stories of important places. Our contributors offer provocations, not prescriptions. Nonetheless, we hope and expect to see evidence of the influence of our contributors'

Ideas that we hope will energize the next half century of preservation practice.

ideas everywhere in the preservation world in the future: in preservation education, which will focus on a far broader range of preservation sites and practices, including oral history, storytelling, and digital history; in preservation practice, with "place" replacing "building" as the heart of our work and the term "paint police" no longer being applied; and in public life, where preservation will be not an afterthought but a starting point for discussions about spreading historical knowledge and cultural understanding, building equitable cities, and protecting a sustainable planet.

MAX PAGE is a professor of architecture and history at the University of Massachusetts Amherst and directs the UMass Historic Preservation Program. He is the author or editor of eight books, including *The Creative Destruction of Manhattan; The City's End: Two Centuries of Fantasies, Fears, and Premonitions of New York's Destruction; Giving Preservation a History: Histories of Historic Preservation in the United States* (with Randall Mason); *Reconsidering Jane Jacobs* (with Timothy Mennell); and *The UMass Campus Guide* (also with Marla Miller). *Why Preservation Matters* will be published by Yale University Press in 2016. He has been a Guggenheim fellow and a Rome Prize recipient.

MARLA R. MILLER directs the Public History Program in the History Department of the University of Massachusetts Amherst. A historian of women and work, she has also worked as a preservation consultant, completing nominations to the National Register of

Historic Places, cultural resource surveys, and other forms of documentation. In 2011, she and three coauthors completed the study *Imperiled Promise: The State of History in the National Park Service* for the Organization of American Historians and the NPS chief historian's office; the study won the 2013 Excellence in Consulting award from the National Council on Public History.

NOTES

1. Quoted in Michael Kimmelman, "Restore a Gateway to Dignity," *New York Times,* February 8, 2012, p. AR1.
2. United States Conference of Mayors, Special Committee on Historic Preservation, *With Heritage So Rich* (1966; repr., Washington, DC: National Trust for Historic Preservation, 1999), 17.
3. Ada Louise Huxtable, "Program of Legislation and Financial Aid to Save Historic Sites Is Urged in Report," *New York Times,* January 30, 1966.
4. On the history of historic preservation in the United States and particularly the NHPA, good points of entry include Charles B. Hosmer, *Presence of the Past: A History of the Preservation Movement in the United States before Williamsburg* (New York: Putnam, 1965); William H. Murtagh, *Keeping Time: The History and Theory of Preservation in America* (Pittstown, NJ: Main Street Press, 1988); Barry Mackintosh, *The NHPA and the NPS: A History* (Washington, DC: National Park Service, 1986); Michael A. Tomlan, ed., *Preservation of What, for Whom? A Critical Look at Significance* (The National Council for Preservation Education, 1997); Norman Tyler, *Historic Preservation: An Introduction to Its History, Principles, and Practice* (New York: W. W. Norton, 2000); Max Page and Randall Mason, eds., *Giving Preservation a History: Histories of Historic Preservation in the United States* (New York: Routledge, 2004); Robert E. Stipe, ed., *A Richer Heritage: Historic Preservation in the Twenty-First Century* (Chapel Hill: University of North Carolina Press, 2003); and John H. Sprinkle, Jr., *Crafting Preservation Criteria: The National Register of Historic Place and American Historic Preservation* (New York: Routledge, 2014).
5. The fifty-nine State Historic Preservation Offices include one for each state as well as offices representing the District of Columbia, American Samoa, Guam, the Republic of the Marshall Islands, the Federated States of Micronesia, the Commonwealth of the Northern Mariana Islands, the Republic of Palau, the Commonwealth of Puerto Rico, and the U.S. Virgin Islands. By 1969, these preservationists were united in the National Conference of State Historic Preservation Officers, which lobbied Congress for funds and discussed common concerns.
6. Sprinkle, *Crafting Preservation Criteria,* passim.
7. Ibid., 27.
8. This language found its way into the Act itself, in which Congress declares, "The historical and cultural foundations of the Nation should be preserved as a living part of our community life and development in order to give a sense of orientation to the American people"; National Historic Preservation Act (Public Law 89-665; 16 U.S.C. 470 et seq., and discussed in Diane Lea, "America's Preservation Ethos," in Stipe, *Richer Heritage,* 11.

9. The story of the failed 1848 effort to preserve Deerfield's "Old Indian House" is recounted in Michael C. Batinski, *Pastkeepers in a Small Place: Five Centuries in Deerfield, Massachusetts* (Amherst: University of Massachusetts Press, 2004).

10. Sprinkle, *Crafting Preservation Criteria*, 5.

11. About a third of the essays contributed here were the product of conversations in the spring and summer of 2015 at Kykuit (the Rockefeller family estate, a historic site in the Historic Hudson Valley owned by the National Trust for Historic Preservation) and at the University of Massachusetts Amherst, both sponsored by the National Trust for Historic Preservation and by the historic preservation programs at the University of Massachusetts Amherst and the University of Pennsylvania. Other essays were solicited from colleagues whose work we knew and admired, as well as from practitioners recommended by both colleagues and contributors. We recognize that the collective shape of the contributions reflects the voices given space here; we could easily name another fifty colleagues whose perspectives would be equally provocative and valuable, and we hope this volume will prompt conversations in a wide range of venues.

12. Theodore Parker, *Ten Sermons of Religion* (Boston: Crosby, Nichols and Co., 1853), 84–85. King first invoked the phrase in the 1958 article "Out of the Long Night," *Gospel Messenger* 107, no. 6 (February 8, 1958): 13. He went on to use it in several other sermons and speeches.

13. James A. Glass, "Impacts of the National Historic Preservation Act," supplement, *CRM* 14, no. 4 (1991): 6–11. Also important at this time was the 1986 conference—marking the Act's twentieth anniversary—"Remembering the Future: The Legacy of the National Historic Preservation Act of 1966" at Mary Washington College, May 29–31, 1986.

14. Nancy L. Ross, "Celebrating 25 Years of Preservation," *Washington Post*, May 9, 1991.

15. Lea, "America's Preservation Ethos," 19. Another concern articulated then, concerning how preservation might address an acute sense of "cultural illiteracy" among the nation's youth, seems to have receded since that time, though recent efforts, such as the National Park Service's *A Call to Action*, continue to focus on the need to engage youth in the agency's mission.

16. *Held in Trust: Preserving America's Historic Places*, The National Historic Preservation Act of 1966 25th Anniversary Report (Washington, DC: Department of Interior, 1991).

17. Ibid., 22.

18. Ibid., 23.

19. Patricia H. Gay, executive director of the Preservation Resource Center of New Orleans, witness statement to the Congressional Committee on Resources, quoted in "National Historic Preservation Act Celebrates 40th," www.georgiatrust.org.

20. "Executive Summary: Recommendations to Improve the Structure of the Federal Historic Preservation Program," January 16, 2009, www.achp.gov.

21. John M. Fowler, "The Federal Preservation Program," in Stipe, *Richer Heritage*, 44.

22. Stipe, *Richer Heritage*, 454–58.

23. Robert Weyeneth to authors, personal communication, October 21, 2015. The authors also thank David Glassberg, as well as the groups of preservationist professionals, activists, and scholars sponsored by the University of Massachusetts Amherst, the University of Pennsylvania, and the National Trust for Historic Preservation at Kykuit (May 2015), and the University of Massachusetts (June 2015) for helpful comments and conversation on this topic. For a similar

conversation in the museum field, see Tammy S. Gordon, *Private History in Public: Exhibition and the Settings of Everyday Life* (Lanham, MD: AltaMira Press, 2010).

24. The subject of diversity in historic preservation practice has long been a subject of substantial discussion. Particularly valuable contributions include Robert E. Stipe and Antoinette J. Lee, eds., *The American Mosaic: Preserving a Nation's Heritage* (Washington, DC: US/ICOMOS, 1987); and Antoinette J. Lee, "From Historic Architecture to Cultural Heritage: A Journey through Diversity, Identity, and Community," *Future Anterior: Journal of Historic Preservation, History, Theory, and Criticism* 1, no. 2 (Fall 2004): 14–23.

25. Points of entry into the literature on women as preservation practitioners include James M. Lindgren, *Preserving the Old Dominion: Historic Preservation and Virginia Traditionalism* (Charlottesville: University of Virginia Press, 1993); Fath Davis Ruffins, "'Lifting as We Climb': Black Women and the Preservation of African American History and Culture," *Gender and History* 6, no. 3 (Nov. 1994): 376–96; Marla R. Miller and Anne Digan Lanning, "'Common Parlors': Women and the Recreation of Community Identity in Deerfield, Massachusetts, 1870–1920," *Gender and History* 6, no. 3 (Nov. 1994): 435–55; Patricia West's chapter "Gender Politics and the Orchard House Museum" in her volume *Domesticating History: The Political Origins of America's House Museums* (Washington, DC: Smithsonian Institution, 1999), 39–78; Shaun Eyring, "Special Places Saved: The Role of Women in Preserving the American Landscape," in *Restoring Women's History through Historic Preservation*, ed. Gail Lee Dubrow and Jennifer B. Goodman, 37–57 (Baltimore: Johns Hopkins University Press, 2003); Barbara J. Howe, "Women in the Nineteenth-Century Preservation Movement," in Dubrow and Goodman, *Restoring Women's History*, 17–36; Polly Welts Kaufman, *National Parks and the Woman's Voice: A History* (Albuquerque: University of New Mexico Press, 2006); and Tara Y. White, "'A Shrine of Liberty for the Unborn Generations': African American Clubwomen and the Preservation of African American Historic Sites" (PhD diss., Middle Tennessee State University, 2010).

26. See Charles B. Hosmer, *Preservation Comes of Age: From Williamsburg to the National Trust, 1926–1949* (Charlottesville: University of Virginia Press, 1981); James M. Lindgren, *Preserving Historic New England* (New York: Oxford University Press, 1995); and Murtagh, *Keeping Time.*

27. For discussions of women and the professionalization of historic preservation, see Barbara J. Howe, "Historic Preservation: The Legacy of Ann Pamela Cunningham," *Public Historian* 12, no. 1 (Winter 1990): 31–61; and West, *Domesticating History.* On New England women's work as historic preservation consultants, see Marla R. Miller, "Women in Historic Preservation: The State of the Field(work)," paper presented at the Third National (U.S.) Conference on Women and Historic Preservation, Mt. Vernon College, Washington, DC, May 19–21, 2000.

28. The group Women in Preservation first met in 1984 with its driving goal being the election of a woman president of the National Trust for Historic Preservation, and today contributor Stephanie Meeks is the first woman in that role.

29. James Marston Fitch, "The Battle for the Past, Preservation vs. Historicism: Postmodernism and the Theme Park," in Martica Sawin, ed., *James Marston Fitch: Selected Writings on Architecture, Preservation, and the Built Environment* (New York: W. W. Norton, 2007), 192.

30. Glass, "Impacts," 10, 8. Glass writes that as this "cadre" of formally trained historians in turn conveyed their knowledge and values to "lay people in each State," who contributed to the documentation and assessment, "buildings that

local preservationists would have sought to preserve before 1966 because of their association with famous events or people were now singled out for retention because of their outstanding architectural designs or their association with famous architects." Glass, "Impacts," 9.

31. There is an emerging literature on the many enduring effects of the bicentennial on public history and historic preservation practice. Early entries include Tammy S. Gordon, *The Spirit of 1976: Commerce, Community, and the Politics of Commemoration* (Amherst: University of Massachusetts Press, 2013); Malgorzata Rymsza-Pawlowska, "Bicentennial Memory: Postmodernity, Media, and Historical Subjectivity in the United States, 1966–1980" (PhD diss., Brown University, 2012); and Julie T. Longo, "'In the Spirit of '76': The American Revolution Bicentennial and Detroit Redevelopment, 1966–1983" (PhD diss., Wayne State University, 2003).

32. Glass, "Impacts," 7.

33. J. Myrick Howard, "Nonprofits in the American Preservation Movement," in Stipe, *Richer Heritage,* 317–19.

34. Glass notes, "When the National Park Service organized an Office of Archeology and Historic Preservation (OAHP) in 1967 to carry out its archaeological and preservation mandates . . . architects and architectural historians were appointed to head the office itself and several key divisions and sections. The OAHP vigorously promoted a 'New Preservation,' which stressed historic districts, architectural and aesthetic values, and adaptation of historic buildings to new, economical, and compatible uses. The 'pump-priming' mechanism of matching grants to the States proved to be a reliable means of inculcating the New Preservation emphases in existing state staff people and inducing State Historic Preservation Officers to hire architects and architectural historians for new professional positions." Glass, "Impacts," 7–8.

35. See "Archaeology and Historic Preservation: Secretary of the Interior's Standards and Guidelines," September 29, 1983, www.nps.gov. These guidelines set criteria in the fields of history, architectural history, architecture, and historic architecture), which themselves resulted from president Richard M. Nixon's Executive Order 11593, "Protection and Enhancement of the Cultural Environment," of May 13, 1971.

36. Marcia M. Greenlee, *Black Americans in United States History: Historic Property Studies of Afro-American Bicentennial Corporation, under Contract to the National Park Service* (Washington, DC: National Survey of Historic Sites and Buildings, Office of Archeology and Historic Preservation, National Park Service, U.S. Dept. of Interior, [1974]). Prior efforts to recognize sites associated with African American history include the 1943 addition to the NPS roster of the George Washington Carver National Monument in Diamond, Missouri, and the 1956 addition of the Booker T. Washington National Monument in Hardy, Virginia. See Patricia West, "'The Bricks of Compromise Settle into Place': Booker T. Washington's Birthplace and the Civil Rights Movement," in *Domesticating History,* chap. 4, and the works by Antoinette Lee cited above. The 1976 publication of Alex Haley's book *Roots* was also a catalyst. As Lee notes, a "benchmark" publication was *Historic Black Resources: A Handbook for the Identification, Documentation, and Evaluation of Historic African-American Properties in Georgia,* produced by the Georgia State Historic Preservation Office in 1984. The year 1995 saw the formation of the National Association of African American Historic Preservation.

37. James Andres, "Minority Groups Climb Aboard the US Preservation Movement," *Christian Science Monitor,* November 9, 1994.

38. Ibid.

39. More recently, initiatives to address gaps have included NPS theme studies "The Earliest Americans Theme Study for the Eastern United States" (2005) and the series Civil Rights in America (including "Racial Desegregation in Public Education in the United States," 2000; "Racial Desegregation of Public Accommodations," 2004; and "Racial Voting Rights," 2007).

40. Patricia L. Parker, "Keepers of the Treasures: Protecting Historic Properties and Cultural Traditions on Indian Land" (Washington, DC: National Park Service, Department of Interior, [1990]). Around the same time, in 1990, Congress passed the Native American Graves Protection and Repatriation Act (NAGPRA), which protected native peoples' rights to their heritage, including historic places and human remains.

41. In 1997, fifteen THPOs met in Salt Lake City and formed the National Association of Tribal Historic Preservation Officers.

42. Donna Graves, "The Legacy of California's Landmarks: A Report for the California Cultural and Historical Endowment," September 2012, www.resources. ca.gov.

43. Lee, "Social and Ethnic Dimensions," in Stipe, *Richer Heritage,* 396.

44. On the former, see "Asian and Pacific Islander Americans in Historic Preservation," www.apiahip.org; on the latter, see "Latinos in Heritage Conservation," www.facebook.com.

45. The NPS civil rights theme studies on racial desegregation and voting rights, undertaken between 2000 and 2009 represent an earlier attempt to address these issues. See "National Historic Landmarks Program," National Park Service, www.nps.gov.

46. Gabriel García Márquez, *One Hundred Years of Solitude* (1967; repr., New York: Harper Perennial, 2016), 1–2.

47. Michelle McClellan, "Place-Based Epistemology: This Is Your Brain on Historic Sites," History@Work, May 25, 2015, publichistorycommons.org.

48. Patricia West McKay made this poetic observation in her March 2015 address to the University of Massachusetts Amherst Applied Humanities Learning Lab.

49. The focus on architecture emerged in 1945, with the recognition of Hampton, the late eighteenth-century Maryland home of the Ridgely family, on its architectural merit alone. The Georgian-style Hampton Mansion (the largest private home in America when it was completed in 1790) was designated a National Historic Site in 1948, the first to be designated on the basis of "outstanding merit as an architectural monument"; see Ann Milkovich McKee, *Hampton National Historic Site* (Charleston, SC: Arcadia, 2007), 105.

50. See Sprinkle, *Crafting Preservation Criteria,* 79.

51. Richard Longstreth, "When the Present Becomes Past," in Antoinette J. Lee, *Past Meets Future: Saving America's Historic Environments* (Washington, DC: Preservation Press, 1992), 213–26.

52. Randolph Hester, *Design for Ecological Democracy* (Cambridge, MA: MIT Press, 2006).

53. *National Register Bulletin* 15 "How to Apply the Criteria Considerations," www .nps.gov.

54. For a discussion of the evolution of "integrity," see Sprinkle, *Crafting Preservation Criteria,* passim.

55. "Definition of National Significance," attached to "Request for Historical Investigations," November 9, 1953, as quoted in Sprinkle, *Crafting Preservation Criteria,* 66n67. Design and setting entered the calculus at a later date.

56. Sprinkle, *Crafting Preservation Criteria,* 63.

57. Laura Feller and Page Putnam Miller, "Public History in the Parks: History and

the National Park Service," *Perspectives: American Historical Association Newsletter* 38, no.1 (2000): 24–26. A 1987 revision "used both a chronological and topical approach and expanded the number of themes to 34, with numerous subthemes and items so that there were over 600 different categories. Some critics of the 1987 framework contended that it pigeonholed sites far too narrowly and represented too limiting an approach to the past."

58. In 1993, the NPS signed a cooperative agreement with the Organization of American Historians to gather "scholars, preservationists, NPS officials, and others to discuss the strengths and weaknesses of the 1987 framework and to develop a rough draft of a revised framework. . . . The group struggled with issues of chronology, periodization, regionalism, cultural diversity, prioritizing of the past, and the need to shift to a perceptual framework that asked not only 'What happened?' but also 'How?' and 'Why?' For the first time, the framework responded to the riches of social history." Feller and Miller, "Public History in the Parks," 25.

59. Feller and Miller, "Public History in the Parks."

60. In 1966, the NHPA shifted the very nature of what should be recognized as historically significant, since at that time, only National Historical Landmarks and NPS units designated for their national significance were listed in the National Register of Historic Places. By the twenty-fifth anniversary of the NHPA, 60 percent of National Register properties were recognized for possessing local significance, and another 31 possessed state significance.

61. Glass, "Impacts,"9.

62. David Morgan et al., "Finding a Place for the Commonplace: Hurricane Katrina Communities, and Preservation Law," *American Anthropologist* 108, no. 4 (Dec. 2006): 706–18 (quotation on 707).

63. Morgan et al., "Hurricane Katrina Communities," 708.

64. Russell Keune, "Historic Preservation in a Global Context," in Stipe, *Richer Heritage,* 357.

65. As of this writing, the NPS is taking steps to revitalize the maritime history preservation grant program; some $1.7 million was made available in 2015 for National Maritime Heritage Grants supporting education and/or preservation projects.

66. See John H. Sprinkle, "'Of Exceptional Importance': The Origins of the 'Fifty-Year Rule' in Historic Preservation," *Public Historian* 29, no. 2 (Spring 2007): 81–103; and Carroll Van West, "The Fifty-Year Stumbling Block," History@ Work, September 22, 2015, www.publichistorycommons.org.

67. Marcella Sherfy and W. Ray Luce, *Guidelines for Evaluating and Nominating Properties that Have Achieved Significance within the Past Fifty Years* (Washington, DC: National Park Service, 1979).

68. "Criteria Consideration G: Properties That Have Achieved Significance within the Past Fifty Years," *National Register Bulletin* 15.

69. To offer another example, in the wake of Hurricane Katrina, New Orleans community organizations nominated two levee breach sites—the 17th Street Canal and the Industrial Canal—to the National Register of Historic Places; these sites were determined to be eligible. See "Levees.org Proposes Placing Levee Breach Sites on National Register" at www.levees.org.

70. Important works concerning the preservation of sites documenting the history of slavery and its aftermaths include Craig Evan Barton, *Sites of Memory: Perspectives on Architecture and Race* (New York: Princeton Architectural Press, 2001); Robert R. Weyeneth, "The Architecture of Racial Segregation: The Challenges of Preserving the Problematic Past," *Public Historian* 27, no. 4 (2005): 11–44. We

thank Bob Weyeneth for identifying this issue of valorizing sites of interracial cooperation.

71. Valuable points of entry here include Page Putnam Miller, *Reclaiming the Past: Landmarks of Women's History* (Bloomington: Indiana University Press, 1992); Dubrow and Goodman, *Restoring Women's History,* especially Carol D. Shull, "Searching for Women in the National Register of Historic Places" (303–17); and Polly Welts Kaufman and Katharine T. Corbett, eds., *Her Past around Us: Interpreting Sites for Women's History* (Malabar, FL: Krieger, 2003).

72. Carol D. Shull, "Women's History in the National Register and the National Historic Landmarks Survey," *CRM* no. 3 (1997): 12–15.

73. Ibid., 12.

74. Cornelia H. Dayton and Lisa Levenstein, "The Big Tent of U.S. Women's and Gender History: A State of the Field," *Journal of American History* 99, no. 3 (December 1, 2012): 793–817.

75. See "Telling the Whole Story: Women and the Making of the United States," www.nps.gov.

76. See "National Register of Historic Places Program: Women's History Month 2015," National Park Service, www.nps.gov. This initiative was funded by a private sector grant to NPS.

77. See David Rotenstein, "Historic Preservation Shines a Light on a Dark Past," History@Work, July 28, 2015, www.publichistorycommons.org, discussing Weyeneth, "Architecture of Racial Segregation," 12.

78. See, e.g., Robert R. Weyeneth, "What I've Learned along the Way: A Public Historian's Intellectual Odyssey," *Public Historian* 36, no. 2 (May 2014): 9–25; Mary Rizzo, "Pulling Back the Curtain and Starting a Conversation," History@ Work, June 23, 2014, www.publichistorycommons.org; Rebecca Conard, "Public History as Reflective Practice: An Introduction," *Public Historian* 28, no. 1 (Winter 2006): 9–13; Anne Mitchell Whisnant, Marla R. Miller, Gary B. Nash, and David Thelen, *Imperiled Promise: The State of History in the National Park Service* (Bloomington, IN: Organization of American Historians, 2011); and Cathy Stanton, *The Lowell Experiment: Public History in a Post Industrial City* (Amherst: University of Massachusetts Press, 2006).

79. Glass, "Impacts," 8.

80. Ibid., 9.

81. Rypkema's writings and economic studies of preservation's impact are numerous. See especially *The Economics of Historic Preservation: A Community Leader's Guide* (Washington, DC: National Trust for Historic Preservation, 2005); Donavan Rypkema, Caroline Cheong, and Randall Mason, *Measuring Economic Impacts of Historic Preservation: A Report to the Advisory Council on Historic Preservation* (Washington, DC, 2011); and *The Federal Historic Tax Credit: Transforming Communities* (Washington, DC: National Trust for Historic Preservation, 2014).

82. Until 1981, federal historic preservation funds could be used for brick-and-mortar work; this kind of federal support was briefly revived by the Clinton administration in 2000 under the Save America's Treasures program. We thank John Sprinkle for bringing this to our attention.

83. Margaret Foster, "San Antonio Fights for Pink House," June 24, 2011, National Trust for Historic Preservation, www.preservationnation.org.

84. A number of our contributors are involved in documenting and celebrating traditional minority communities. For example, Everett Fly helped found the Historic Black Towns and Settlements Alliance, whose mission is "to work collaboratively to actively preserve and promote the heritage, history and culture of these historic places by utilizing their human, environmental, built, arts, and

humanities resources to nurture economic development and to support an enhanced quality of life for their residents, neighbors and fellow Americans." See "Historic Black Towns and Settlements," www.south.unc.edu.

85. On the National Public Housing Museum, see also Richard Anderson, "Interpreting the Past, Wrestling with the Present," History@Work, July 24, 2015, www.publichistorycommons.org.

86. Elsewhere Antoinette J. Lee has described the slow expansion of social and ethnic history in preservation practice; Lee, "Social and Ethnic Dimensions," in Stipe, *Richer Heritage*, 385–404. Brian Joyner reminds us that the NHPA was passed in the same era that gave us the Civil Rights Act and the Wilderness Act and Michelle McClellan notes that the NHPA emerged alongside the National Organization for Women. On connections between history and social activism in this era, see James Green, *Taking History to Heart: The Power of the Past in Building Social Movements* (Amherst: University of Massachusetts Press, 2000).

87. National Historic Preservation Act (Public Law 89-665; 16 U.S.C. 470 et seq.).

88. Carl Elefante, "The Greenest Building Is . . . One That Is Already Built," *Forum Journal: The Journal of the National Trust for Historic Preservation* 21, no. 4 (Summer 2007): 26–38. See also www.sohosandiego.org and the Green Lab at National Trust for Historic Preservation, www.preservationnation.org.

89. Public historians have been actively engaged in discussions about how historians who work in the public sphere—in museums, at historic sites, with oral history and archives—can contribute to the sustainability movement. Some of this work is summarized in a special issue of the *Public Historian*, "Public History and Environmental Sustainability," *Public Historian* 36, no. 3 (August 2014).

What Historic Preservation Can Learn from Ferguson

MICHAEL R. ALLEN

The events that unfolded in Ferguson, Missouri, in 2014 continue to challenge historic preservation to be more than an exclusionary bureaucratic consensus. As the National Historic Preservation Act (NHPA) reaches the half-century mark, its prescribed mode of engaging evolving urban history fails to account for public self-determination in identifying heritage, for promoting the protection of sites emblazoned with meaning in the very recent past, and for leveraging the interpretation of space to inform the urgent need for social justice in American cities. Sites that have suddenly been inscribed with highly significant associations to St. Louis' history—the site at which Michael Brown fell dead after being shot by officer Darren Wilson, the QuikTrip convenience store that was burned in the riots following his shooting, and other, related sites of police violence in St. Louis—these locations poke holes in the methods of preservation. Yet they also suggest remedies for preservation practice that are inclusive, responsive, popular, and divorced from historicization.

> The events that unfolded in Ferguson challenge historic preservation to be more than an exclusionary bureaucratic consensus.

In other words, looking at Ferguson from the perspective of historic preservation shows us that the field needs to discard historicization in favor of history. History is a great moving target that does not bend to federal law or local statue. History defies taxonomies of vernacular architecture, because it always creates new forms. There are no limits to history's subjects and objects, although the NHPA's

regulatory framework attempts to impose them. Few St. Louisans, what-ever their beliefs, would say that what happened in Ferguson in 2014 is not important, but the National Park Service reviewer might well find the QuikTrip rubble ineligible for listing in the National Register of Historic Places. Preservationists may be the last people to acknowledge the historic associations embodied by unlikely landmarks, and that is to our shame.

When we follow a line of thought that turns works of architecture into emblems of eras or events, we need legible, intact emblems. So much of historic preservation involves cataloging and protecting these emblems. There are no emblems for events such as the death of Michael Brown and the demonstrations that followed. There are only sites where real, unresolved, and difficult history unfolded.

On Canfield Drive, a perpetual array of stuffed animals and memen-tos marks the location in the middle of the street where Michael Brown died. Commemoration as ritual is now an ingrained spatial function, but it troubles notions of structure and integrity. Perpetual impermanent memorialization is a fluid function, not a fixed object with a clear boundary. Surrounding the site are several three-story brick-and-vinyl apartment buildings, built in 1970 in a style identi-cal to hundreds in the St. Louis area alone. If the site were to be designated an official landmark or listed in the National Register of Historic Places, what would be included?

Some residents have pushed to build a permanent memorial, yet a tree planted with a plaque was vandalized. Meanwhile, the site on Canfield Drive and the continued tourism it has drawn has resi-dents of Canfield Village to move, or to express distaste for the site's ongoing presence. Resident Shirley Scales told *St. Louis Post-Dispatch* reporters Jesse Bogan and Walker Moskop in March 2015 that the memorial unsettled her life at Canfield Green. She had moved to another apartment to avoid the site. "I wanted to be up past the mur-der site," Scales told the reporters. "I didn't feel comfortable there."

More infamous than site of the shooting is the Ferguson QuikTrip that looters—not protestors—burned on August 10, 2014. The loot-ing and burning were prompted by the erroneous rumor that Brown had been suspected of shoplifting there, and that the owner had made the police call that led to Brown's demise. (Another convenience store

In Ferguson, Missouri, protestors gather in front of a Quik Trip convenience store in the wake of the killing of an unarmed black teenager, Michael Brown, who was fatally shot on August 9, 2014, by a white police officer, Darren Wilson. The building was later demolished. Because of a false report that Brown had shoplifted from the store, the site became a center of antiracism activism in the city. PHOTO COURTESY OF MICHAEL ALLEN.

was the actual site of the alleged shoplifting.) Despite the misconception, QuikTrip's charred and gruesome remains have given rise to a new sort of public space. Photographs from 2014 show the Ferguson QuikTrip both in its fiery throes and as a sort of temporary arena for gathering, holding discussions, and protesting. One tag drawn across a shiny fuel station pump declared the site "QT People's Park (Liberated 8-10-14)," an apparent reference to the similarly occupied site where "Bloody Thursday" took place in Berkeley, California, in May 1969.

I publicly raised the question of whether the QuikTrip should be preserved following the site's fire and occupation. By the end of August 2014, the store's management had erected chain-link fencing and had removed the remaining gasoline to contain and isolate the space that had been used for Ferguson's agonistic grieving and revolt. In the wake of the QuikTrip closure, no other space served the function of that site. Protests diffused along West Florissant Avenue, and the political momentum lessened. The QuikTrip site had proved to be a significant space, and the direct product of this mess we call

MICHAEL R. ALLEN

American history, and yet the community in Ferguson was ambivalent about preserving it.

The Urban League produced its own form of commemoration and reuse of the site: the QuikTrip has now been demolished to make way for a new community center designed to help heal Ferguson's inequalities. The visible wound of the QuikTrip, a tangled and unsightly work of popular architecture, found little support as a popular preservation project. Instead, the site will live on as symbolized through a new work of architecture—albeit one that will avoid direct reference to the "people's park."

What will be preserved in Ferguson? Historic preservation seems to have ceded this question because of the unusual nature of the sites involved and the temporal closeness of the event. Yet Canfield Green may be gone by the time we can historicize Ferguson. The QuikTrip already is. Will a plaque or monument convey the events of 2014 in any teachable way?

Sites that acquire significant public meaning instantly through mass action or unrest often are bulldozed, cordoned off, or otherwise closed before the future of their physical forms can be discussed or debated. Even the designation of a site less physically altered—and therefore better suited to meet the bureaucratic preservation ideal of "integrity"—such as Chicago's Roberts Temple Church of God in Christ, where the funeral of Emmett Till took place in 1955, happened only in 2005. The contentious reconstruction at the site of the former World Trade Center offers an illustration of the complicated politics of healing and of the liberatory redress for preservation when it concedes literally "saving" the remnants of a troubled site.

As preservationists, we can take away several lessons from the confounding nature of these sites in Ferguson: we need to embrace thinking beyond the bureaucratic limits of the National Historic Preservation Act; we need to abandon the historicizing motivations that seek easy emblems for eras, styles, and building types; and we need to listen to and support communities that ask open questions about the future of sites, not walk away when communities choose preservation plans that do not fit our models.

In some ways, we simply need to heed the counsel of public architectural historian Dolores Hayden, who wrote twenty years ago in

The Power of Place: "Restoring significant shared meanings for many neglected urban spaces first involves claiming the entire urban cultural landscape as an important part of American history, not just its architectural monuments."[1] Ferguson's most lasting monument will be the impact that the death of Michael Brown has on laws and culture. When Ferguson has healed, when racism has been stamped out of St. Louis culture, and when justice is within the reach of every American, the events in Ferguson will have achieved their highest significance. Then we will look to the sites as carriers of history. What will we find? And how will preservationists have aided in protecting sites that will by then have gained greater significance in local and national narratives of social change?

MICHAEL R. ALLEN is director of the Preservation Research Office and lecturer in American Culture Studies and Landscape Architecture at Washington University in St. Louis. Allen had led architectural surveys, historic district nominations, and rehabilitation planning efforts across St. Louis, East St. Louis, and in other cities. Allen's writing on architectural history includes chapters in *The Making of an All-America City: East St. Louis at 150* (2011), *Buildings of Missouri* (forthcoming, 2016), and numerous scholarly and popular articles. Additionally, Allen has authored or coauthored over fifty National Register of Historic Places nominations. Allen serves on the boards of the National Building Arts Center and Modern STL, as well as the advisory board of American Communities Trust.

NOTE

1. Dolores Hayden, *The Power of Place* (Cambridge, MA: The MIT Press, 1997), 11.

MICHAEL R. ALLEN

From Passion to Public Policy

Making Preservation More Sustainable

ERICA AVRAMI

The past half century has seen the codification of historic preservation as an accepted form of public policy. Through legislation at the national, state, and local levels, tax incentives, zoning overlays, listing mechanisms, and other tools, preservation has matured from a grassroots movement to an integral part of governance structures for the built environment. However, the world in which preservation functions has changed dramatically in fifty years. The earth's population has more than doubled, the world is more urban, and the planet's capacity to sustain life is challenged by the overconsumption of land and resources. Globalization and migration patterns have likewise contributed to dramatically different social and economic conditions, as well as architectural acculturation, as communities and markets become increasingly connected. Yet divisions within society are still fraught with conflict and injustice.

These dynamics have put new and increasing pressures on urban land use policy, and especially on preservation. In recent years, the protection of historic buildings and districts has been called into question on a number of counts, including its potential role in gentrification and the displacement of low-income residents, the perceived stifling of architectural creativity and economic vitality, the lack of cultural diversity in the places that are landmarked and among the people who participate in preservation, and the environmental sustainability of older buildings and low-density historic districts.

The legal rationales of the modern preservation system are premised on the notion that historic places positively contribute to quality of life and to community building. These notions have been

operationalized through policies and regulatory frameworks in which historical associations and architectural significance play a primary role in decision making to list or landmark, and for which aesthetics serve as the basis for managing change through design review. This curatorial approach has served the field well in terms of growing the roster of National Register listings and locally protected sites, but the toolbox it has engendered is not sufficient to meet the challenges on the horizon.

Preservation is now compelled to confront the indirect effects of its work and to consider criteria of success that are not part of the field's existing practices and decision-making frameworks. While rigorous processes have evolved over the decades for documentation, research, designation, and design review, limited tools and methods have been developed to evaluate preservation's long-term outcomes beyond the technical or the aesthetic. In response to these conditions, and to build the policy rationale for preservation, practitioners and academicians have forged new avenues of research to demonstrate the economic impacts of heritage protection, from increases in property values to job creation to the generation of tourism revenue. New research is also growing in support of the positive environmental impacts of older buildings and neighborhoods, further making the case for the affirmative role of existing (historic) structures in the ecological well-being of the planet.

Such research helps to demonstrate preservation's contributions to sustainability writ large—economic, environmental, and social—but likewise highlights some fundamental weaknesses in the field. Firstly, most of these studies are advocacy-driven; they generally seek to justify the status quo of the preservation enterprise rather than analyze how policy might evolve in order to meet contemporary societal concerns. Secondly, they adopt indicators of success that are beyond the existing policy mandate or scope of preservation. Decisions about what structures, sites, or districts to designate are generally not guided by the potential to increase economic value or reduce the carbon footprint. Yet more and more, the preservation field is using these environmental and economic metrics to justify its cause.

The preservation of historic places is fundamentally pursued because of its social benefits. But for the past half century, the field has very loosely defined those benefits and largely relied on the

ERICA AVRAMI

"saving" of structures and sites as its primary indicator of success. If, indeed, heritage is important because of its potential to transfer historical knowledge, or promote social cohesion, or protect cultural diversity, or enhance resilience, or foster civic engagement and community agency, shouldn't we be developing designation guidelines and project evaluation criteria that incorporate these aims? Shouldn't we be evaluating preservation policy based on what we are directly seeking to achieve, rather than on its indirect benefits? Or should some of these indirect benefits become explicit goals of the preservation enterprise and thus policy?

The charge over the next fifty years is to be daring by demonstrating the courage to change policy.

These questions are not easily answered, but they drive home the need to move beyond preservation as a passionate grassroots movement and take on the responsibilities of ensuring its effectiveness and sustainability as a form of public policy. Other forms of public policy, from environmental protection to education, collect data and have developed indicators of success and evaluative methods to measure effectiveness and assess the need for change over time. The charge of the field over the next fifty years is to be introspective by examining the difficult questions about what preservation is seeking to achieve and how policy is performing, and to be daring by demonstrating the courage to change policy in ways that help it to perform better. In practical terms, that means:

Redefining preservation's indicators of success. These may vary from community to community and between national, state, and local levels, but until the field can more robustly articulate the societal outcomes it is seeking to achieve, it cannot effectively evaluate and improve policy.

Developing tools and metrics for evaluating success. No tool or metric will be perfect, and if these were easy to develop, the field would have done so long ago. But we are at a juncture that begs for bold exploration and experimentation if preservation is to contribute positively to social, economic, and environmental sustainability.

Shifting focus and resources from preservation's front end (designating more) to the back end (assessing the effectiveness of designations and preservation

projects). The challenges on the horizon call for greater emphasis to be placed on data collection and research related to the outcomes of preservation. How are early historic districts, for example, faring (socially, environmentally, economically), and how has preservation positively—or negatively—contributed?

Revising policy to incorporate findings. The fear of potentially losing ground in the seemingly endless preservation battle must be overcome in order to acknowledge potential shortcomings in current approaches and to improve preservation policy so that it is more sustainable and responsive to a changing world.

ERICA AVRAMI, PhD, is the James Marston Fitch Assistant Professor of Historic Preservation at Columbia University's Graduate School of Architecture, Planning, and Preservation. She formerly served as research and education director for the World Monuments Fund and as a project specialist for the Getty Conservation Institute.

Dislodging the Curatorial

DANIEL BLUESTONE

In the name of stewardship, we preservationists have abided by too many inane, overwrought, curatorial, highly regulated approaches to adapting old buildings to new uses, making additions to historic structures, and constructing new buildings in historic localities. We are armed to the hilt with local preservation ordinances, "The Secretary of the Interior's Standards for the Treatment of Historic Properties," National Park Service design guidelines, and international charters built on the ideals of compatibility, harmoniousness, and contextual sensitivity.[1] Our trained professionals withhold historic landmark designations, deny tax credits for restoration projects, reject proposed plans, and delay building permits guided by zealous faith in the primacy of original fabric and underlying artistic intention; pursuing a curatorial-based materialism in relation to the objects of preservation desire, be they buildings, districts, or landscapes, means that they take on a life of their own. Those objects seemingly become ends in themselves, stuff largely detached from broader engagements with the society of the present or the politics and possibilities of our collective future.

This often prevents us from realizing the vibrant preservation movement we need. Indeed, all to often it dissipates our energy and distracts from the most promising aspects of heritage conservation. We need to challenge the idea put forth in the title of James Marston Fitch's *Historic Preservation: Curatorial Management of the Built World* (1982). Putting curatorship ahead of everything else is problematic, at best. In 2009–10 the stewards of the UNESCO World Heritage Site at Jefferson's University of Virginia undertook the restoration of

Pavilion X on the Lawn. Drawing on the latest scientific paint analysis, they decided to paint the pavilion not in the now dominant white but rather in the grayish tan sandstone color that Jefferson apparently chose in the 1820s. The contrast was jarring to alumni sensibilities but perhaps usefully had people negotiating the slippage between history, tradition, and memory. However, the controversy around this decision also seemingly reduced historic preservation work to a discerning choice of paint color, arrived at scientifically and aesthetically.[2] It is here that the stuff of preservation seems to launch off into a narrow and arid realm that collapses in on itself rather than opening outward to engage a public in an effort to recognize the connections between history and the past, contemporary society and culture, and, most importantly, the future.

We need to devote more energy to being far more articulate about why a historic place matters.

Rather than squandering our time on paint colors and considering whether a building that lacks its original windows has lost its integrity, we need to devote more energy to being far more articulate about why a historic place matters. We need to set aside the fastidious, precious descriptions of architectural and landscape resources demanded by the National Park Service for completing Section 7 of the National Register of Historic Places, which is devoted to "description." We should rely on photographs and a very short statement of the changes made through time, with those changes treated as part of history rather than as threats to integrity. We should instead focus our attention on a more vital and thoughtful Section 8, covering "significance." Why does this historic place matter? If we can be articulate about what is important about a historic place then we can aim to establish a performance-based system of evaluating integrity and additions and new constructions. Then the question will become: Do the changes being considered make this a better place to live in or visit? Do the changes contribute to or distract from the broad significance of the place?

The ideals of compatibility and harmoniousness and sensitivity assume that somehow there is a value to insulating the past from the present. People who visit heritage sites fly in jet planes, stay in

DANIEL BLUESTONE

air-conditioned wi-fi hotels, and place calls using satellite signals; yet, somehow we aim to suspend all that and regulate a landscape that keeps the modern world at bay in historic localities. The heritage visiting public seems headed in a very different direction. Selfie sticks are as popular for tourist consumption as traditional trinkets and souvenirs. Those stick-end images circulate through cyberspace as they settle onto Facebook and Instagram—juxtaposing past and present.

In the United States, the earliest sites of historic preservation were sites related to national and local history. In the course of the twentieth century the movement narrowed, settling comfortably on architectural production and style as a leading frame of analysis. This has hobbled and distracted the movement. The insistence on harmony, integrity, and compatibility really suggests that style and form are what preservation is all about. We would have a stronger movement if we saw historic sites as places caught up in the process of critical reflection on the past and its constructive relationship to the present and future. If we regulate sites as if we wanted to hold the present and future at bay, we run the risk never realizing preservation's potential to foster a culture of critical thinking and environmental recycling.

In January 2015, I taught a class in Iraq for some of the county's leading heritage professionals. Some Iraqi officials have sanctioned plans that would erase more recent historical and cultural layers from significant sites. These efforts often make it nearly impossible to link past history to the concerns of the present or to the efforts at envisioning and shaping a future that draws vitality from tangible cultural heritage. Scraping sites of more recent history and narratives often renders them irrelevant in ongoing cultural and political discourse. Islamic State fighters provided a stark context for the class as they demolished mosques in Mosul and other cities in Iraq, used sledgehammers and chain saws to destroy Assyrian statues and sculptures at Mosul's Nineveh Museum, and burned thousands of old books and manuscripts in the Mosul Public Library. Islamic State fighters are making a contemporary political use of this material culture while the actual stewards of such cultural artifacts stammer and stumble, unable to articulate why the culture should matter to the broad public—beyond their anchoring of a tourism-based service economy. The stewards treat such places and objects with curatorial zeal, which means that they focus on style and

on establishing provenance and location on a timeline; what they do much less well is approach material culture as being capable of illuminating the lived present and the desired future.

Dislodging the curatorial impulse in heritage stewardship could provide a necessary first step in opening up the conceptual and actual space for the preservation movement to take up the most urgent and pressing social and political issues of our time.

DANIEL BLUESTONE is a professor of art history and architecture at Boston University, and the director of the Preservation Studies Program. He is a specialist in nineteenth-century American architecture and urbanism. His book *Buildings, Landscapes, and Memory: Case Studies in Historic Preservation* (2011) received the Society of Architectural Historians 2013 Antoinette Forrester Downing Book Award for "the most outstanding publication devoted to historical topics in the preservation field that enhances the understanding and protection of the built environment." His book *Constructing Chicago* (1991) was awarded the American Institute of Architects International Book Award and the National Historic Preservation Book Prize.

NOTES

1. The "The Secretary of the Interior's Standards for the Treatment of Historic Properties" can be found at www.nps.gov. For international charters, see especially Article 13 of the 1964 Venice Charter of the International Congress of Architects and Technicians of Historic Monuments: "Additions cannot be allowed except in so far as they do not detract from the interesting parts of the building, its traditional setting, the balance of its composition and its relation with its surroundings." *The Venice Charter* (United Nationals Educational, Scientific and Cultural Organization, 1964). And see the Athens Charter for the Restoration of Historic Monuments of 1931 International Congress of Architects and Technicians of Historic Monument: "In the construction of buildings, the character and external aspect of the cities in which they are to be erected should be respected, especially in the neighbourhood of ancient monuments, where the surroundings should be given special consideration." *The Athens Charter for the Restoration of Historic Monuments* (Athens: 1931).
2. "Everything That's Old Is New Again," *The University of Virginia Magazine* (Spring 2010); David J. Neuman, "Restoring a World Heritage Site and Beyond: Current Historic Preservation Efforts at the University of Virginia," American Institute of Architects, www.aia.org.

A Preservation Movement for All Americans

DAVID J. BROWN

The creation story for preservation turns in the mid-twentieth century from a focus on high-style architectural landmarks to a grassroots and activist movement. Jane Jacobs in Greenwich Village, Barbara Capitman in Miami Beach, and others led tens of thousands of citizens across the country to fight the nature and pace of change in their neighborhoods. This instinct to shape the communities we want, instead of accepting what others conceive for us, remains. Unfortunately, many do not connect this instinct with preservation practice today.

Any assessment of preservation finds that we have failed to fully capture the public's heart.

To reach those who share our values, preservation should be inspired by that fundamental change in its past. By democratizing preservation in and for the twenty-first century, we can build a thriving, vibrant movement.

Any assessment of preservation finds that we have succeeded in our work yet failed to fully capture the public's heart. Let's start with our success. America's cities are magnets for the young, creative class, and these individuals are voting with their feet to live, work, and play in older and historic neighborhoods. The National Trust recently examined data from five major cities in the United States and found that up to 90 percent of the hip bars and restaurants in those communities were located in older buildings. In the past thirty-five years, the federal historic rehabilitation tax credits have been used to preserve more than forty thousand buildings, and have brought a private sector investment that exceeds $117 billion and generates

Samuel and Michele, members of a HOPE crew (the National Trust's "Hands-On Preservation Experience" initiative), worked alongside Larry Singleton, from Oak Grove Restoration Company, in the summer of 2014 to rehabilitate the Grandview Farmhouse at Woodlawn Plantation, a National Trust for Historic Preservation site. PHOTO BY JOHN BOAL/NATIONAL TRUST FOR HISTORIC PRESERVATION.

$1.27 in taxes for every $1 spent by the federal government. President Barack Obama has used his power under the Antiquities Act to designate as national monuments some of the most important, yet underappreciated, sites that tell the broad story of America, places such as a Japanese internment camp in Hawaii and Chicago's Pullman neighborhood—the heart of the American labor movement. Studies have demonstrated that local historic districts provide strong economic value to communities.[1] Jane Jacobs's statement "Cities need old buildings so badly it is probably impossible for vigorous streets and districts to grow without them" has never looked so prescient.[2]

And yet, preservation is under assault. Economists such as Harvard's Ed Glaeser travel the book-and-lecture circuit blaming historic preservation regulations for the lack of affordable housing in Manhattan. Surveys by the National Trust find some fifteen million Americans who share preservation values but do not identify as preservationists.[3] Congress threatens to eliminate the historic rehabilitation tax credits, and many consider the review process to acquire those credits

DAVID J. BROWN

cumbersome. In its almost eight years in office, the Obama administration has cut funding for preservation, eliminated programs such as Save America's Treasures, and called for the weakening of one of the country's most important preservation protections. In too many places, it has been years—if not decades—since there was the support and political will to establish a local historic district.

Management guru Peter Drucker has noted, "People in any organization are always attached to the obsolete—the things that should have worked but did not, the things that once were productive and no longer are."[4] Could preservationists be too attached to tools designed to fight the last war? Have we "won" and yet do not know how to build on our success?

Fifty years ago, preservation operated as an outsider movement, with citizens working against the grain of normal policies, plans, and development practice. As a result, many of our tools were created as exceptions and Band-Aids, designed to give older buildings, landscapes, and neighborhoods a chance for survival in an otherwise hostile environment. Newly minted professionals came in to administer those tools. Although preservation is, in some places, now accepted as the norm, the challenge and the opportunity for the next fifty years is taking the proven benefits of preservation to scale. If Jane Jacobs was right—if saving, reusing, and retrofitting old buildings is a good thing—how can we make this happen more easily and more often?

A democratization of preservation suggests we must move the protection and reuse of older and historic environments from the purview of the few to work that all of our citizens can embrace. New tools have to be wide-ranging and accessible, compelling many more individuals to join us. Some of this work should focus on expanding our definition of preservation.

To build a movement for all Americans, we must recognize that preservation takes many more forms—what the University of Pennsylvania's Randall Mason describes as "small *p*" preservation—than the ones associated with our work today.[5] Frankly, we need tools that give every person a voice in determining what is worth preserving in their community.

These tools should move beyond surveys focused on architectural

attributes and completed by preservation professionals, and should engage citizens in leveraging open data and GIS technology to measure and visualize a variety of assets and opportunities. Although buildings over fifty years old constitute more than half of the structures in many communities, on average, only 5 percent of those buildings are protected through traditional preservation zoning.

As we democratize the understanding of what matters, we should reconsider our one-size-fits all tool of classification. Buildings whose preservation we want to encourage come in a variety of types and levels of importance.

Democratizing preservation also calls for us to work preemptively and collaboratively with all communities. In far too many places we have told our stories in a way that conveniently forgot the majority of the people whose lives were part of our layered history. The change from working against to working with marginalized communities in retaining their community structures (both social and spatial) is among the key crossroads of the preservation movement today.

James Marston Fitch, in his *Historic Preservation: Curatorial Management of the Built World* (1982), addresses "preservation in tomorrow's world." He notes, "Although national and local institutions are essential to the process [of preservation], the new and critically important factor is citizen participation." By taking the road marked "democratization," we may find a new level of relevance for the past in today and tomorrow's world.

DAVID J. BROWN is the executive vice president and chief preservation officer of the National Trust for Historic Preservation. He previously served as the director of Historic Staunton Foundation and the founding director of the Preservation Alliance of Virginia. Brown was also appointed as chairman of the Governor's Commission to Study Historic Preservation in Virginia, and he currently serves on the executive committee of the International National Trusts Organisation (INTO).

NOTES

1. See, for instance: "Older, Smaller, Better: Measuring How the Character of Buildings and Blocks Influences Urban Vitality," National Trust for Historic Preservation, www.preservationnation.org.
2. Jane Jacobs, *The Death and Life of Great American Cities* (New York: Vintage, 1961).
3. "Field Guide to Local Preservationists," National Trust for Historic Preservation, www.preservationnation.org.
4. Peter F. Drucker, *The Five Most Important Questions You Will Ever Ask* (San Francisco: Jossey-Bass, 2008).
5. Heather A. Davis, "Q & A with Randall Mason," *Penn Current,* March 19, 2015, www.upenn.edu.

Preserving Social Character and Navigating Preservation Divides

..

JAPONICA BROWN-SARACINO

In this essay, I offer recommendations for preservation practice from a comparative study of rural and urban gentrification that unexpectedly called my attention to preservation. Specifically, I uncovered debates among residents of four sites—two New England towns (Provincetown, Massachusetts, and Dresden, Maine), and two Chicago neighborhoods (Andersonville and Argyle)—about the costs and benefits of preservation, about which facets of local character must be "saved," and about what manner of preservation one ought to engage in.[1]

In a variety of settings, from town halls to festivals and coffee shops, residents wrestled with consequential questions about the relation between gentrification and preservation. In this essay I forward three core lessons from the field. Echoing informants, I advocate for the value and timeliness of working to preserve the social character of place. I also call for recognition of the utility of listening to and creating bridges between preservation camps on the ground. To support both ends, I call for updated research on the relation between preservation practices and gentrification.[2]

In the four changing places I studied, the bulk of gentrifiers—highly educated and residentially mobile newcomers—engage in preservation efforts of one kind or another. A minority is indifferent to preservation, embracing "progress" and the transformation of their neighborhood or town in their own image. However, most belong to one of two preservation camps.

Members of the first camp primarily advocate for or support preservation of landscape and buildings. Among these, some regard these

as strategies for economic redevelopment. Still others regard them as methods for sheltering local heritage and character in the face of swiftly advancing change.

A second camp is critical of the above strategies. Most in this second camp are a breed of gentrifier I term "social preservationists." They are highly self-conscious gentrifiers who recognize their complicity in gentrification, and, as a result, engage in political, symbolic, and private efforts to preserve local social "authenticity" that they associate with certain longtime residents. They advocate for preservation, but not of landscape or buildings. Instead, they wish to protect people, their institutions, and practices from displacement.[3] One said, "To have a huge building saved where the people who lived here are all gone is to me not real preservation." Some social preservationists propose that landscape and historic preservation, intentionally or not, advance gentrification and contribute to the disruption of longtimers' culture and practices and, eventually, to their physical displacement. In this sense, they regard other forms of preservation as not merely alternative approaches but as thwarting the preservation of social character. One fumed that by preserving buildings and institutions, residents were preserving "monuments to a dying culture."[4]

The first core lesson I relay, about the importance of working to recognize and maintain the social character of place, comes from social preservationists. As a result of expanding gentrification and urban residents' increasing concern about it, the problems that social preservationists highlight demand attention. Consider protests in San Francisco against "Google Bus," which carries employees from their San Francisco neighborhoods to Google headquarters in Mountain View, or regular forums on gentrification in my own Boston neighborhood.[5] Residents—new and old alike—call for affordable housing and lobby against high-end establishments.

Why this turn? Social preservationists propose that, in the face of rapid change, what lends place character is not its history but, instead, contemporaneous conditions or the very recent past. In Provincetown, on the tip of Cape Cod, they lobby to preserve Portuguese fishermen and struggling artists, but not the town's whaling history. In Dresden, Maine, which is thirty minutes inland from coastal Boothbay Harbor, the object of attention is shifting from farmers (of whom there are

fewer and fewer) to longtimers who work the land in other ways, such as by operating gravel pits. Undergirding the desire to preserve the here and now is growing anxiety about gentrification's pace and scale. The degree to which media, scholars, and everyday actors increasingly frame gentrification as a social problem amplifies this anxiety, which has extended from the metropolis to small towns of the kind I studied.

I urge us to follow social preservationists by expanding efforts to preserve the social fabric of neighborhoods.

From afar we can challenge some of social preservationists' premises. For instance, preservationists do not seek to preserve all. They carefully select which social groups to "save." They also overestimate the role of individual residents, whether themselves or the historic or landscape preservationist, in driving gentrification. And they underrate gentrification's entrenchment in broader processes, such as the decline of urban industry and rise of neoliberal policies.

Despite these cautionary points, I urge us to follow social preservationists by expanding efforts to preserve the social fabric of neighborhoods. After all, my research indicates that a sizable cohort of urban dwellers who are rich in cultural, economic, or social capital wishes to see preservation efforts directed at the protection of social character. Concretely, this means advocating for affordable housing and longtime residents' businesses and institutions. It may sometimes also require abstaining from preservation projects that, insofar as social preservationists are concerned, fuel gentrification's flames.

A second lesson emerges from the multiplicity of approaches to preservation—from social to historic to landscape—I encountered in the field. In my sites, these approaches often clashed. Debates about what and how to preserve reflect and amplify core differences in orientations to gentrification and "authenticity" (e.g., between those who locate the value of a place in the past and those who locate it in the present). I suspect that this heterogeneity of viewpoints exists among practitioners, too. After a recent talk for heritage professionals, several articulated social preservationist concerns, while another asked me, "How can I get my town to gentrify?" For her, efforts to

preserve markers of the town's past depended on a gentrification-induced infusion of capital.

Is this discord inevitable? I call us to provide tools that might build bridges between these camps, which, ultimately, share a concern with guarding places against total transformation and a recognition of the value of "place character" and distinction.[6] Thus, a second core lesson is that we ought to position ourselves at the forefront of efforts to fuse multiple preservation aims.

Finally, to enhance the resources we bring to the first two objectives, as the third core lesson, I echo recent calls for further empirical studies of linkages between "revitalization" and preservation.[7] Does preservation serve the role—as a mechanism for advancing gentrification—that social preservationists (among others) cast it in? Assuming that this is at the very least sometimes the case, are there instances when economic revitalization and preservation are more or less closely coupled? This knowledge is essential for navigating the discord about preservation apparent in four gentrifying communities, and for thinking strategically about how best to harness growing concern for the maintenance of the social character of places.

JAPONICA BROWN-SARACINO is associate professor of sociology at Boston University. She is the author of *A Neighborhood That Never Changes: Gentrification, Social Preservation, and the Search for Authenticity* (2009), which won the 2010–11 Urban Affairs Association Best Book Award, and editor of *The Gentrification Debates* (2010). Articles from her current project, on identities and ties among lesbian migrants to four small U.S. cities, have appeared in *Social Problems, American Journal of Sociology,* and *Qualitative Sociology.*

NOTES

1. See my publications "Social Preservationists and the Quest for Authentic Community," *City & Community* 3, no. 2 (2004): 135–56; "Virtuous Marginality: Social Preservationists and the Selection of the Old-timer," *Theory and Society* 36, no. 5 (2007): 437–68; *A Neighborhood That Never Changes: Gentrification, Social Preservation, and the Search for Authenticity* (Chicago: University of Chicago Press 2009); and *The Gentrification Debates: A Reader* (New York: Routledge, 2010).

2. See Stephanie Ryberg-Webster, and Kelly Kinahan, "Historic Preservation and Urban Revitalization in the Twenty-first Century," *Journal of Urban Planning Literature* 29, no. 2 (2014): 119–39.

3. Crucially, they do not seek to preserve all local residents; their arguments about which social groups support local character and therefore are worthy of preservation rest on presumptions about social groups' relative value and "authenticity," as well as on assessments of a neighborhood or town's "true" character (Brown-Saracino, "Virtuous Marginality").

4. Quotes are from Brown-Saracino, *Neighborhood That Never Changes*.

5. On the Google Bus protests, see "Activists Accuse Tech Community of Throwing San Francisco Under the Bus," bits.blogs.nytimes.com.

6. On "place character," see Jason Kaufman and Matthew Kaliner, "The Re-Accomplishment of Place in Twentieth Century Vermont and New Hampshire: History Repeats Itself, Until It Doesn't," *Theory & Society* 40, no. 2 (2011): 119–54; Harvey Molotch, William Freudenburg, and Krista Paulsen, "History Repeats Itself, But How? City Character, Urban Tradition, and the Accomplishment of Place," *American Sociological Review* 65, no. 6 (2000): 791–823; and Paulsen, "Making Character Concrete: Empirical Strategies for Studying Place Distinction," *City & Community* 3, no. 3 (2004): 243–62.

7. See Ryber-Webster and Kinahan, "Historic Preservation."

Steps toward Decolonizing the National Historic Preservation Act

..

KURT E. DONGOSKE
AND
THERESA PASQUAL

The National Historic Preservation Act (NHPA) was passed by Congress in 1966 because Congress recognized that "the spirit and direction of the Nation are founded upon and reflected in its heritage," and that this "historical and cultural foundation . . . should be preserved as a living part of our community life and development in order to give a sense of orientation to the American people."[1] Over the past fifty years, this sense of orientation to the American people has privileged an Anglo-American and scientific rationalist perspective. Native American perspectives on their heritage and how these perspectives have been unintentionally disadvantaged in the application of compliance with the National Historic Preservation Act is the focus of this short essay.

Section 106 of the National Historic Preservation Act is the primary nexus for Native American involvement, through government-to-government consultation, in an agency's compliance with the NHPA. We focus on archaeological resources because these are tangible manifestations of Native American heritage that are frequently encountered on the landscape, and because the resultant treatment and management of these resources by federal agencies underscores how the Section 106 process can disenfranchise and alienate Native Americans from their own heritage. Our experiences as the Tribal Historic Preservation Officers for the Pueblo of Zuni and the Acoma Pueblo, respectively, directly inform on the position presented here.

Section 106 of the NHPA requires agencies to consider the effects of an undertaking on historic properties and to seek ways to mitigate any adverse effects to identified historic properties. One of the initial

steps toward compliance with Section 106 is to identify and evaluate historic properties that may be located within the area of potential effects of an undertaking. Typically, the federal agency employs archaeologists to survey the project area to identify and document physical evidence of past human behavior (e.g., archaeological sites) that may be considered historically significant. Problems for native people occur during this identification stage because federal agencies generally evaluate the significance of archaeological sites solely under Criterion D: for their scientific information potential. Little, if any, consideration is given to the Native American perspective of these places or to the vital role they play in the individual and collective identities of tribal people that makes them eligible for inclusion on the National Register of Historic Places under Criteria A and B.

Thus, the federal agency privileges a Western materialist, scientific rationalist perspective.

For example, for the Zuni people archaeological sites are a physical validation of traditional migration histories and as such play a significant role in Zuni cultural identity. The Pueblos of Zuni frequently explains to federal agencies during the section 106 process that these archaeological sites should be considered eligible to the National Register under Criteria A and B for the role they play in the history of the tribe and because they were made by important people (ancestors) in tribal history. In most cases, the federal agency will dismiss the tribal claims, stating that the association is too general and not specific enough to warrant eligibility consideration. By not recognizing the tribal associative values to archaeological sites under Criteria A and B, the federal agency unwittingly contributes to a nefarious three-hundred-plus-year history of colonial oppression in which science, legislation, and regulations were often employed to diminish and explain away Native peoples' primacy rights and claims to the landscape in favor of colonial land taking and imperialistic and capitalistic enterprise.

When the eligibility of an archaeological site is uncertain or when mitigation is required, federal agencies may implement nature and extent testing (how far subsurface archaeological deposits extend within or beyond the artifact surface expression of the site) or a data

KURT E. DONGOSKE AND THERESA PASQUAL

recovery program without prior meaningful consultation with a tribe or consideration of the tribal value of the archaeological site. When a federal agency authorizes archaeological testing or a resultant data recovery program, it views the eligibility of these sites solely from a Criterion D eligibility; that is, for their scientific information potential. In this case, once scientific information has been recovered through mapping, testing, excavation, and documentation, adverse effects to the resource are said to have been mitigated—but only from a Western scientific perspective. Other values, sometimes intangible and unquantifiable, but no less of importance to tribes under other criteria are not mitigated when the research design addresses only Criterion D. Thus, the federal agency—typical of many governmental agencies—privileges a Western materialist, scientific rationalist perspective of archaeological resources while disadvantaging the Native American values and perspectives of these important places and the role they play in defining Native American identities. In addition, the act of archaeological testing and data recovery may damage those characteristics of an archaeological site that make it eligible for the National Register as a traditional cultural property, or under Criteria A and B.

For example, for the Zuni people, archaeological sites are the homes of Zuni ancestors that retain sacred and spiritual qualities that the Zuni believe are inherent in these places. All archaeological sites—including but not restricted to pictographs, petroglyphs, habitation areas, artifact scatters, special use areas, and other archaeological manifestations—are considered ancestral sites imbued with great cultural and religious significance. From a Zuni perspective, these archaeological sites have never been abandoned but continue to maintain significant life and spiritual forces. When Zunis visit archaeological sites, they experience a compression of time, in which the past and present converge to provide an experience for the individual Zuni that validates his or her traditional narrative and cultural identity. It also manifests a direct communication between present-day Zunis and their ancestors, who still reside as spiritual forces at these places. These places in the landscape are imbued with the souls of ancestral Zuni people. These sacred places are alive and infused with emotion.

Continuing to privilege Western science perceptions of archaeological sites over Zuni values perpetuates colonialism, resulting in the disenfranchisement and alienation of the Zuni people from the federal historic preservation process, and denies the Zuni a meaningful and effective voice in preserving places important to their heritage. The ideals behind the National Historic Preservation Act that birthed the Section 106 process were well intended, but the process as it is applied by federal agencies has left Native Americans to deal with the unfair ramifications of its application. The federal process does not currently encourage a meaningful, negotiated compromise with traditional communities regarding how the agency evaluates significance, effect, or designs culturally appropriate measures to lessen adverse effects to Native American heritage resources.

The next fifty years of historic preservation should recognize this disparity in the application of Section 106 and should actively seek to engage native peoples more inclusively and meaningfully in the Section 106 process. In so doing, both advocates and practitioners should be consciously aware of inherent biases in language, definitions, and criteria that favor built environments. We encourage an awareness that not all qualities and characteristics used to determine eligibility can be or should be quantified. Federal agencies seeking compliance with Section 106 should set out in the beginning to create an environment in which appropriate traditional knowledge is shared and valued. This means acknowledging and including tribal values that may not necessarily be identified, or comprehended, as having a place within the compliance process. We encourage the use of indigenous terminology when appropriate to convey values, relationships, significance, and complex systems that are not easily understood or conveyed in English.

It is important and proper for federal agencies, archaeologists, and tribes to partner in creating ways within historic preservation to appropriately manage tribal heritage resources and to maintain the harmony between the corporeal and spiritual worlds. After all, it is our collective past that we are entrusted to protect.

KURT E. DONGOSKE is the principal investigator for the Zuni Cultural Resource Enterprise and the tribal historic preservation

KURT E. DONGOSKE AND THERESA PASQUAL

officer for the Pueblo of Zuni. He has thirty-seven years of experience as an archaeologist, has worked throughout the western United States with a primary focus on Arizona and New Mexico, and has designed, implemented, and completed numerous archaeological and ethnographic projects that have incorporated the perspectives of both the Hopi and the Zuni people.

THERESA PASQUAL is the former director of the Acoma Historic Preservation Office. Her current work in the fields of archaeology, conservation, and historic preservation allows her to explore the ethical challenges, conflict of values, and intersects where true change can occur among diverse stakeholders. Pasqual is currently pursuing a degree at the University of New Mexico and is a recipient of three-year Kellogg Fellowship grant.

NOTE

1. Section 1(b) of Public Law 89-665; 16 U.S.C. 470 et seq.

From Minority to Majority

Building On and Moving Beyond the Politics of Identity in Historic Preservation

GAIL DUBROW

Although the places designated as landmarks during the past fifty years tend to be firmly anchored in time and place, what is recognized to be significant about the past—and therefore deemed worthy of preservation—has undergone dramatic change. As historians have fleshed out the histories of women, ethnic communities of color, LGBTQ, and other underrepresented groups, identity-based advocacy groups have advanced new initiatives to find previously overlooked historic resources and revise the interpretation of existing landmarks, while challenging the broader preservation movement to adopt more inclusive practices. This brief essay raises the twin questions of how far we've come in moving preservation beyond its elite and exclusionary origins and what needs to be done in the coming decades to make preservation a more democratic and inclusive sphere of cultural activity.

The most significant social and political movements of the past fifty years, including civil rights, second-wave feminism, and gay liberation, have not only changed laws and social policies but have also reshaped American culture, including the field of historic preservation. Leveraging political pressure and capital in the cultural realm, groups eager to preserve places associated with African American, Latino/a, Asian America, women's, and LGBTQ history have pressed cultural resource agencies and nonprofit organizations to survey previously neglected resources, add significant properties to landmark registers, and develop plans for their protection. As a result, much more is now known about historic places that reflect our nation's diverse heritage, and preserving cultural diversity has become an explicit goal of a

number of organizations, including the National Trust for Historic Preservation and the National Park Service.

The power of identity-based groups to advocate for their own interests, however, hasn't necessarily translated into productive alliances that benefit the many who've been disenfranchised, nor have these independent initiatives coalesced into a new majority guiding the agenda of the preservation movement. Most advocates for preserving women's history, for example, haven't fully extended their interests to advance racial and ethnic inclusiveness. Past work on LGBT heritage has been noticeably strong on the "G"—that is to say, the historical experience of gay white men—and weak on addressing other aspects of queer experience. As a result, large gaps remain in our knowledge of historic resources, and few places consciously reflect the intersections of identities. We also have difficulty seeing, much less addressing, the systemic assumptions, biases, and interests that are embedded in a preservation movement that evolved without the participation of subordinated groups. Adapting an axiom of women's history to the preservation case: It's not sufficient to simply "add sites and stir." What's needed is a reexamination of preservation's basic premises from the perspective of those who've been excluded.

Multiple claims to public memory raise difficult questions about how to define the "period of significance."

The process of identifying places associated with previously neglected aspects of our history has begun to reveal the limits of foundational policies and practices. Bureaucratic distinctions that guide contemporary preservation policy, for example, between tangible property (such as buildings) and intangible aspects of heritage (such as sites of strikes and places of ritual and celebration) often are at odds with the integrated way many cultural groups define their own cultural preservation agenda. The close relationship between social inequality and various forms of dislocation and dispossession raise deep questions about the primacy given to an owner's consent in preservation action. Successive layers of occupation and use of particular sites, and therefore multiple claims to public memory, raise difficult questions about how to define the "period of significance" of historic properties and about how interpretation can best recognize

multiple stories at any given place. The key to examining these deeper questions about preservation is bringing many voices to the table, not just as advocates for their own special interests but in the interest of rethinking what preservation could become.

My vision and hope for the next fifty years is that these relatively new advocacy groups and constituencies move from the margins to the center of the preservation movement, bringing their independent, identity-based preservation interests into more effective alliances that bridge the divides of race, class, gender, and sexuality. While identity-based politics have resulted in a more inclusive agenda for what we preserve, the democratic future of how we preserve depends on bringing their experience, insights, and perspectives to bear on redefining the scope, policies, practices, and priorities of the preservation movement as a whole.

Advancing this agenda requires building effective alliances among and between groups dedicated to advancing equity and justice in cultural as well as other realms, with the goal of formulating a shared agenda for the protection of the nation's heritage. To this point, mainstream preservation groups have engaged in outreach efforts to diversify their fold, lending resources and legitimacy to what to this point have largely been grassroots initiatives. The next step toward building alliances might be the formation of a diversity-related preservation coalition that brings independent initiatives into dialogue, and provides a platform for mutual support and the foundation for developing a shared preservation agenda independent of the interests of established preservation groups.

Additionally, emergent leadership in grassroots groups might be cultivated to form the next generation of leadership in the preservation movement. Indeed, many professional development programs are organized on a cohort basis. The establishment of a peer-oriented professional development program for emerging leaders, particularly at the midcareer rather than student level, might build the relationships between individuals and interest groups needed to establish effective alliances; build skills for preservation action; and reposition members of underrepresented groups as experts not just on identity issues but on preservation writ broadly. In everyday practice, it means continually raising the question of who is invited to the table, whose

GAIL DUBROW

expertise is recognized, whose priorities matter, and what more can be done to realize a progressive vision for the future of preservation.

GAIL DUBROW is professor of architecture, landscape architecture, public affairs, and history at the University of Minnesota. She received a PhD in urban planning from UCLA (1991), and served on the urban planning faculty at University of Washington from 1989 to 1995, where she was associate dean of the College of Architecture and Urban Planning. She is the author of two award-winning books, *Sento at Sixth and Main,* with Donna Graves (2002), and *Restoring Women's History through Historic Preservation,* with Jennifer Goodman (2003).

Shockoe Bottom

..

*Changing the Landscape of Public History
in Richmond, Virginia*

ANA EDWARDS

Drive east on Broad Street in Richmond, Virginia, from downtown, pass the Egyptian Building, and you'll quickly head down a steep hill toward the traffic light at 17th Street–Oliver Hill Way, which in 1737 was the westernmost street in the original thirty-two-block grid of the city. Continue on up to Church Hill on Broad Street to St. John's Church, where Patrick Henry famously gave his "Give me liberty or give me death!" speech in 1775. You won't miss it: signs and historic markers point the way, and the church is easily seen and beautifully maintained. (There's a website, too.)

You can now turn around and look back down the hill at Shockoe Valley, now called Shockoe Bottom. Until it was encased in a concrete tunnel in the 1920s, Shockoe Creek ran through that valley and emptied into the James River. From your car you probably won't have noticed that by the time you got to Oliver Hill Way you had already passed the entrance to a cemetery for the African people of early Richmond, where in 1800 enslaved blacksmith Gabriel was hanged for leading a rebellion against slavery behind a banner that proclaimed "Death or Liberty!"

No sign will point the way, but once you find it, interpretive markers do let you know you are standing at the site of excavation of Robert Lumpkin's slave-trading complex (known in antebellum Richmond's black community as "the Devil's half acre"), one of the largest in the city that operated from the 1840s through the end of the Civil War. But there's almost nothing to demonstrate the true scale of that business—that Richmond's Shockoe Bottom was second in size only to New Orleans in the domestic trade in enslaved humans for the thirty years

Shockoe Bottom, in Richmond, Virginia, was the largest slave market outside of New Orleans in the nineteenth century, but was largely covered over by Interstate 95, parking lots, and deliberate forgetting. The sign in the foreground shows a photograph of Lumpkin's Jail, a notorious facility for holding slaves, many of whom died and were buried nearby. In the distance are the towers of Virginia Commonwealth University's medical school, in the midst of which, overlooking Shockoe Bottom, stands the White House of the Confederacy. PHOTO COURTESY OF MAX PAGE

Shockoe Bottom

leading up to start of the Civil War in 1861, that this valley was filled with traders, jails, brokers, merchants, and suppliers for the daily life of a slave society, and that more than three hundred thousand people were sold out of Virginia in that period, most of them from Richmond.

The Defenders for Freedom, Justice & Equality is a social justice organization in Richmond that began its activities in 2002 with demonstrations against the unjust treatment of incarcerated men and women and seeks to present the connections among local, national, and international events and issues—typically involving racism and economic injustices. One of our earliest public history projects was the installation of a historical highway marker to point to the life of a twenty-four-year-old black man in early nineteenth-century Richmond who determined to lay his life on the line in the struggle for freedom, and was executed on the city gallows on the site of a burying ground in the heart of the city that that had since become an interstate highway and a parking lot. This project, called the Sacred Ground Historical Reclamation Project, resulted in the establishment of an annual commemorative event on October 10, the anniversary of Gabriel's martyrdom, the *Virginia Defender* newspaper (2005–present), a weekly radio show (2005–13), and a grassroots campaign to reclaim what has become known as Richmond's African Burial Ground (2005–11).

When we started, most people you might have asked about Gabriel's Rebellion or the burial ground in Shockoe Bottom wouldn't have had any idea what you were talking about. Now both are becoming more commonly known. Lumpkin's Jail became world-renowned after *Smithsonian* magazine published a story about the archaeological discovery of the footings of every building in Robert Lumpkin's operation, including the two-story jail.

By now, few in Richmond are not familiar with the community's struggle to prevent a baseball stadium from being built in the Bottom. In 2014 the area was nationally recognized as an endangered historic site, and we could make the case for historic preservation precisely because of what was learned during the campaign to reclaim the burial ground—by reading books and studying maps to understand the city's evolution from one of William Byrd's plantations in the 1690s to the capital of the "colony and dominion" of Virginia in 1780, and of the Confederate States of America in 1861.

While we, as a society, face down the more familiar legacies of embedded, institutionalized racism and primacy of white privilege in our social structures, we are coming to understand how they "color" the valuation and prioritization of arenas other than the political. Why our scholars study and interpret what they do; why our urban planners tear down and renew what they do—these decisions are based on what topics have been deemed important to understand, to address, to advance. In New York City in 1991, the bones of 419 enslaved Africans were dug up from an eighteenth-century cemetery near Wall Street in plain view of the public, unleashing an outrage from those who bore witness and a demand for recognition of the value of the remains and the stories they could tell. In Richmond in 1996, the discovery of bones during a university construction project created controversy over how their potential archaeological and anthropological value was dismissed compared with the current process for engaging a representative descendant group of city residents to determine proper fate and legacy for the remains. Both events demonstrate the critical need for subjective perspectives of observers, recorders, and intellects previously dismissed as incapable of an objectivity that has hardly yielded objective results.

For thirteen years, the Defenders have insisted that Richmond's invisible and devalued black history must now be understood, made public, understood, and honored, and mined for truths to help us address present-day struggles. Our role is to add to what is known and amplify what isn't known well enough. Richmond's leading role in U.S. domestic trafficking in human labor can no longer be sloughed off: how long it went on, how profitable it was, the creation of the construct of race and false hierarchies to justify enslaving African people, the economic capital made possible only by the industry of the enslaved, the "peculiar institution" that led to the Civil War and its aftermath, virulent segregation policies, Jim Crow laws, eugenics, lynchings, economic deprivations, and the divisions between black and white that are at the heart of some of today's most damaging social problems.

In some ways, it is the discovery of the invisibility of these histories that makes them so compelling. The African Burial Ground was not known in the late nineteenth and twentieth centuries because it

was already gone—filled in with tons of soil in part so Broad Street could finally connect Capitol Hill to Church Hill. But once known, a sense of urgency arose to remove the offensive parking lot and protect the sanctity of the graves. The story of Gabriel's Rebellion was purposefully silenced because of the threat to the sense of safety of the white community surrounded by the ever-present possibility of uprising and retribution. Now, the history, told by tour guides and handbooks because no building or artifact remains of the remarkable events in which Gabriel and his fellow conspirators participated, has present-day weight and relevance. Our conscience tells us that these events mattered then and matter now—that this place is rightly considered a site of conscience by the International Coalition of Sites of Conscience, a national treasure by the National Trust for Historic Places, and site worthy of protection by Preservation Virginia.

Walk the original streets of Richmond, founded in 1737, look up toward the spot where in 1775 Patrick Henry spoke so passionately about the value of liberty, then turn and look the other way, toward the spot where twenty-five years later a young black man gave his life in pursuit of liberty. Walk to the places of business of large-scale slave traders Robert Lumpkin and Silas Omohundro, both of whom took formerly enslaved women for wives. Stand where chaplain Garland H. White of the U.S. Colored Troops was reunited with his mother on April 3, 1865—Richmond's Emancipation Day—after having been sold away twenty years earlier. These places, these people's life journeys help us understand our selves, or at least help us articulate our questions.

If you drive around the city, you see who has been valued to this point, who has represented "us" to the world. It's just not enough. Richmond's story is incomplete. By giving priority to historic discovery and preservation, to places steeped in both pain and resistance, we face our worst and best selves. In Shockoe Bottom, we can reclaim history itself if we claim the actual sites, turned, we hope, into a memorial park with commemorative monuments and interpretive centers.

Inasmuch as the United Daughters of the Confederacy, and ultimately the state of Virginia, decided in the late nineteenth and early twentieth centuries that they needed Richmond's urban landscape to reflect and enshrine the "lost cause" narrative, so do I—a daughter of

ANA EDWARDS

enslaved Africans (and European American slave owners and Indians expelled westward) now living in this most historic city—feel the time has come to see the public landscape of Richmond reflect and commemorate the three-hundred-year narrative of my people as well.

With the controversial placement of a memorial to tennis champion Arthur Ashe on Richmond's Monument Avenue, Richmonders (black and white, for different reasons and from different pulpits) in 1996 seemed finally to be publicly marking their discomfort, or frustration, with their city's Confederate self-portrait. From the moment of its unveiling, the Ashe memorial became a pivot point in the city's conversation about race and power and control of the public landscape. I do think that when people finally understand that Ashe fought against racism on the court here as well as on behalf of black people in South Africa, then his memorial's location on Monument Avenue will have new poignancy, and reveal new truths.

The time is ripe for tapping the myriad voices, vehicles, and places that have been missing or dismissed as irrelevant.

Richmond is a changing city, and the time is ripe for tapping the myriad voices, vehicles, and places that have been missing or dismissed as irrelevant to its development and its identity. With the reclamation of the African Burial Ground in Shockoe Bottom, Richmonders acknowledged the black community's assertion that its historic role in the city's evolution must become visible and tangible.

By virtue of the Sacred Ground Historical Reclamation Project's approach to reclaiming places and events important to black history in Richmond, we have become public historians. We recognized that engaging public history helped us question, evaluate, and mark human and social needs in the present. Public historians and preservationists, especially those cultivated from our historically marginalized communities and ethnicities will be stepping forward and claiming parity in the value of their voices in the interpretation and valuation of these sites.

As a lay interpreter of some of Shockoe Bottom's historic sites and a Richmond resident and activist, I think it will be good to have monuments to an old and cruel way of life challenged, replaced, relocated or

reinterpreted, and to have the next generation of understanding and social vision interpreted and embodied anew, which I certainly hope is based on our shared entitlement and access to universal human rights.

ANA EDWARDS is chair of the Sacred Ground Historical Reclamation Project, a 2004 initiative of the Defenders for Freedom, Justice and Equality, a Richmond, Virginia–based social justice organization that grounds its work in the principles of the right of oppressed peoples to self-determination. She worked for eight years to help reclaim Richmond's African Burial Ground, and is currently engaged in the community struggle to preserve and memorialize historic Shockoe Bottom.

Historic Preservation

..

Diversity in Practice and Stewardship

EVERETT L. FLY

I believe that practitioners and constituents must expand the ways they address the cultures of America that are represented in our places and landmarks. Whether a practitioner is in private or public practice, having a broad exposure to and appreciation of the diversity of our culture is essential. Diversity requires that professionals apply their education and training differently than in the past fifty years. This is even more important for practitioners in the public sector, such as State Historic Preservation Officers, municipal preservation officers, and public entity staffs.

Black historic resources and black practitioners have been systematically and institutionally undervalued and disrespected.

Constituents, advocates, and residents of small and minority communities cannot hold their stories to themselves and expect nonresidents to appreciate and respect local culture and place. Fresh themes such as civil rights through property ownership and cultural legacies in the physical environment offer opportunities for broader interpretation of the significance of people and events. In addition, community stewards must use Internet platforms, social media, and on-site interactive programs much more often than traditional house and institutional museum scenarios sustain resident participation to attract broader audiences beyond local boundaries.

As I consider this subject in the first half of 2015, America is going through major, and painful, struggles in accepting its racial diversity and living up to its civic responsibility to respect and value the contributions of all segments of its society. Black historic resources and

McNair, in Harris County, Texas (established circa 1924) is one of more than five hundred unincorporated historic Black settlements established across the United States between 1865 and 1930. PHOTO COURTESY OF EVERETT FLY.

black practitioners have been systematically and institutionally under-valued and disrespected in the field of historic preservation.

A pattern of biased attitudes and discouraging practices has been repeated for decades in all parts of the United States. First, practitioners have marginalized vernacular structures owned, or built, by blacks because the architectural style was not classical (colonial, revival, Romanesque, etc.). Second, public practitioners question the significance of nineteenth-century buildings designed and built by blacks because they were not recognized as professional architects. These interpretations ignore the fact that racial segregation and discrimination prevented blacks from attending accredited white schools of architecture in the nineteenth and early twentieth cen-turies. Without academic credentials from white institutions, blacks were not allowed to take state examinations for professional licensing. Third, practitioners interpret developed properties owned by blacks as being "insignificant" because the vernacular landscape was not

EVERETT L. FLY

classically styled (English landscape garden, country place, Olmsted style, etc.). Fourth, State Historic Preservation Offices (SHPO) and staff declare properties owned by blacks to be ineligible for National Register of Historic Places (NRHP) consideration because the SHPO is not able to visit a remote site. Fifth, State Historic Preservation Officers declare black history related properties to be ineligible for NRHP consideration because the SHPO is unaware of the site's broader cultural significance (politics, literature, music, folklore, cultural landscape, etc.) beyond architecture and engineering. And finally, State Historic Preservation Offices discourage NRHP nomination work because the SHPO is not aware of current black history research or of the broader (geographic or discipline) cultural significance of the resource.

Without question, researching, interpreting, and preserving a historic resource that is documented by public records and built in a classical style is demanding. It is much, much easier to research and interpret the classically styled properties and recorded events (with related people) than vernacular properties with few, if any, traditional public record documentation and black cultural associations. For a century (1863–1964), a staggering number of public records, private collections, lands, and buildings related to black history and culture were ignored, destroyed, or manipulated for less than honorable reasons. But the difficulty of researching a black community should not be a reason to discount its significance. A large volume of authentic records can be found in private collections and rare documents depositories such as the National Archives.

Too often black communities and residents limit their stewardship to local contexts, single disciplines, and personal perspectives. Early black enclaves, settlements, and towns were composed of people with varied skills, talents, aptitudes, intellects, and life experiences. Residents of these communities combined their physical and intellectual resources to form a collective society and culture. They were integral members of economic, religious, educational, or social networks that extended far beyond their local boundaries. The physical and cultural traces of people of color, and of their communities, must be researched and interpreted in multidisciplinary approaches that

expose their collaborative history and critical roles in American life and history. Each personal family story must be connected to other people and places, no matter what race, to represent history that is valuable and authentic.

Prescription/Framework for Advancement

I would propose a multifaceted approach to effect changes in the attitudes and makeup of the preservation community, as well as in the way preservation professionals are trained and kept up to date in American historic preservation policy and practice. First, all preservationists should learn how to apply the appropriate criteria for evaluation to different types of resources, including cultural, ethnic related, thematic, and landscape. Second, new teaching formats should require field experience in at least two different cultural settings. Continuing education study of multiethnic cases should be required for public and private practitioners. For generations, all preservationists, including people of color, have been forced to study classical architectural styles and employ traditional interpretations as the exclusive standard of significance. There is no reason that both aspiring and seasoned preservationists should not be exposed to the broad, and more legitimate, range of cultures that compose the authentic sources of American history and culture. Historic black towns and settlements have contributed to the evolution and success of every state in America. These communities are the stewards of a large body of authentic documentation held by private citizens and nonacademic institutions. Practitioners should be made aware of this material and if necessary trained to use it to complement traditional academic and institutional archive documentation. Partnerships must be developed with academic institutions to digitize these materials and make them available for reference through the Internet. Finally, more people of color must be trained and deployed in historic preservation. More should be done to systematically recruit, train, and retain people of color in all aspects of historic preservation. Internships, mentorships, academic scholarships, and special project assignment formats should all be used. As I conducted research for this essay (in summer 2015), I was not able to find one single historic

EVERETT L. FLY

preservation agency, organization, or professional association that could identify a current African American state historic preservation officer in the United States.

The *Merriam-Webster* dictionary defines a myth as "an idea or story that is believed by many people but that is not true." The oversimplified history and narrow historical interpretations that have been used to define American historic preservation to date will continue to produce myths until more inclusive accounts are accepted and presented for public and professional education and included. Today, many continue to spread and perpetuate myths that hold all of us back and keep us, as a nation and as a culture, ignorant of some of our most relevant history.

EVERETT L. FLY is a professional landscape architect (Harvard University Graduate School of Design) and architect (University of Texas at Austin). He is a fellow of the American Society of Landscape Architects. His pioneering research project, "Black Settlements in America," a career-long study of the origin and evolution of historic black settlements, has identified over twelve hundred significant but forgotten or unrecognized Native American and African American settlements. President Barack Obama awarded Mr. Fly a 2014 National Humanities Medal for his work in preserving the integrity of African American places and landmarks.

Latinos in Heritage Conservation

Establishing a National Vision for American Latinos and Historic Preservation

SARAH ZENAIDA GOULD

Latinos in Heritage Conservation was born out of a desire to connect with other Latinos doing historic preservation work in Latino communities. In July 2013, I was fortunate to meet Desiree Smith when we were fellows at the National Association of Latino Arts and Culture Leadership Institute. Desiree was working for a historic preservation organization in San Francisco, and I was an active member of the Westside Preservation Alliance, a community-based Latino historic preservation group in San Antonio. We discussed sharing ideas and information about preservation efforts in our respective cities, and Desiree explained that she and her colleague Laura Dominguez had also been talking about the need for a national network of Latinos working to protect Latino historic spaces. This conversation eventually led to a series of conference calls beginning in the spring of 2014, each one bringing in a few more contacts. We launched a Facebook page in October 2014, and the following month held an affiliate session at the National Trust for Historic Preservation's National Preservation Conference. As more people expressed an interest in joining our efforts, we made plans for an inaugural summit in May 2015 to coincide with Historic Preservation Month. More than fifty people from around the country attended the summit and contributed to shaping the vision of this growing organization. Professional and community-based preservation workers, scholars, and students—including several members of the National Park Service's American Latino Scholars Experts Panel, who oversaw the publication of the 2013 American Latino Theme Study—gathered to define the group's mission, vision, and initial goals and priorities.

We knew that groups and individuals were hard at work on Latino preservation issues in cities and towns across the United States, but it was hard to keep track of what was happening in other places unless you knew someone there. Historically and culturally significant sites and structures are tangible links to our past and are worthy of preservation, and yet less than 1 percent of National Historic Landmarks are connected to Latino history. With so much work to do to correct this deficiency, a national network would provide a platform for raising the visibility of heritage conservation in Latino communities and for empowering groups and individuals to take direct action to protect and sustain historic places in their local area as well as across the country. It would enable the creation of a national voice for preservation issues affecting Latino communities, and would allow us to share our struggles, our victories, and our lessons learned. It would allow us to collectively raise our voices to protect places that matter.

Less than 1 percent of National Historic Landmarks are connected to Latino history.

We envision this network as one that equally welcomes professional preservationists *and* community preservationists. For we all have knowledge, ideas, experiences, and strategies to share. Together we can advocate for policy changes—for example, rewriting the designation criteria to be more culturally inclusive, and creating protections for economically vulnerable and historically rooted communities—at all levels to increase the protection of sites and structures that matter to our communities, and advocate for the funding to enact such preservation goals.

For Whom and What Purpose Do We Preserve?

Working to preserve historically Latino spaces means that we are working to demand that our history be recognized as being equally important to U.S. history as any other Americans' history; to demand that sites and structures associated with our history be acknowledged and respected; to teach our own communities about navigating and questioning the policies of historic preservation; to fight against gentrification that is too often the result of profit-based growth policies

and attempts to clean up the "blight" perceived in our communities (it is our experience that too often development displaces poor and working-class people of color and erases physical signs of our history in the process); and to fight the enduring specter of colonialism that is pervasive in so many of our Latino majority cities and that promotes a colonial fantasy of Latino America while ignoring real Latinos and real history.

First and foremost we do this work for our Latino communities, communities that have been devalued by the powers that be for too long, and yet within these communities we know and value our past and understand the need to preserve places that matter. We also do this work for all of the people of the United States, because Latino history is American history and American history is Latino history.

The Vision

In establishing a national network for Latino heritage preservation, we seek to push historic preservation practices into a new era of inclusion.

We seek to advocate for more inclusive policy change at local, state, and national levels.

We seek to commit ourselves to *concientización* (consciousness raising), to undertake the work of raising awareness of the need for historic preservation of Latino-related sites and structures among our communities *and* among policy makers.

We seek to challenge "the criteria" that have too often been used to limit sites and structures deemed worthy of historic preservation to those associated with "great white men."

We seek to challenge established definitions of architectural and historical integrity to acknowledge the historic treasures in our barrios, which are as authentically American as Mount Vernon or Monticello.

We seek to identify the barriers to Latino heritage conservation so that we can break them down.

We seek to maintain an open definition of Latino heritage

SARAH ZENAIDA GOULD

preservation so that we do not repeat the exclusionary practices of existing preservation organizations.

We seek to acknowledge multiple forms of preservation work, ranging from the designation of historic sites and structures to community storytelling about places that matter to maintaining cultural traditions.

We seek to bridge the divide between professional preservation and community activism, for our movement needs both.

We seek to increase funding—at local, state, and national levels— for the identification and protection of sites and structures related to Latino history.

We seek to serve as a communication network for all those committed to a more inclusive vision of historic preservation.

We seek to unite to save significant sites and structures across the nation and to serve as a community that shares knowledge, ideas, experiences, and strategies.

We seek to find others with similar goals.

Latinos in Heritage Conservation recognizes the important preservation work already being done in cities across the United States while also recognizing that Latino communities have largely been left out of the work of mainstream preservation groups. Latino communities have to demand changes in the way preservation work is currently practiced, as well as changes in the policies and values that have led preservation work in the last century. Latinos in Heritage Conservation will advocate for more inclusive approaches to preservation, including the equally important roles of policy and community activism in protecting our historic sites and structures; it will serve as a network for those committed to these changes; and it will work to change the shape of historic preservation to more accurately reflect the demographics of our multiethnic society.

SARAH ZENAIDA GOULD, a cultural historian and curator based in San Antonio, Texas, is a cofounder of Latinos in Heritage Conservation. Her research focuses on the intersections of comparative

ethnic studies, material culture, and popular culture. She received a BA in American studies from Smith College and an MA and PhD in American Culture from the University of Michigan. She is a former fellow at the National Museum of American History, the Winterthur Museum, and the American Antiquarian Society.

SARAH ZENAIDA GOULD

The Necessity of Interpretation

DONNA GRAVES

A recent symposium in Washington, DC, organized by National Park Service (NPS) leadership focused on how to make the National Historic Landmarks program better reflect "the histories of all Americans." Cultural diversity is now embraced as a fundamental goal by the NPS, by the National Trust for Historic Preservation, and by many local preservation organizations and agencies. Yet these programs have a very long way to go before they achieve this aim. Despite important NPS initiatives to address gaping holes in our federal registers, the National Register of Historic Places and National Historic Landmarks don't represent the richness and complexity of U.S. history; the roster of designated sites still overwhelmingly reflects the experiences of white male Americans who possessed economic and political resources. Yet merely enlarging the number and range of sites listed by these programs in itself will not create a more inclusive and relevant preservation movement.

The National Register and the National Historic Landmarks programs are tools that are not easily available or, frankly, of central interest to communities whose histories have generally been marginalized or obscured. It is puzzling that preservationists usually halt their efforts once a physical structure becomes protected when, in fact, it is the story about the place that these communities are passionate about preserving and sharing. The majority of the buildings and sites that hold such histories are modest in nature and often elicit an indifferent response; even the very people whose histories they reflect are sometimes baffled by the preservationist's emphasis on physical property alone. A

community's most vital attachment is to its lived history—without that story being conveyed, a structure or site is an empty shell.

I asked the participants at the NPS symposium to imagine a table filled with dishes from many culinary traditions: pupusas, grits, lumpia, a madeleine, sushi, and bangers and mash. The breadth of resources and stories that could be encompassed by the National Register and National Historic Landmarks programs are obviously even more varied and rich than American foodways. The preservation process in the United States needs to become a dining table but has been functioning as a three-legged stool. The three legs preservationists rely on are identification, documentation, and registration. The next generation of preservationists must add a fourth leg of interpretation, so that it can transform the movement into a generous table where others will feel welcome and invited to join the feast.

With robust storytelling, historic sites become vehicles for crossing barriers of time and personal experience.

Historian Raymond Rast has pointed out that the "goals and methods of the historic preservation movement are no longer in alignment," and has identified standards of physical integrity as one of main barriers to a more inclusive national preservation movement.[1] The premise that intact historic structures can tell their own stories is embedded in the National Register and National Historic Landmarks programs themselves, which suggest that buildings and other properties can "speak" to present-day visitors. Yet places rarely communicate their historic significance without interpretation or educational programs to inform visitors.

For many communities whose histories are not yet reflected in federal, state, or local registers, important historic events and experiences took place in modest building types that are often subject to alteration or demolition, such as storefronts, factories, community halls, and modest residential neighborhoods. The fact that these sites have often changed since their professionally assessed "period of significance" should not deny the importance of their histories or the potency of conveying them in the places where they occurred. In fact, a changed physical environment has much to say about historical erasure, adaptation, and survival. It also makes how to protect such

DONNA GRAVES

properties a more urgent consideration and reinforces the need to find creative ways to communicate the power of their stories.

Interpretation allows preservation to fulfill multiple goals beyond conserving the physical remains of past eras—with robust storytelling, historic sites become sources of information, platforms for education, and vehicles for crossing barriers of time and personal experience. Interpretation can acknowledge the multiple layers of history embedded in most sites, articulate multiple claims to place, and allow us to better understand and confront difficult aspects of the past that still shape our social landscape. Multilayered interpretation is important not only for presenting a more accurate account of the past but also for supporting a more engaged relationship with the nation's increasingly diverse population. Interpretation can provide a route to the holy grail of "relevance" that many preservation organizations seek, but only if it is based on authentic engagement with communities associated with the site in the past and in the present.

This type of robust, dynamic, and inclusive interpretation affords tools for expanding the ranks of those who value the preservation of historic places. This is not news to many who steward public historic sites. Numerous examples prove this, from the best National Park interpretive programs to sites such as New York's Lower East Side Tenement Museum, Chicago's Hull House, and Oakland's Peralta Hacienda. But it is time for the historic preservation movement to become creative and consistent about how interpretation of historic sites can be built into our process as a legacy equal to the physical aspects of place we work to protect.

How can this be done? A first step would be requiring all cultural resources studies to include at least one detailed interpretive strategy among their deliverables.[2] Historic site interpretation can take myriad forms, from the familiar media of plaques, films, and walking and driving tours to visual and performing artworks rooted in site. The still-unfolding field of digital humanities will continue to reveal how new technologies help us to recover, recall, and share histories of place. Preservationists can test the waters through projects that leverage the expertise and community roots of potential partners such as state and local humanities and arts councils, colleges, community development organizations, and others.

To support these efforts, it will be necessary to build a funding infrastructure for interpretation of a broader swath of historic places parallel to that available to historic house museums through (admittedly skimpy) sources such as grants from the National Endowment for the Humanities and the Institute for Museum and Library Services. City councils might be persuaded to consider public access to robust interpretation as a critical urban amenity akin to the arts. "Percent for preservation and interpretation" ordinances could join percent for art programs in channeling a small fraction of development costs into the common realm of the built environment. Such development fees would support deeper research and community engagement into the significance of historic sites, especially for communities who have not had equal access to resources that support documentation and interpretation of their connections to place.

Documentation and even landmark designation of places that are important to histories but have been neglected or overlooked is only part of the work necessary to recall these histories in public memory and create a more inclusive historic preservation movement. Developing powerful and sustained ways to make the histories of those sites available and relevant is just as crucial. If the next generation makes interpretation as crucial a part of heritage conservation as physical preservation, the historic preservation movement will fulfill its promise as a tool for fostering a critical understanding of history and collective memory, of place attachment, and of social justice and equity.

DONNA GRAVES is an independent historian/urban planner based in Berkeley, California. Working with communities and public agencies, she develops interdisciplinary public history projects with an emphasis on social equity and sense of place. Recognition for her work includes the Vernacular Architecture Forum's first Advocacy Award, the National Park Service's Home Front Award, and a Loeb Fellowship at Harvard University's Graduate School of Design.

NOTES

1. Raymond W. Rast, "A Matter of Alignment: Methods to Match the Goals of the Preservation Movement," *Forum Journal* 28 (Spring 2014): 13–22.
2. A similar recommendation (Recommendation 1.3) concerning cultural resource work in the NPS is made by Anne Mitchell Whisnant, Marla R. Miller, Gary B. Nash, and Dave Thelen in *Imperiled Promise: The State of History in the National Park Service* (Bloomington, IN: Organization of American Historians, 2011), 59.

Keeping Us Honest

..

What Our Buildings Tell Us about the Health
of Our Communities

ROSANNE HAGGERTY

My thirty years of working to solve homelessness began with the renovation of a single-room occupancy hotel (SRO) in Times Square. From its opening in 1923, the Times Square Hotel had been a functioning residential hotel, providing a low-cost housing option for New Yorkers living in poverty or in various states of transition. The hotel's flexible nightly fee structure allowed people to come and go as they needed, and the relatively few rules and conditions ensured that people who might not be able to find more desirable housing elsewhere could at least find a safe place to sleep in West Midtown. Over the years, poor management and the decline of the surrounding Times Square area facilitated the building's slide into disrepair, and by the early 1990s it was a bankrupt wreck.

I had some personal experience with buildings such as the Times Square Hotel, having spent a fair amount of time in SROs in Hartford, Connecticut, as a child. Frequently my parents would take my siblings and me to these buildings, where we would visit the elderly residents we knew from our church. The spaces themselves were uninspiring, but they served a core function in our community and provided a secure home for individuals who were alone and with few resources. As I considered the fate of the Times Square Hotel, I returned again and again to this basic awareness of the important role that SROs have played in communities.

Ultimately, I created an organization to acquire and revitalize the Times Square Hotel as simple, single-room apartments for homeless individuals and low-wage workers, combined with onsite supportive services and a variety of community spaces and activities. We listed

the building on the National Register of Historic Places and used the historic rehabilitation tax credit to restore the once grand lobby and classic facade. It was a preservation-based approach to reducing homelessness and maintaining income diversity in a gentrifying neighborhood—and it worked. People stayed housed; their lives improved; and they came to share a sense of belonging.

Preservation's force lay in its unique ability to recenter questions of purpose.

But the Times Square Hotel was more than a solution to homelessness. It was also a lesson about the power of preservation as a worldview and as a method for combatting inequality. Preservation's force lay in its unique ability to recenter questions of purpose in planning and development. Dilapidated buildings such as the Times Square Hotel seemed of little value, but preservationist thinking urged us to ask, "Why is this building here in the first place, and what was it originally designed to do?" The historical function of SROs as vital community infrastructure for vulnerable populations highlighted the ongoing need for this type of housing.

Consider a more recent example.

In Northeast Hartford, Connecticut, one of the communities in which my organization does its work, sits the former Swift & Sons gold-leafing factory. Built in phases beginning in the late nineteenth century, the factory in its heyday employed more than four hundred people in and around the neighborhood. Most notably, the factory produced the leafing that still covers the dome of the Connecticut state capitol. But by the 1990s, the factory was no longer competitive. In 2004, the factory finally shuttered its doors, contributing to the economic decline that had already begun to overtake the neighborhood.

Since then, the factory has sat vacant. In 2010, its former owners donated it to Community Solutions and asked us to find a way to use it to help improve the Northeast Hartford community. The easiest solution would have been to bulldoze the building and build new affordable housing, and we had the skills and experience to do that. But that wouldn't have solved the employment needs that the factory had previously met. The situation called for clear thinking about the factory's origin and purpose.

The Swift factory had been a jobs anchor for the neighborhood once before, we thought. Why couldn't it become one again?

Today, we are revitalizing the factory as a community hub for job creation and healthy food access, another issue critical to the future of Northeast Hartford. On its completion, the preserved building will include a commercial kitchen and culinary training space, a food business incubation space, a community health clinic, and a branch of the local public library with digital and employment resources. The project has also become the centerpiece of the federal Promise Zone plan to revitalize the entire neighborhood.

Like the Times Square Hotel, the Swift factory is a context-dependent example, but a creative preservation-based approach like this could contribute to social problem-solving efforts in nearly every city. The broadest opportunity may lie in the revitalization of public housing.

Traditional public housing is out of vogue with today's planners, who argue that public housing buildings have decayed beyond repair and have become hotbeds of crime and social isolation. But in most cities, the primary force behind the deterioration of public housing has been decades of poor maintenance and financial neglect. Meanwhile, popular alternatives, such as demolition and replacement with low-rise, mixed income housing, have typically resulted in significant displacement and the loss of affordable units, exacerbating needs for affordable housing.

A preservation mindset encourages us to return to the problem that public housing was originally intended to solve: a dearth of affordable housing options in America's cities. The preservation of existing public housing infrastructure, combined with thoughtful improvements to buildings and to the urban design of public housing campuses and neighborhoods, could help address this problem while also solving the classic design flaws that inhere in many of the oldest public housing buildings.

In studying New York City's public housing stock, for example, we have found that energy infrastructure can be updated and made more efficient, child care and common areas can be added through unit reorganization and lobby-level bump-outs, and crime can be fought via glass facade expansions that increase the number of eyes on public

ROSANNE HAGGERTY

spaces. These improvements can make public housing safer, more livable, and cheaper to operate, all without sacrificing any of the affordable units our cities need so direly. Jane Jacobs had this idea in 1961 in *The Death and Life of Great American Cities*. We think it's time it was actually demonstrated.

Preservation is not an end in itself, as some have tried to make it, but it carries a key lesson for those concerned with rising inequality in our cities: all buildings and designed spaces were initially built to solve problems, and many were built to solve social problems. Today, whatever their condition, these properties invite us to consider, value, and take responsibility for honoring their original purposes as we shape the communities we live in. Preservationists must be key actors in protecting public housing while standing for its thorough improvement and redesign. Working with residents and other community stakeholders, it's time to make what exists better. We can start with Jane Jacobs's inspired and practical guidance, "re-weaving" public housing blocks into their surrounding neighborhoods and investing in making public housing buildings safe, healthy, and vibrant places to live.

ROSANNE HAGGERTY is the president of Community Solutions, a not-for-profit working with communities throughout the country to apply design thinking and other system-level approaches to reducing homelessness and intergenerational poverty. Earlier she founded Common Ground and oversaw the development of three thousand units of supportive housing, many involving the use of historic properties. She is a MacArthur Foundation fellow, an Ashoka fellow, and a recipient of the Jane Jacobs Medal for New Ideas and Activism.

Lessons from the High Line

Don't Preserve. Repurpose.

ROBERT HAMMOND

The High Line was never about preservation so much as about transformation.

From the start, our mission to save the abandoned, elevated railway line along the west side of Manhattan meant expanding the definition of "preservation," because we had to be willing to modify the structure in order to turn it into what it is today—a free open space, a public park. We preserved its essence, and honored its history, but we also repurposed it, and we made sure to do it with the guidance of the people who would be affected by it most.

Joshua David and I cofounded Friends of the High Line in 1999. We had met at a community board meeting on the fate of the High Line. About half of the original elevated railroad track, which ran all the way to Spring Street, had been torn down. The last mile and a half, running through Chelsea's backyard, had survived so far thanks in part to the efforts of a local activist, Peter Obletz, in the 1980s. It had been announced that mayor Rudy Giuliani's administration wanted to have the elevated track torn down.

Joshua and I wanted to see if there wasn't some way to preserve it. We had no expertise in urban planning, architecture, horticulture, or even community planning. And we didn't know much about preservation. We just wanted to see the old railroad track become a space we all could use.

Even with our limited expertise, we knew that this idea would expand the definition of "preservation." It was clear from the first time we walked onto those vacant tracks. I don't know what I expected, but I never could have predicted those wildflowers. We had to wade through waist-high Queen Anne's lace. It was so expansive and beautiful, and

there was so much potential. It was not the type of project you want to preserve by just applying a new coat of paint.

It called for new life.

But before we could think about what the space would be, we had to keep the High Line from being torn down.

We never imagined the complexities of a reclamation project in New York City, but, as it turns out, because the High Line was privately owned by a railroad company, the legal, political, and financial complications of turning it over to the city, and from there to the public, were challenging.

An incredible level of community activism was required to build the momentum needed to jump these hurdles. The energy of the neighbors who came together and fought to reclaim the structure was kinetic. That energy became one of the most enduring strengths of the High Line today. Before the first shovel went into rebuilding the park, there was a long, hard-fought grassroots effort that successfully saved the High Line for the community.

This citizen energy became the life force of the High Line. The voices who stepped up to help save the High Line had big ideas for how they ultimately wanted to use it. Some were preservationists driven by a desire to stay connected to the history of New York City. But many others were not involved in the preservation movement. Especially for many younger residents, what truly interested them was not how to encase history, but how their city functioned and could function. To many, it wasn't about saving the High Line for its own sake, but saving it for a new use.

So we opened the conversation up to the surrounding neighborhoods. Mining local expertise and input helped shape the High Line into something that would be valuable and accessible to the public. We inquired about and considered the needs of the area. We also commissioned a planning study with the Design Trust for Public Space to look at all possible options. It was a long process. But it was vital to incorporate a variety of voices, consider a variety of options, and end up in a place that was truly shaped by the community. And it's remarkable today to see how many of the principles laid out in that study are reflected in the ultimate design you see today, created by James Corner Field Operations, Diller Scofidio + Renfro, and Piet Oudolf.

Cities often are hesitant to ask the community for input for fear of having to take all suggestions into account and ending up with a watered-down vision—the dreaded look of a designed-by-consensus space. We wanted the community to feel a part of the decision about how to repurpose the High Line and, hopefully, part of stewarding it into the future. So we listened and followed a lot of the community's advice, but not all of it, and when we didn't use something, we went back to them and told them why. We started a dialogue. And that dialogue continues today.

We would be able to honor the structure with the freedom to modify it for today's world.

This vibrant community input led us further away from a strict, traditional definition of "preservation." If we were committed to exploring all the possible uses of the High Line, we had to be open to plans that may merit changing the structure.

That's why Friends of the High Line never sought historic preservation status. We knew some alterations and changes would be required to suit community needs. A landmarked structure would lock us into a more rigid definition of "preservation." By *repurposing* instead of just *preserving*, we would be able to honor the structure and maintain its essence, with the freedom to modify it for today's world.

This distinction between *preservation* and *repurposing* is what made this a success. The High Line was driven by how people wanted to use the space. That's why so many people use it, and why the community continues to steward it. We never could have been fully committed to including those community voices if we weren't willing to modify the structure. In the same way, trusting community input to guide those modifications let us honor the structure's history while giving it a place in today's world. Preservation alone can leave us stuck in the past; repurposing offers a path to the future.

People often reach out to Friends of the High Line in hopes of creating a similar project out of a similar unused structure. What anyone working in urban space and preservation today can learn from the High Line is that the structure did not define its success, and won't define the success of any future similar projects.

Instead, success came from *repurposing*. The essence of the High

ROBERT HAMMOND

Line was already there, and we preserved it: the open space, the natural beauty, the tension of old and new, nature and steels, and the glimpse of history. It was this energy—not the past, but the future—that I believe will preserve the High Line indefinitely.

ROBERT HAMMOND is the cofounder and executive director of Friends of the High Line, a nonprofit he started with Joshua David in 1999. Since the High Line opened in 2009, it has become one of the city's most popular destinations, welcoming over six million visitors in 2014. His accolades include a Rome Prize by the American Academy in Rome (2010); an honorary doctorate from the New School (2012); and, jointly with David, the Rockefeller Foundation's Jane Jacobs Medal (2010) and the Vincent Scully Prize (2013). He is a coproducer of *A Matter of Death and Life,* a film about cities through the lens of Jane Jacobs.

Historic Preservation and the Life Cycle

NEIL HARRIS

American medical journalism is increasingly consumed by critical social issues—health costs, unequal access to medical care, the multiplication of unnecessary tests, and conflicts of interest posed by pharmaceutically subsidized physicians. End-of-life care figures prominently among them. An aging population, blessed by gains in life expectancy, confronts difficult treatment choices as critics raise troublesome questions. Have physicians become so absorbed by their war on disease and the newly available weapons to fight it that they have lost sight of their patient responsibilities? And have patients and their families become so transfixed by the hope of medical miracles that they insist on pursuing every option, no matter how expensive or improbably successful, that science and surgery can offer? Ominous reports calculate the overwhelming expenses consumed by the last months or weeks of life, often spent attached to tubes in the confines of a hospital or nursing home. Philosophers, along with some doctors, raise the possibility that letting go can make more sense than continuing to stave off the inevitable. An entire commerce translates end-of-life directives into legally binding commitments. Living wills detail the circumstances under which aggressive medical intervention can be barred.

Buildings are not people, of course. But various practices recognize certain parallels and affinities. Groundbreakings, cornerstone layings, and topping-off ceremonies all acknowledge the significance of building life cycles. These rites of passage, commercialized as many of them are, constitute counterparts to the birth announcements, baby showers, and christenings that mark our own paths to personhood.

They also remind us of the meanings we affix to the built world and the emotional attachments it excites.

It is the end of life, however, that makes analogies more difficult. While human death may be postponed, it cannot be averted. Buildings, on the other hand, can go on indefinitely. Spared acts of deliberate destruction or natural calamities, they can survive thousands of years, their longevity reassuring, inspiring, and consoling even amid transformations of church and state, movements of populations, challenges of revolution, and changes of regime. But as with humans, can the costs of prolongation become too heavy and the results unrecognizable?

Skeptics complain that enthusiasts insist on preserving what is irretrievable and fundamentally altered, alongside what is basically intact and sustainable. Angry debates have broken out over campaigns to save radically renovated structures simply because of sentimental associations. The bitter seven-year fight over the fate of Rhodes Tavern in Washington, DC, involving citizens committees, court battles, a referendum, and electoral clashes, is a case in point. Despite the memories surrounding the structure that had served disparately as boarding house, town hall, bank, tavern, and press club, its alterations had been numerous and fundamental. Rebuilding it would be "fake, like a Hollywood set," one prominent preservationist asserted, to the irritation of many of his colleagues.[1] And the tavern, still fondly recalled today by some in Washington, did come down to make way for Metropolitan Square.

The destruction—or murder—of New York City's Pennsylvania Station, Chicago's Stock Exchange and Garrick Theater, Minneapolis' Metropolitan Building, and other cherished masterpieces still produces near universal mourning. These serve as poster children for thousands of other lamentable losses. But struggles to preserve badly maimed and fundamentally rebuilt structures can become exercises in futility. Faced with the razing of his memorable Larkin Administration Building in Buffalo, New York, Frank Lloyd Wright declared that it was worthy of a decent burial. Years of neglect and ongoing deterioration had left it, according to the newspapers, a "spectacle of decay," a battered and despoiled remnant of its former self.[2] What was wrong with letting it go?

Some buildings need acknowledgment of the moment when, for one reason or another, despite many moments of glory, their time on earth is gone. Like human bodies, structures inevitably age. Much can be done to keep them going. Just as human beings have available a range of medical and surgical interventions, complete with organ replacements and newly inserted joints, so builders and architects can address disease and dysfunction, facades can be renewed, and systems can be modernized. But when costs become too high, when replacements are too multiple, when all the ventilators and feeding tubes are no longer effective, when the very soul has departed, then it may be appropriate to say good-bye.

One of our ongoing problems is knowing how to say farewell.

Human bereavement has its rituals meant both to comfort mourners and to eulogize the dead. Religious or civil funerals offer the opportunity to remember, take stock, and reaffirm. Commissioned portraits, sculptures, and requiem masses testify to affection, gratitude, and respect. But building rituals are linked almost exclusively to the beginning rather than the end of life. One of our ongoing problems is knowing how to say farewell.[3] As preservationists mount campaigns to save what is memorable, incomparable, and salvageable, it seems right to recognize that not everything falls into these categories. Once an effort, even a worthy effort, fails to spare a candidate for survival, it is important to move beyond expressions of dismay. We need devices to memorialize more effectively, perhaps to commission obituaries and farewell services for the newly departed. Scattered instances of this—as in the 2013 demolition of the former Boston Herald building or the funeral offered a Philadelphia row house—are already taking place.[4] And perhaps we could use the concept of living wills to spare the truly damaged from the indignities of overly extended and extensive intrusions.

Who will be responsible for these living wills, who will officiate at the ceremonies of departure, how will we make certain the ambitious heirs to these sites (quite often real estate developers) do not unnecessarily shorten the lives of the building patients—these questions should be addressed with sensitivity and deliberation, just as human end-of-life decisions must be handled with compassion and prudence. But denial is only one stage in the grieving process, and far

NEIL HARRIS

too often it is where the failed efforts end. Developing better ways to honor and recall our building necrology should occupy our attention in the days to come, alongside continuing struggles to preserve what can be saved.

NEIL HARRIS is Preston and Sterling Morton Professor of History and Art History, Emeritus, at the University of Chicago. His books include *Building Lives: Constructing Rites and Passages* (1999) and *Capital Culture: J. Carter Brown, the National Gallery of Art, and the Reinvention of the Museum Experience* (2013). He has served on the boards of the American Council of Learned Societies, the Institute of Museum Services, the Smithsonian Council, the Henry Francis du Pont Winterthur Museum, and the Newberry Library.

NOTES

1. The commentator was J. Carter Brown, director of the National Gallery of Art and chairman of the Fine Arts Commission in Washington. See Neil Harris, *Capital Culture: J. Carter Brown, the National Gallery of Art, and the Reinvention of the Museum Experience* (Chicago: University of Chicago Press, 2013), 339. For further commentary on this controversy, see ibid., 337–43.
2. For discussion and references, see Jack Quinan, *Frank Lloyd Wright's Larkin Building: Myth and Fact* (New York: Architectural History Foundation, 1987), 128. See also the comments in Neil Harris, *Building Lives: Constructing Rites and Passages* (New Haven, CT: Yale University Press, 1999), 158–59.
3. Museums and historic houses may face similar issues, and some commentators have been using clinical metaphors to describe them. See Amy Rogers Nazarov, "Death with Dignity: Ethical Considerations for Museum Closures," *Museum News* 88 (July–August 2009): 38–43.
4. Travis Anderson, "Veterans Salute Building's Passing," *Boston Globe*, April 8, 2013; and Kathy Matheson, "Elaborate 'Funeral' for Decrepit Philadelphia Row House," San Jose *Mercury News,* May 26, 2014 (article for the Associated Press). Various versions of this story appeared elsewhere, in newspapers and on the web. The occasion in Philadelphia included hymns, eulogies, a "hearse-like dumpster" in a marching procession, and a community meal.

A Grand Coalition

TONY HISS

Over the last fifty years historic preservation has come of age just in time to play a historic and lead role in the half century ahead, which is certain to be a period of both global warming and global swarming. By 2060 average world temperatures could rise by as much as seven degrees Fahrenheit; the world will add more than two billion inhabitants; and the United States' population of 325 million will rise to 400 or 500 million. By 2044, the country will become a "majority minority" country, and the new patterns of settlement won't just be urban.

How can we prepare for what will be an unprecedented age?

Most Americans will live in about a dozen "megaregions," connected bands of cities such as Southern California's "Los Diego" amalgam and the growing Northeast Corridor. In 1967 the term "BosWash" was used to describe this chain of cities, which by then already extended from Boston to Washington, DC, but the emerging shape of newer megaregions is longer, and BosWash itself has already become "Newland," stretching from Newport News, Virginia, to Portland, Maine (so maybe it should be "Portport"). There's an ecological side to this, too, now that biologists such as E. O. Wilson are asserting (see, for instance, his recent book *Half-Earth*) that the only way to stave off a mass extinction crisis will be to set aside as much as half of the planet for the ten million other species with which by his estimate we share the earth.

How can we prepare for what will be an unprecedented age? It could be like packing for a journey to a time and place in some ways unimaginable. What will we want with us? Which flashlights, com-

passes, water bottles, PowerBars, extra socks, or emergency Mylar blankets in our current stock will give us the best chance to arrive, survive, and thrive? We'll need all our wits. Our best bet is to take along and passionately safeguard all those landmarks, whether built objects or natural terrain, that have the capacity to steady us and carry us forward, things that have more than one use because they add an extra dimension and resonance to the moment by opening us up to a longer past and a wider present. These most special landmarks serve as our sentinels, reality checks, talismans, beacons, landing lights, reminders of where we've been and how we've organized ourselves. Collectively, they help us stay focused, think better, understand more.

Grand Central Terminal, for instance—one of my longtime favorite places in New York City—isn't just admirable because it still effortlessly handles vast crowds after more than a century of use, but because it gives us enough space to let us see how we create that effortlessness by each of us minutely adjusting our pace and trajectory as we move through the building so that no one bumps into anyone else. Over by the Hudson River an addition to the city much too recent to qualify as a legal landmark, the new High Line park, built on an abandoned, elevated freight train line, presents and celebrates the sea breezes, the birdsong, and the calmness that pervade the city just two stories above the cacophony and seeming disorder down on the streets.

It will take a grand coalition—a coming together of preservationists and conservationists, both of whom will be stretched and energized by the process—to compile a complete packing list of all the entry-point objects and places that can sustain us en route to 2066. But it has to be done, now that both humanity and the biosphere face risk. Not all the things or places that can help us have been formally acknowledged as landmarks by either group, let alone heralded by both.

New York's oldest tree, for instance, a 134-foot-tall tulip poplar on a steep and almost unknown hillside in Queens, is in itself a capsule history of the entire city in addition to being a natural treasure. Stand next to its deeply furrowed bark and gaze up at its tangled, circular, broken-umbrella crown of branches high overhead, and in the silence of the hillside you realize that this 460-year-old tree, a strong, uninterrupted thread of life that will flourish for at least another

hundred years, towered over any bystanders long before the just-arrived Dutchman Peter Minuit thought he was buying Manhattan Island from the Indians in 1626 (they didn't consider it theirs to sell).

Preservationists may need to look back even further—way, way back. Humanity's story so far doesn't begin a dozen generations ago at Mount Vernon; or four hundred generations ago, when the glaciers retreated and humanity settled down and invented farming and cities; or even before that, with the astonishing paintings on the walls of the Ice Age caves. Instead, it traces straight back to that strange precursor species that more than three and a half million years ago stood upright and left a line of measured and purposeful footprints in the volcanic ash in Laetoli, in Tanzania. This eighty-foot-long track made by three unknown beings no more than four or five feet tall but already walking upright and gazing at a far horizon is among the most awe-inspiring and precious of human artifacts.

It is also past time for preservationists and conservationists to make common cause with the builders of the new. We cheat humanity and stunt lives whenever we put up a structure that is not from the outset landmark-worthy—something to be proud of and worth saving, something to nourish us long after 2066.

What are the practical steps ahead, the footprints we can leave behind on the pathway to 2066? Unlike this country's National Trust for Historic Preservation, the English National Trust for Places of Historic Interest or Natural Beauty is a single organization that dates back to Victorian times and that works, as its website says, "to preserve and protect historic places and spaces—forever, for everyone." It now safeguards a whole lot of each—stately homes, gardens, entire villages, farmland, more than a half million acres of wildlands, and 775 miles of coastline—along with sixty-one pubs.

That kind of arrangement until recently seemed unlikely to appear here, but 2015 saw the emergence of "One NPS," an unprecedented reaching out within the many layers of the National Park Service—historic building curators, historic landscape stewards, wild landscape superintendents—to craft a single vision and a common approach. "Imagine the collective power the Park Service could have if the agency truly performed as a 'system' of national parks and programs," a One NPS manifesto put it, "reaching across divisions and breaking

down silos." It makes eminent sense to do this because, as a friend of the Park Service recently wrote me, "the same agency that manages Yogi and pic-a-nic baskets also administers historic preservation tax credits and the National Historic Landmarks program."

The trick is to get our many conservation and preservation groups, each a bright, shining star, to see themselves as forming a single constellation of protection. They can acknowledge that at the deepest level they both draw from the same well—the galvanizing urgency that overtakes people when they realize that something beloved and nearby, a fixed reference point they've always counted on, is about to disappear forever. Both groups then unlock the same door, reconnecting our personal memories to the larger, longer, unending stories of inheritance and existence.

A single, unifying purpose is at work here. Given that so much is at risk, how fortunate that a train station and a tree, along with the many essential examples that will immediately spring to your mind as you read this, can shake us out of the lonely daydream that the present moment is isolated from all the lives that preceded and will follow us, and all the life around us.

TONY HISS was a staff writer at the *New Yorker* for more than thirty years, and since then has been a visiting scholar at New York University. He is the author of thirteen books, including the award-winning *The Experience of Place* (1991) and, most recently, *In Motion: The Experience of Travel* (2012). His next two books are about a revolution in health care in rural Ecuador, and a sweeping program to create a continent-wide system of connected landscapes throughout North America.

Making Preservation Work for Struggling Communities

A Plea to Loosen National Historic District Guidelines

ANDREW HURLEY

The genius of the "new" preservation paradigm, ushered in by the National Historic Preservation Act of 1966, lay in its capacity to save and to restore viability to endangered buildings at a neighborhood scale through the practice of adaptive reuse. Although the law was not responsible for the financial enticements that ultimately steered investment toward the rehabilitation of crumbling but salvageable buildings, it established criteria for credentialing districts where tax incentives and grant funds could be applied. Through historic district rebranding, thousands of neglected properties across the United States were repaired, spruced up, and repurposed as festival marketplaces, trendy shops, offices, and desirable homes. For all its transformative achievements, a formula designed to spur private investment in buildings with distinctive architectural features produced minimal yields in the nation's poorest quarters. As a result, many urban areas steeped in history have continued to disintegrate, decay, and thin. If historic preservation is to remain a vital force in the enterprise of urban landscape stabilization, historic districts present the most urgent challenge. To meet it, the next generation of preservationists would do well to consider a more flexible, holistic approach, responsive to the redevelopment needs and historical sensibilities of local communities.

> *The next generation of preservationists would do well to consider a more flexible, holistic approach.*

Whereas federal urban renewal and highway-building programs posed the primary threats to intact urban landscapes in the 1960s, abandonment and disinvestment have taken their place as the chief

Despite the much-heralded success of historic preservation as an urban revitalization strategy, many inner-city areas, such as this stretch of North 13th Street in St. Louis, continue to suffer from abandonment and decay. PHOTO COURTESY OF ANDREW HURLEY.

culprits of evisceration in aging communities inhabited by people of color and the impoverished. In Rust Belt cities devastated by the slow bleed of deindustrialization, depletion reached crisis proportions in the early twenty-first century. By 2007, Buffalo and St. Louis staggered under the burden of more than thirty thousand vacant housing units. In Cleveland and Detroit, the corresponding figures exceeded fifty thousand. In each of these examples, vacancy rates approached 25 percent of the total housing stock. "Legacy cities" were not the only places afflicted by the forces of desertion and dereliction; similar processes emptied Indian pueblos of the American Southwest, and Sunbelt communities set adrift by the closing of military installations. Over the last decade, the situation has deteriorated further due to rising levels of income inequality and the mortgage foreclosure crisis, both of which have extended the phenomenon into lower-income suburban subdivisions. For all of the damage inflicted by serrated streetscapes and crumbling buildings, what is truly at stake for people

who remain in these places is the viability of communities as they come under assault from the pressures of population loss, infrastructure collapse, and the breakdown of social supports.

Why has the "new" preservation failed these areas? Part of the answer resides in the difficulty of surmounting the racial prejudices that organize real estate markets and the global economic forces that deflect investment streams from certain regions. But the preservation community shares culpability for peddling a program that has overemphasized architectural aesthetics in its valuation of places. Unfortunately, the physical inventory of many low-income neighborhoods is not easily converted to marketable real estate. Moreover, integrity provisions in National Register nomination guidelines requiring a critical mass of remaining historical inventory preclude eligibility for areas that have lost much of their physical fabric. This stipulation eliminates the prospect of preservation-oriented subsidies for neighborhoods with significant physical attrition. In direct defiance of hard-core conservationist principles, legacy cities have explored "rightsizing" urban design strategies that aim to concentrate populations and infrastructure in constricted development nodes, while simultaneously razing the remnants of older neighborhoods elsewhere. No wonder inhabitants of towns and neighborhoods bypassed by heritage-based revitalization perceive the late twentieth-century preservation paradigm as irrelevant at best and counterproductive at worst.

Betrayed by official formulas promulgated by the U.S. Department of the Interior and implemented by a multitude of state offices, marginalized communities have pursued alternative preservation strategies to leverage the identity-building and agenda-setting power of local heritage. Typically, grassroots preservation is less about protecting buildings than protecting values, traditions, and the underlying structural conditions that generate social capital. When residents of Philadelphia's Mantua neighborhood gathered to memorialize a demolished crack house in May 2014, testimonials elaborated on the local tradition of private home ownership. In Old North St. Louis, the recent conversion of empty lots into food gardens, chess parks, and outdoor exercise stations marked an attempt to maintain public gathering spaces and a measure of self-sufficiency. Some Indian pueblos in New Mexico have long viewed the disintegration of adobe structures

as a natural and time-honored process of returning to the earth what sprang from the earth. Yet they have been adamant about rebuilding according to venerated design principles, including dirt flooring and the spatial arrangement of domiciles to delineate a common plaza.[1] What these disparate communities share is a strong sense of what made places work in the past and why those dynamics still matter.

To reassert its relevance as a tool for revitalization, the preservation movement must find ways to accommodate and reward a wider range of heritage-based revitalization strategies. Fortunately, there are indications of an openness toward potentially useful frameworks. Thinking about historic sites as cultural landscapes has encouraged property managers to focus more on the underlying ecological dynamics supporting an intermingling of natural and human-constructed elements. Likewise, acknowledgement of intangible heritage has directed attention to the rituals, customs, skills, and knowledge systems that sustain cultures across generations. What are needed are formal mechanisms to translate these concepts into official designations that will avail struggling communities to funding streams and professional assistance.

Even in places where the adaptive reuse of vintage structures makes little sense as a comprehensive revitalization strategy, a selective approach to property renovation has merits. Historic preservation's capacity for generating fresh investment, boosting real estate values, and providing marketable job skills make it a valuable instrument for communities to keep in their redevelopment toolkits. For preservation to play a constructive role as part of a multipronged economic recovery program, a few simple policy adjustments are in order. One is to relax integrity criteria in historic district guidelines. Another is to eliminate the requirement that applicants identify a period of significance to which qualifying structures must demonstrate some association. This modification would allow communities to draw from a more expansive palette of historic assets. These relatively minor tweaks represent important first steps toward a more versatile and inclusive approach to conserving and restoring built landscapes in alignment with the planning goals and economic ambitions of marginalized communities.

ANDREW HURLEY is professor of history at University of Missouri–St. Louis. He is the author of *Beyond Preservation: Using Public History to Revitalize Inner-Cities* (2010), which won the National Council on Public History prize for best book in the field in that year. In four other books and more than a dozen articles, Hurley has explored the history, built environment, and preservation of urban places.

NOTE

1. Jamie Blosser and Shawn Evans, "Owe'neh Bupingeh Rehabiltation Project: Challenging the Norms of Affordable Housing and Historic Preservation," in *Proceedings for the Seventh International Earthbuilding Conference,* ed. Cornelia Theimer Gardella, 88–93 (Santa Fe: Earth USA 2013–Adobe in Action, 2013).

Should the NHPA Have a Greater Sense of Urgency?

BRIAN JOYNER

The National Register was developed with the notion of creating an inventory of historic assets that conveyed a sense of who we are as a nation, from the town square to the Supreme Court. Over time, it was determined that fifty years was the point at which a property or site became historic. This fit the existing paradigms of the fields that make up cultural resources: archeology, architecture, and history. Traditionally, the practitioners of those fields considered our historic past from a sober distance, giving due reverence to the grand manse of a founding father, a cradle of our democracy, or flashpoints in the crucible of our national evolution. But history, its effect on or how it is affected by the built environment, is upon us as quick as lightning. It unfolds with such velocity and ferocity that today it seems to occur in between breaths, not eras. This may have always been the case. We are no longer at ease to leisurely consider its impact. Perhaps we never were.

Perhaps the National Historic Preservation Act, in particular the National Register, should create a forum, a place of dialogue about our historic resources. It should engage us in a contemporary examination of what it means to be American. I suggest giving the National Register more urgency. Let's shorten the period of historic significance and lean on the skills of journalism and public history to increase the relevance of the program to the public.

... properties that have achieved significance within the past 50 years shall not be considered eligible for the National Register.
—Criterion Consideration G, the National Historic Preservation Act, as amended

The structure of National Register documentation adheres to a historiography that favors a long view, with well-established antecedents to guide it. Yes, certainly big "H" history—national politics, war, industrial progress, high-end architecture, famous men—but small "h" history as well—small-town main streets, rural farming, homogeneous enclaves—find ample representation in the collected American past. We should not be surprised by this. Consider it myth making: Give us all of the narratives that the nation has co-signed upon, that reify the notions of our history that we are comfortable with, and move them into our national mythology. As John Sprinkle points out in his essay featured in this book, "To Expand and Maintain a National Register of Historic Places," only 3 percent of the ninety thousand National Register nominations have been updated for content, a desperate requirement for the expansion of the inventory, which means that these narratives, however incomplete, become fixed. Codification creates stasis. Stasis is resistant to change, and the best way to forestall it is to make change wait. Like, fifty years.

This is an age of history activism.

The Historic Sites Act of 1935 initially rejected anything "after 1870" as being historic. Between the 1940s and 1950s, clarification of the fifty-year rule came through a series of discussions and documents among the National Parks System Advisory Board and staff related to the agency's Historic Sites Survey. The issues included preference of architectural significance over historical significance, a "twenty-five-year" policy as it related to deceased individuals, and that pesky 1870 date. With that, the fifty-year rule was reaffirmed and codified.[1]

However, buildings are renovated, rehabilitated, or destroyed within fifty years. People die and memories fade. Longevity ≠ significance for the property or the event. Yet, preservation has maintained the fifty-year rule as a practice. Is there a reason that twenty years cannot provide a requisite period of reflection? Or ten years? While there may be no benefit to instantaneously designating a place historic— the rule minimizes the political pressure of designating an event or place as historic by providing objective measures—time alone is not an indication of a site's impact on the American landscape.

Consider a seminal event that shaped the modern preservation

BRIAN JOYNER

movement. The demolition of Penn Station involved a building that was fifty-two years old. Its construction represented the growth of the nation and the city of New York as an industrial power. It represented the nation's aspirations. It was a landmark as soon as it was completed. The shock of its 1963 removal took place against the backdrop of incredible economic growth following World War II, urban renewal, and the suburbanization of the nation. There is historic context for understanding what happened, discussions about how it happened, and the impact of the demolition when it happened. The station's replacement is decried as hideous, which should be beside the point. The bias toward architectural aesthetics created the hue and cry over Penn Station's loss, but it helped spawn a new paradigm for preservation as tool for change.

I believe that this is an age of history activism. Current trends such as pop-up thematic websites, mobile or in-the-moment oral history projects such as StoryCorps and the Philadelphia Public History Truck Project that capture individual stories or the small "h" history of neighborhoods, buildings, local events, and photojournalism provide context and immediacy to the historic narrative.[2] Alan Barth said that newspapers are but the first rough draft of history.[3] Public historians and archeologists are putting themselves on the front lines of history, not waiting to stand a respectful distance from the events before applying their training. They are writing the next draft as it happens. This is because the professionals have ample understanding of the historic context of many of the events occurring. We recognized the significance of September 11, 2001, or the election of Barack Obama as the first African American president immediately. The press knew it immediately; public opinion knew it immediately. This understanding is informed by our historic past and by the training provided to new professionals.

The reason that social justice movements could form so quickly in Ferguson, Missouri, and in Baltimore, Maryland, is because those incidents of overly-aggressive policing had antecedents: the slave patrols that brutally recaptured enslaved people; the post-1880s Black Codes that criminalized African American bodies and places; the unchecked, if not police-sanctioned, extrajudicial violence against people of color, such as the Zoot Suit Riots in 1940s Los Angeles; the

overt display of police violence against protesters during the modern civil rights movement; and the beating of Rodney King in the early 1990s. Front-line journalists document and contextualize the affairs of the day; public historians are not much different. This first draft helps to form the public opinion of historical events; the use of newspapers (virtual and physical) as primary documents by historians speaks to the significance of that initial opinion. Combing through the digital stream and tactile stacks of information, the public historian picks up the thread, provides the context. The Maryland Historical Society and the public history program at the University of Maryland, Baltimore County, are collaborating with the community in creating an ongoing archive of events following Freddie Gray's death.[4] This is the palimpsest of a potential nomination for the National Register.

Furthermore, I make the case that preservation is a tool for social justice. The National Historic Preservation Act was one of the Johnson administration's suite of laws, such as the Civil Rights Act, the Wilderness Act, and Medicare/Medicaid. The 1960s and 1970s were a time of activism, of citizen and federal engagement in the critical issues addressing America. Historic events occurred daily—the moon landing, the counterculture revolution, the sexual revolution, and the assassination of multiple leaders to try and stem the tide of change. All were more threatening changes than the ones our sitting president has offered and which have been met with such irascibility. As a federal program, the National Register should serve the needs of the public. It has done much to reinvigorate our urban cores in the last decades. It can do more to teach us about living in today's increasing diversity and complexity.

BRIAN JOYNER is a resource management professional for the National Park Service (NPS) with experience in public history, engaging communities, and working collaboratively with internal and external partners. Joyner has researched diverse and underserved communities as related to historic preservation and public history, and has produced several publications for the Park Service. The views expressed here are explicitly the views of the author only.

NOTES

1. John Sprinkle covers the administrative history of this topic thoroughly in "'Of Exceptional Importance': The Origins of the 'Fifty-Year Rule' in Historic Preservation," *Public Historian* 29, no. 2 (Spring 2007): 81–103. Specifically, he cites a 1948 report in which the fifty-year rule is affirmed, which is upheld with the 1952 report (p. 84). Elaine Stiles indicates it was in 1952 when the fifty-year rule was set in place to ensure consistency in existing policy. See Elaine Stiles, "*50 Years* Reconsidered," *Forum Journal* 24, no. 4 (Summer 2010): 15–22.
2. The Philadelphia Public History Truck Project serves as a mobile museum dedicated to the story of all of Philadelphia. For more on its efforts conducting oral history documentation, see www.phillyhistorytruck.wordpress.com. StoryCorps provides people with the opportunity to record, share, and preserve the stories of their lives. It has grown from a booth in Grand Central Station in New York to mobile booths traveling the country and a StoryCorps app, with initiatives to record stories of September 11 survivors, military veterans, those suffering from memory loss, the LGBTQ community, and Latino and African American communities. See www.storycorps.org for more information.
3. Alan Barth wrote this in a book review for the *New Republic* 108 (1943): 481, but an earlier version of this statement was made in the *State* (Columbia, South Carolina) on December 5, 1905: "The newspapers are making morning after morning the rough draft of history." See Jack Shafer, "Who Said It First? Journalism Is the First Rough Draft of History," www.slate.com; cf. www.readex.com.
4. This archive is available at www.baltimoreuprising2015.org.

Preservation and Invisibility

JAMIE KALVEN

I enter the conversation about the future of historic preservation through a particular door. As a writer and organizer, I witnessed and documented the unfolding of Chicago's "Plan for Transformation": the erasure of the city's massive concentrations of high-rise public housing and the forced relocation, under the flag of "mixed income redevelopment," of those for whom they were home. That experience—I have referred to it elsewhere as "the unmaking of place"—informs my thinking about historic preservation and my sense of what questions are worth pursuing.[1]

Chief among them: What responsibilities do preservationists bear to the unpreserved, to places and populations that have been disappeared? This question invites a rethinking of the role of historic preservation that could yield a more inclusive movement, one that speaks to the experiences and needs of those of our fellow citizens—the displaced, the nomadic, the urban refugees—who struggle to remain visible against forces pushing them ever deeper into invisibility.

As a newcomer to the field, one who is still learning its idiom, history, and traditions, I feel the need to be explicit about my assumptions:

The central focus of preservation should be on places rather than buildings.

Places are dynamic. So we need to think in ecological terms about the mesh of relationships that support their vitality, adaptability, and resilience. It is those qualities, above all, that we should take care to preserve.

If the practice of preservation can be understood as historical inquiry by way of the built environment, then such inquiry also needs to attend to the ways places are informed by absences—by that which has been rendered invisible yet continues to exert a strong gravitational field.

My proposal flows from these assumptions: the practice of historic preservation should directly engage the ways structural inequalities in our society are expressed, reinforced, and hidden by the built environment.

I am not proposing this as an abstract exercise. There are things that can be learned only on the ground, as Wendell Berry once put it, by subjecting oneself to one's subject. Such an approach requires immersion in particular communities suffering varying degrees of abandonment. It requires active inquiry into the dynamics that support life and those that stunt life in those places. And it requires engagement with local energies and interests in the debates and controversies that are the medium for problem solving and innovation in a functioning democracy.

It is critically important to recognize the efficacy of disappearing places and populations.

This proposal arises out of the endlessly rich negative example of Chicago's "transformation." The dismantling of high-rise public housing has had grave ramifications for many communities—above all, those it destroyed but also those forced to absorb waves of displaced public housing tenants—as well as for the city as a whole.

Whatever else one might say about the process, it is critically important to recognize the efficacy of disappearing places and populations. It works. It is a key tool for enforcing inequality and, at the same time, for obscuring the realities of inequality, thereby enabling us to accept the unacceptable and tolerate the intolerable. The restructuring of the city is thus a remapping of our moral imaginations, affecting what we can see and what we cannot, how issues are constructed and the parameters within which they are engaged.

Yet historic preservationists were largely absent from the public debate about the plan and the resistance to its implementation. The

two exceptions to this generalization that come to mind only add to its force. First, preservationists have been supportive of the initiative to establish a National Public Housing Museum in Chicago.[2] Second, they intervened with respect to the Lathrop Homes, the last major redevelopment project in the Chicago Housing Authority's portfolio, arguing that its architecture and landscaping are historically significant. Both are instances, however welcome, of traditional preservation advocacy. What preservationists did not do is engage the realities on the ground as perceived and experienced by residents or contribute to a process by which the things they valued about their communities and wanted to preserve were acknowledged and given weight.

The absence of preservationist voices made it all the more easy for crude, self-serving arguments to prevail: after decades of abandonment by the city-as-landlord, the city-as-reformer declared high-rise public housing a monolithic failure. "Anything," it was said, "is better than this." That logic gave policymakers carte blanche to pursue not just demolition of structures but the erasure of place.

There was no space in the official narrative for the ways in which the identities of residents were woven into the places where they lived or for the forms of meaning and beauty they had created there. On the contrary, residents were told that their homes were being destroyed for their own good and that their attachment to place was pathological.

I do not mean to suggest that the robust involvement of preservationists would have affected the outcome. Maybe so. Probably not. But it was the right fight, the necessary fight, and it would have deepened the strategic capacity of the movement in the future to resist abandonment and ultimately invisibility. For the great question bequeathed by Chicago's experience is what form would a redevelopment process that honored residents' identities, memories, and sense of place take?

I am thus brought, somewhat to my surprise, to the proposition that the future of the historic preservation movement turns on the recognition and acceptance of its underlying radical nature. Radical, that is, in the sense of going to the root and calling things by their true names.

JAMIE KALVEN is a writer and human rights activist in Chicago. He is the author of *Working with Available Light: A Family's World after Violence* (1999) and the editor of *A Worthy Tradition: Freedom of Speech*

in America (1988), by Harry Kalven Jr. Since the 1990s, Kalven has worked in and with inner-city neighborhoods, as consultant to the resident council of the Stateway Gardens public housing development and the Henry Horner Homes.

NOTES

1. Remarks at the James Marston Fitch Charitable Foundation Symposium, "The Accidental Preservationist: Artists, Artisans, Outliers, and the Future of Historic Preservation," October 17, 2014. See "The Unmaking of Place," Invisible Institute, www.invisible.institute.
2. See the National Public Housing Museum website at www.nphm.org.

Repeal the National Historic Preservation Act

THOMAS F. KING

Here's my proposal for the next half century of historic preservation: Congress should repeal the National Historic Preservation Act (NHPA)—and its ancestor, the Historic Sites Act of 1935—and let us try to build something better, unencumbered by NHPA's simplistic assumptions and bureaucratic excrescences.

The NHPA was enacted because:

The NHPA and the way it has been implemented have created a Frankenstein monster.

1. Historic places—notably including urban neighborhoods, rural cultural landscapes, and the ancestral living, burial, and ritual places of Native Americans (who, however, were barely visible in NHPA's foundational literature)—were being destroyed right and left by the forces of development unleashed in the wake of World War II;

2. Existing law—the Historic Sites Act, the Antiquities Act, and the Reservoir (Archaeological) Salvage Act—did little or nothing to control the damage; and

3. The federal government had done little to encourage the public to preserve anything.

The NHPA was an effort to address these problems, and it has done some good. It is especially appreciated by those of us who—like this author—have built careers in its practice.

But the NHPA and the way it has been implemented have created

a Frankenstein monster, and it's time—past time—to put a stake in its heart.

Why? Well, first consider the fundamental question of why we want to preserve historic places. Of course, there are many reasons, ranging from the practical—that in the interests of frugality we ought to keep using what we've got—to the ethereal—that many historic places are beautiful, intellectually challenging, and spiritually engaging. But the core value of historic places, I think, from which everything else springs, is that they represent aspects of our valued cultural environments. Those environments, comprising the land, air, water, living things, institutions, buildings, and structures we're used to, and the relationships among them, are what give us our identities. They evolve, they change, they must sometimes be changed (as, for example, when we abandon a long-cherished institution like homophobia), but there's psychic risk in, a psychic cost to, changing them, and it shouldn't be done willy-nilly.

So we enact laws like the NHPA to encourage people to value the cultural environment, and to discourage government at least from destroying it without consideration.

But a law like the NHPA, addressing only one tiny aspect of the cultural environment, risks elevating that aspect at the expense of others, creating a distorted system that actually works against the purposes it is intended to serve. That, I think, is what we have created under the NHPA.

The major distortion built into the NHPA is that it has at its core a "national register" of historic places. There are three problems with this institution. First, "historic places" represent only a tiny part of the cultural environment. By emphasizing them, we automatically de-emphasize other parts, such as culturally valued social institutions, plants and animals, lifeways, and belief systems, except where they can be related somehow to historic places.

Second, the register and its attendant systems must be managed, and we have developed a vast, clumsy bureaucracy to do it. This bureaucracy comprises elements of the National Park Service (NPS)—an organization that does fine work in National Parks but relates poorly to the outside world—together with State and Tribal Historic Preservation Officers (SHPOs and THPOs), "certified" local

governments, the Advisory Council on Historic Preservation (ACHP), Federal Preservation Officers (FPOs), and a host of nonprofit and often rapaciously for-profit corporations, each with its own narrow authorities and interests, each interested first and foremost in institutional survival. The purposes this "system" was theoretically designed to serve have become hard even to envision; maintaining and manipulating it (or particular pieces of it) has become the main functions of its various parts.

Third, the whole operation is inherently elitist. A register of places judged worthy by a high government official (the Secretary of the Interior's representative) based on analyses by professional (though often not very seasoned) historians, architects, and archaeologists has no chance of reflecting the cultural values of the nation's communities—particularly communities without the resources to hire their own professionals and lawyers.

Let me briefly suggest what I think might replace the NHPA. Could we have a law-based system designed to protect, maintain, and promote respect for the cultural environment, as opposed to the itsybitsy, narrowly defined aspects of it represented by National Register–eligible chunks of real estate? I think we could.

I am a fan of Randolph Hester's notions of "ecological democracy" and "sacred structure," though I can quibble with his terminology. Notably in Manteo, North Carolina, Hester and his students worked with the community to define what aspects of the cultural environment were perceived as important to those who lived there. They then helped the community's political leaders build a development and land management system around those aspects, which they called Manteo's "sacred structure."[1]

It seems to me that we could build something like Hester's approach into federal law to replace the National Register. Let the federal government help each community, neighborhood, tribe, or other group define its own "sacred structure" (perhaps using less highfalutin terminology), use it as a key element in its local planning system, and require federal agencies to respect it.

Would this be a perfect system? Of course not. Like any other, it would be subject to political manipulation, so rules would have to be developed to keep such manipulation in check. As Hester himself has

THOMAS F. KING

pointed out, even Manteo's sacred structure has not been immune to gentrification and resegregation.[2] And something would need to be done about things like archaeological sites in which professionals are interested but about which the local community might not give a flying fig.

I think, however, that Hester's approach is an alternative worth considering, and there are doubtless others. What we should not do is take the NHPA as holy writ and close our eyes to potentially superior alternatives.

Fifty years is long enough; let's consider real change.

THOMAS F. (TOM) KING is a consultant and writer based in Silver Spring, Maryland, who has practiced in and around historic preservation since the 1960s. He holds a PhD in anthropology, with research in western North America and the Pacific Islands, and has devoted his career to heritage management and environmental impact assessment. He has authored, coauthored, or edited ten textbooks, numerous journal articles, a novel, and a nonfiction trade book, and authors a blog at www.crmplus.blogspot.com.

NOTES

1. Randolph Hester, "Sacred Structures and Everyday Life: A Return to Manteo, North Carolina," in *Dwelling, Seeing, and Designing: Toward a Phenomenological Ecology,* ed. David Seamon, 271–97 (Albany: State University of New York Press, 1993). See also Randolph Hester, *Design for Ecological Democracy* (Cambridge, MA: The MIT Press, 2006). For a short summary of Hester's approach, see "Manteo Sacred Site Mapping" at www.planningtoolexchange.org.
2. Hester, "Sacred Structures," 295.

Cronocaos

...

REM KOOLHAAS

Architects—we who change the world—have been oblivious or hostile to the manifestations of preservation. For instance, since Paolo Portoghesi's 1980 *Presence of the Past* exhibition, there has been almost no attention paid to preservation in successive Venice Architecture Biennales.

Our firm, the Office of Metropolitan Architecture (OMA) and AMO have been obsessed, from the beginning, with the past. Our initial idea for our 2010 exhibit *Cronocaos* was to focus on twenty-six projects that have not been presented before as a body of work concerned with time and history.[1] In one room of the exhibit we showed the documentary debris of these efforts. The year 2010 was the perfect intersection of two tendencies that so far have untheorized implications for architecture: the ambition of the global task force of "preservation" to rescue larger and larger territories of the planet, and the (corresponding?) global rage to eliminate the evidence of the postwar period of architecture as a social project. In a second room we showed the wrenching simultaneity of preservation and destruction that is destroying any sense of a linear evolution of time. The two rooms together document our period of acute CRONOCAOS."

Embedded in huge waves of development, which seem to transform the planet at an ever-accelerating speed, there is another kind of transformation at work: the area of the world declared immutable through various regimes of preservation is growing exponentially. A huge section of our world (about 12 percent in 2010) is now off-limits, submitted to regimes we do not know, have not thought through, and cannot influence. At its moment of surreptitious apotheosis,

preservation does not quite know what to do with its new empire.

As the scale and importance of preservation escalate each year, the absence of a theory and the lack of interest invested in this seemingly remote domain become dangerous. After thinkers like John Ruskin and Eugène Emmanuel Viollet-le-Duc, the arrogance of the modernists made the preservationist look like a futile, irrelevant figure. Postmodernism, in spite of its lip service to the past, did no better. The current moment has almost no idea how to negotiate the coexistence of radical change and radical stasis that is our future.

As we head toward a climax of preservation, ambiguities and contradictions build up:

- Selection criteria are by definition vague and elastic, because they have to embrace as many conditions as the world contains.

- Time cannot be stopped in its tracks, but there is no consideration in the arsenal of preservation of how its effects should be managed, how the "preserved" could stay alive and yet evolve.

- There is little awareness in preservation of how different cultures have interpreted permanence, or of the variations in material, climate, and environment, which in themselves require radically different modes of preservation.

- With its own undeclared ideology, preservation prefers certain authenticities. Others—typically, politically difficult ones—it suppresses, even if they are crucial to understanding history.

- Through preservation's ever-increasing ambitions, the time lag between new construction and the imperative to preserve has collapsed from two thousand years to almost nothing. From retrospective, preservation will soon become prospective, forced to take decisions for which it is entirely unprepared.

- From a largely cultural concern, preservation has become a political issue, and heritage a right—and like all rights, is susceptible to political correctness. Bestowing an aura of authenticity and loving care, preservation can trigger massive surges in development. In many cases, the past becomes the only plan for the future . . .

- Preservation's continuing emphasis on the exceptional—that which deserves preservation—creates its own distortion. The exceptional becomes the norm. There are no ideas for preserving the mediocre, the generic.

The march of preservation necessitates the development of a theory of its opposite.

In a global groundswell of revulsion, one particular genre has escaped the embrace of preservation. Open season has been declared on postwar social architecture. At its zenith, a strong public sector created the conditions in which architecture as a social project could flourish. At its nadir, a public sector, debilitated by the market, destroys it. There is now a global consensus that postwar architecture—and the optimism it embodied about architecture's ability to organize the social world—was an aesthetic and ideological debacle. Our resignation is expressed in the flamboyant architecture of the market economy, which has its own built-in commercial expiration date.

Just like modernization—of which it is part—preservation was a Western invention. But with the waning of Western power, it is no longer in the West's hands. We are no longer the ones who define preservation's values. The world needs a new system mediating between preservation and development. Could there be the equivalent of carbon trading in modernization? Could one modernizing nation "pay" another nation not to change? Could backwardness become a resource, like Costa Rica's rainforest? Should China save Venice?

The march of preservation necessitates the development of a theory of its opposite: not what to keep, but what to give up, what to erase and abandon. A system of phased demolition, for instance, would drop the unconvincing pretense of permanence for contemporary architecture, built under different economic and material assumptions. It would reveal tabula rasa beneath the thinning crust of our civilization—ready for liberation just as we (in the West) had given up on the idea.

REM KOOLHAAS, a Dutch architect, architectural theorist, and urbanist is director of the Office for Metropolitan Architecture and

AMO, the firm's research arm; he is also a Professor of Practice and Urban Design at Harvard University's Graduate School of Design. In 2000, he was awarded the Pritzker Architecture Prize, for career achievement in the art of architecture.

NOTE

1. For a discussion of the exhibition, see "An Architect's Fear That Preservation Distorts," www.nytimes.com.

Whose History, Whose Memory?

A Culturally Sensitive Narrative Approach

NA LI

Over the last fifty years, the focus of historic preservation has shifted from the saving of individual elite houses to the preservation of neighborhoods, landscapes, sites of memory, and sites of production. Engaging voices of all sorts, historic preservation has moved from a staid, traditionalist field toward becoming an active social movement that embraces the conflicting and emotional characters of urban built environments, and has therefore become an integral part of urban planning practices.

In recent years, historic preservation has begun to ask some important and urgent questions. What is missing in preserved urban landscapes, and what is counted as authentic history? Whose past and whose memory do we try to interpret and preserve, and which versions of history do we choose to remember, or neglect? More diverse and inclusive interpretations of history bring a renewed attention to the ordinary and the vernacular. So interpreting and preserving the past often involves the negotiation and renegotiation of meanings and values, through signs, symbols, artifacts, and landscapes, along with political and power struggles.

However, even with a greater emphasis on public participation, a well-intentioned participatory process may flounder in the face of local culture. Often, the public arrives at the planning table with different agendas, cultural values, and personal priorities that are often different from what we, as professionals, have programmed. Therefore, emotional sensitivity based on understanding the power structures and cultural norms within a particular community are critical. The challenge here is twofold: first, how to communicate and

balance competing values through storytelling, and second, how to accomplish this in culturally diverse settings.

A culturally sensitive narrative approach (CSNA) addresses this challenge. With its qualitative and critical spirit, CSNA focuses on intangible, immeasurable, and invaluable aspects, and works best in communities that have an evolving social history. I suggest the following steps for this approach:

1. Background information collection: Collect quantitative and qualitative data on demographics, geography, economic development, architectural styles, material culture, and most important, social history.

2. Interpretive analysis: Milestones in preservation planning policies, the role of the public, the results of public participation, and pivotal events influence the outcome of those policies.

3. Cultural immersion and field investigations: These are largely ethnographic, and can be carried out at different scales based on resources available.

4. Building narratives: Identify key interview respondents, conduct oral history interviews, preferably in the field, and construct narratives.

5. Reframing preservation planning policies: Distill themes from different narratives, and incorporate those themes to reframe preservation policy making; use local perspectives as the basic frame of reference; and validate the analysis with the stakeholders though public meetings.

6. Implementing new preservation planning policies: Keep the communicative interface between and among stakeholders (especially residents) open, and keep public debates alive.

The above six steps form an organic process, and can be carried out at different scales. At the heart of this process lies a shared authority in urban space: rather than abstract policy makers and architectural artists (as they are often viewed by the general public), preservation planners move toward a format of storytelling and oral history, to

elicit the insiders' views, emotions, and, above all, collective memories of the place. Oral history as a methodology consists of life history interviewing and historical events analysis, both of which deal with organic memory. Oral history, which is sometimes viewed with suspicion, may provide less verifiable factual evidence but may also illuminate the psychology of a community. There are many cultures within which storytelling is commonly adopted to pass on knowledge and share collective memory, and this bears special significance for those who inherit a strong oral tradition. Under such circumstances, providing venues for storytelling may serve to highlight different histories and their connections to built forms that are most meaningful for different groups of people. During this process, preservation planners will need to attend to how stories are told and emotions evoked.

We need to allow residents to tell their own stories..

More concretely, oral history provides the most obvious academically tested means of engaging storytelling in the process. Scholars advocate using oral history for collective grassroots experience, to include the collective experience of marginalized groups; Linda Shopes argues for essentially the same process—a reflective, critical approach to memory in the context of community history.[1] Dolores Hayden suggests incorporating socially marginalized voices for this approach.[2] All strive for a more inclusive and participatory approach to make the invisible visible. Unlike tangible sources, which often go through a single interpretation, the symbolic and intended meaning of an oral history make it accumulative over the generations and open to multiple interpretations. To achieve this, we need to spend a substantial amount of time in the field, with humility and diligence, and allow residents to tell their own stories at their own pace and in their own terms.

Central to CSNA are first, building a critical case; second, understanding the local, "insider" culture; and third, building and analyzing place-centered narratives. Bringing preservation planning and public history perspectives together, CSNA demonstrates that the more tightly collective memory is integrated in communicative planning through narratives or storytelling, the greater the likelihood

that urban landscapes can be identified with communities' senses of place, and that preservation will become an honest inquiry of history. In this shared inquiry, we can address the emotionally compelling issues embedded in an urban built environment without compromising our academic or professional rigor. In this process, the value of preservation increases as places elicit emotions, fragile and often difficult histories, and the relationships between communities and landscapes.

The bottom line is that urban landscapes should be interpreted and preserved as public history, and the most efficient way to achieve this seems deceptively simple and matter of fact: local residents should be encourage to record their memories of their neighborhoods. Our task, therefore, is to help the public better understand the environment in which they reside, to expand their individual perspectives to become collective ones, and, ultimately, to preserve a past to which the public is emotionally committed.

NA LI is a research fellow of the Institute for Advanced Studies in Humanities and Social Sciences at Chongqing University, and an adjunct professor at Shanghai Normal University, China. She is the author of *Kensington Market: Collective Memory, Public History, and Toronto's Urban Landscape* (2015). Na Li is at the forefront of efforts to establish public history in China. Her work contributes to a better understanding of historic preservation and public history at an international scale.

NOTES

1. Linda Shopes, "Oral History and the Study of Communities: Problems, Paradoxes, and Possibilities," *Journal of American History* 89, no. 2 (2002): 588–98.
2. Dolores Hayden, *The Power of Place: Urban Landscapes as Public History* (Cambridge, MA: MIT Press, 1997).

"They That Go Down to the Sea in Ships"

Putting Life into Maritime Preservation

JAMES M. LINDGREN

Maritime preservation began with Oliver Wendell Holmes's successful effort in 1830 to save USS *Constitution,* but a century of setbacks followed. Then, with Carl Cutler bringing the whaleship *Charles W. Morgan* to the Mystic Seaport Museum in 1941, Karl Kortum opening the San Francisco Maritime Museum in 1951, and Peter Stanford founding New York's South Street Seaport Museum in 1966, preservation took root.[1] After president Lyndon B. Johnson signed the National Historic Preservation Act, landside preservationists grasped NHPA's possibilities, and while many fought urban renewal's destructiveness, others extended it to promote the new social history, vernacular culture, and an emerging environmentalism. Maritime preservation, however, lagged behind the landside movement by twenty years and lost much in the interim. Facing unique challenges, maritime organizations received comparatively little federal aid or national attention. America's founding, identity, and prosperity had originated in the seas, but as their historical artifacts, culture, and waterfronts vanished, too few Americans took notice. Fifty years after NHPA's passage, maritime preservationists recognize that sea culture must not be consigned to museums; it must be kept alive and oriented toward people so that the past can instruct the present and the future. The task is urgent, and even worldwide, but the necessary supporters and funds remain elusive.

Sea culture must not be consigned to museums.

In maritime studies, Jesse Lemisch pioneered the new social history. "Maritime history, as it has been written," he suggested in 1968,

"has had as little to do with the common seaman as business history has had to do with the laborer. In that mischianza of mystique and elitism, 'seaman' has meant Sir Francis Drake, not Jack Tar; the focus has been on trade, exploration, the great navigators, but rarely on the men who sailed the ships."[2] With that, historians pushed preservationists to refocus. South Street introduced the port's overlooked sailors, laborers, and craftsmen through a Sidewalk History Program (1976). Mystic Seaport launched the Paul Cuffe Memorial Fellowship (1989), promoting the study of African Americans and Native Americans. In its first decade, thirty-four fellows helped reinterpret the village and fleet. As a result, *Morgan*'s story included more seamen, artisans, and even inhabitants of faraway places.

Preservationists also protected everyday vessels. In 1960, the iconic *Constitution* became a National Historic Landmark, but in 1966, *Charles W. Morgan*, the nation's last wooden whaler (1841), and San Francisco's *C.A. Thayer*, a rare lumber schooner (1897), became the first floating commercial vessels so named. Other significant vernacular ships, including San Francisco's *Alma*, a scow schooner (1891), and Mystic's *L.A. Dunton*, a Gloucester fishing schooner (1921), joined them and illustrated their crews and culture.

But the National Register's standards were often unrealistic regarding ships, because most had been so changed that their original materials or character were often lacking. Only forty-six vessels were listed a decade after the register's creation. Between 1969 and 1978, a mere 1 percent of federal grants for historic properties went to maritime projects. Losses greatly exceeded wins. In 1979, National Park Service (NPS) registrar James Delgado reported that the number of surviving historic ships—some 270, mostly naval—represented "less than one-tenth of 1% of the vessels built in the U.S." Consequently, in 1974 senator Edward Kennedy first proposed special funding and a ship register, but the National Trust and NPS undermined the bill.[3]

South Street president Peter Neill lamented in 1988 that that was "a symptom of national indifference to our maritime patrimony. The total Congressional investment in the preservation of maritime resources [consisted] of one $5 million appropriation in 1977 that was divided among 135 projects in 33 states."[4] Preserving floating ships is unique because adequate maintenance and repeated restoration are

often cost-prohibitive. As skeptics say, "A ship is a hole in the water into which you pour money." In 1993 the National Trust even closed its short-lived maritime office.

Others emphasized local action. Mystic's John Gardner, the guru of small boatbuilding, wanted to recreate the craftsman tradition he had learned in Maine and in 1970 established educational programs. He believed (as did NHPA backers in 1966) that preservation has "got to enrich our lives in the present and in the future."[5] By building and sailing replicas, Gardner's classes nurtured creativity, participation, and maritime culture.

The Waterfront Historic Area League (WHALE) of New Bedford, Massachusetts, shared Gardner's grassroots approach. Dispirited by the New Bedford Whaling Museum's reluctance to save its port neighborhood, WHALE began creating historic districts in the mid-1970s, and established a national park in 1996. Resisting gentrification, the league rallied to protect the city's fishing fleet (New England's largest) and kindled appreciation of its people and culture. In tow, the whaling museum shifted its program. Having once glorified the whale hunt that enriched WASP merchants and masters, it now included people of color and whale conservation.

Maritime preservation today is still treading water, as in the case of two National Historic Landmarks. While the NPS allowed San Francisco's *Wapama*, the nation's last wooden steam schooner (1915), to go to the breakers in 2013, the state of Hawai'i is threatening *Falls of Clyde*, the last four-masted, iron-hulled Indiaman (1878). Even South Street, which in 1998 was designated by Congress as "America's National Maritime Museum," was at death's door after misguided development, mismanagement, and disaster (9/11 in 2001, and Hurricane Sandy in 2012). In 2015, as the museum struggled to survive, the National Trust placed the seaport on its list of the eleven most endangered sites.

Money is often the issue. Organizations rest on four legs: philanthropy, program revenue, membership, and government aid. Today, direct government funding is problematic. But why not heritage tax credits, whereby taxpayers can earmark money for federal, state, or local causes, as they can on a 1040 for the Presidential Election Campaign Fund? Host cities must also step in, perhaps by setting up tax-based cultural development corporations. Public education is

JAMES M. LINDGREN

still paramount, whether through schools, experiential programs, or membership. In all, the advances in maritime preservation that began with the NHPA have bettered the nation, but most organizations are stretched. As it says in Psalm 107:23, "They that go down to the sea in ships" still await a safe harbor.

JAMES M. LINDGREN is professor of history at SUNY Plattsburgh, and the author of *Preserving South Street Seaport* (2014), *Preserving Historic New England* (1995), and *Preserving the Old Dominion* (1993). His *Preserving Maritime America: Public Culture and Memory in the Making of the Nation's Great Marine Museums* is forthcoming. He earned a PhD in U.S. history at the College of William and Mary in 1984.

NOTES

1. James M. Lindgren, "Preserving Maritime America: Public Culture and Memory in the Making of the Nation's Great Marine Museums" (forthcoming).
2. Jesse Lemisch, "Jack Tar in the Streets: Merchant Seamen in the Politics of Revolutionary America," *William and Mary Quarterly* 25 (July 1968): 372.
3. Dick Sheridan, "Port of Missing Ships: Whatever Happened to the South Street Dream?" *New York Daily News*, March 26, 1989; James M. Lindgren, *Preserving South Street Seaport: The Dream and Reality of a New York Urban Renewal District* (New York: New York University Press, 2014), 110–11.
4. Peter Neill, "Who Cares about Historic Ships?" *New York Times*, August 2, 1988.
5. Owen Thomas, "Small Wooden Boats Make Waves Again," *Christian Science Monitor*, April 26, 1998.

Preservation toward Conservation

RICHARD LONGSTRETH

The practice of historic preservation in the United States has long been partial to inclusivity. During the nineteenth century and the first half of the twentieth century, the prevailing prejudice favored buildings that were considered old, focusing on work of the colonial and federal periods, with occasional forays into the antebellum decades. Within those parameters, interest was wide-ranging. For every exceptional property—a Mount Vernon or an Independence Hall, for example—there were many others that were venerated for their typicality and often for their historic value to the communities in which they stood. From the remnants of Spanish colonial and Mexican settlements in the American Southwest to the early dwellings and houses of worship in New England; from the buildings documented by architects and those published in the *White Pine Series* to the images of architecture and landscape propagated by Wallace Nutting; from the work carefully selected by William Sumner Appleton for acquisition by the Society for the Preservation of New England Antiquities to those moved to create museum villages in the Midwest and Plains states, representational qualities prevailed over exceptional ones.[1] The majority of work so identified was by then rare, even threatened with extinction, but the attribute most often touted was how these examples embodied what were once common patterns.

A fascination for the typical broadened dramatically in two basic ways during the 1960s and 1970s, facilitated by passage of the National Historic Preservation Act of 1966. The National Register of Historic Places that was established by the act enabled the listing of properties no less than fifty years old—an extraordinary temporal frame

at that time—and gave emphasis to local significance. The criteria, which continue to mark the standard at all levels nationwide, were intentionally broad so as to capture "everything worth preserving," in the words of the register's first keeper, William Murtagh.[2] With the rise of concern for everyday activities and cultural patterns among historians of many kinds at more or less the same time, the scope of work listed has extended far beyond that envisioned by those who crafted the register's criteria in the first place. From a Japanese bathhouse in Seattle to a fire tower in the

preservationists . . . need to set their sights on broadening their impact through a holistic approach . . .

Adirondacks; from fishing craft in the Chesapeake to houses erected by Norwegian immigrants in Wisconsin; from a gas station in Iowa to a night club pivotal to the emergence of gay rights in New York, properties eligible for listing on the National Register encompass a spectrum that addresses historical significance in virtually all of its tangible dimensions.

Given our embrace of so many manifestations of the past, one might deduce that the American landscape is in an extraordinary state of preservation. Conversely, the long-standing European prejudice toward monumental architecture—cathedrals, palaces, castles, and fortified towns—could lead one to believe that ordinary fabric of any vintage, save that in protected districts, would be neglected. In fact, the situation is, of course, just the reverse. Many American communities have been ravaged by changes that have unnecessarily shown little regard for the historic context into which they are inserted, while European counterparts often exhibit a greater sense of continuity. Thousands of buildings that could enjoy at least another century of productive use—many of them far better constructed than their counterparts today—are demolished or reach a state of serious neglect each year. Why? The penchant for newness remains deeply embedded in American culture. New buildings are ostensibly better than old—a belief that has received fresh, if misguided, impetus from the imperatives of energy conservation. Even most remodeling projects are fashioned to display modern attributes, not historic ones. To be sure, a great surge of interest in and respect for the physical past

has occurred in the United States over the past fifty years, but this enthusiasm affects only a small fraction of what could be preserved. In Europe, on the other hand, the practice of maintaining, repairing, and replacing old fabric more or less in kind is widespread, affecting far more of the built environment than that which is officially protected. What we term "historic preservation" in the United States is elsewhere part of a much larger phenomenon called "conservation."

Beyond its role in protecting the natural environment, "conservation" is known in this country as a means of keeping certain salient qualities of a place. For some decades many communities have used conservation districts to ensure that height, setback, density, function, and other factors associated with zoning are maintained. This practice has been found to be especially beneficial in residential areas where pressures for more intense development are strong; however, this form of conservation does not ensure that the character of a place is preserved. Other calls for "conservation" have been fuelled in recent years as a counterthrust to the regrettable tendency among a number of state historic preservation offices and even the National Park Service to treat certified rehabilitation for tax credits more as a restoration program than as the rehabilitation program it was intended to be. "Loosen up!" cry many proponents of economic revitalization. Much the same call for relaxing regulations has come from advocates of rehabilitating low- and moderate-income housing. But without attention to the details of a building—its doors, windows, masonry, woodwork, ornamental embellishments, and the like—the character of its design can be lost. Conservation needs to be focused on details as well as general qualities.

Although it is hard to find strong national leadership in the field today, preservationists at every level in both the public and private sectors need to set their sights on broadening their impact through a holistic approach to conservation that encompasses all scales—from moldings and hardware to general matters of form and space—and embraces continuity while allowing for needed change. As in Europe, this ethic should be broad-based—a natural way to maintain or revitalize properties of all ages—and needs to become a common way of doing things among homeowners, the business community, designers, and artisans. This is no mean order. It requires a transformation

RICHARD LONGSTRETH

of the way we as a culture think about our environment, and an eschewal of many long-held habits. A Herculean task indeed, but one that can be accomplished if the steps taken to conserve the natural environment over that past half century are any indication. Does our own habitat deserve anything less? It is up to those who are dedicated to historic preservation to take the lead. No one else will. A major portion of our built environment is a stake.

RICHARD LONGSTRETH is an architectural historian and a professor at George Washington University, where he directs the program in historic preservation. He has written extensively on the history of architecture in the nineteenth and twentieth-century United States, including most recently *The Department Store Transformed, 1920–1960* (2010). A longtime contributor to the preservation field, Professor Longstreth has held leadership positions with the Society of Architectural Historians, the Vernacular Architecture Forum, Preservation Action, and the Frank Lloyd Wright Building Conservancy; from 1989 to 1994 he was a member of the National Historic Landmarks Advisory Group.

NOTES

1. Launched in 1914 under the auspices of two associations of wood manufacturers, the *White Pine Series of Architectural Monographs* was issued bimonthly. Its pages contained a wealth of documentary photographs of eighteenth- and early nineteenth-century American domestic architecture. During the 1920s its parameters expanded to include other building types. In 1933 the series became part of *Pencil Points* (later *Progressive Architecture*).
2. Conversation with author, Washington, DC, August 1978.

Historic America—and the Unremarked Rest

DAVID LOWENTHAL

Preservationists need to consider how registering and sequestering specific chosen sites and structures affect the stewardship of the national landscape as a whole. I served on an English Heritage committee that had previously been devoted only to parks and gardens and then had expanded to include landscapes. The parks and gardens people were troubled by us landscape folk. "We nominate scores or maybe hundreds of sites," they charged, "but you people want to embellish the whole country; you are too expensive." They were right; our concern was all England.

Preservationists inevitably pervert the past they celebrate..

My concern now is for all America. As with my English parks and gardens colleagues, American preservationists select a finite number of sites and structures for admiration and protection. How do these choices alter the way we perceive the rest of the country, presumably lacking sufficient historic merit for nomination? Are the preserved sites venerated in contrast to the forgettable remainder? Are they adored as precious jewels for occasional worship amid the quotidian banality of their modern surroundings? As with wilderness, similarly specially protected in the wake of public outrage against the loss of iconic landmarks, in the 1964 Wilderness Act those who preserve cultural artifacts stress the rare and the special at the risk of demeaning the places where we perforce pass most of our lives and form our tastes.[1]

Preservationists inevitably pervert the past they celebrate, for setting it apart and protecting it also homogenizes it. The segregation of

the past is not a new problem, nor one peculiar to America. But it is especially egregious in new-settled lands. The felt impress of human habitation there is relatively scanty and recent. And mobility and modernization preclude an enduring intimacy with locale. "We corrupted Old-Worlders are much more sloppy and imprecise with our ancient monuments; we have lived with them for centuries," the British architectural historian Reyner Banham remarked of American historic preservation in 1981.[2] While Americans characteristically accorded awesome respect to their scant antiquities, the English dealt casually with their more substantial legacy, and the French and Italians, surfeited by past remains, more casually still. In the mid-nineteenth century, John Ruskin noted, "Abroad, a building of the eighth or tenth century stands ruinous in the open street; the children play round it, peasants heap their corn in it, the buildings of yesterday nestle about it, and fit their new stones into its rents. No one wonders at it, or thinks of it as separate, and of another time; we feel the ancient world to be one with the new. . . . On the Continent, the links are unbroken between the past and present, [whereas] in England [we] have our new street, our new inn, our green shaven lawn, and our piece of ruin—a mere specimen put on a bit of velvet carpet."[3]

Today's historic America, if seldom ruinous, is nonetheless a congeries of carpeted specimens. Rescued by the bulldozer from the unremarked present into ostentatious antiquity, not only are they segregated from their hugger-mugger surroundings, they are also rejigged by protection and display to become more and more alike. Present-day intent and artifice homogenize the past as "The Past" rather than as the highly different pasts they actually were. Whether antiquated or modernized, idealized or domesticated, the past gets set apart as an indiscriminate whole. Its multiform segments merge into generalized pastness.

To be sure, much that is past does have a family likeness. Things of similar material weather in roughly similar ways, though agency and pace differ with locale. Obsolescence also homogenizes; relics now functionally useless all feel anachronistic, whether ten years out of date or ten centuries. But above all our own appreciative intervention makes the past seem essentially one. The diversity of previous things and people is flattened into uniformity, as with the generic antique

aura of grainy old photos. We minimize past distinctiveness, unite former folk as alike "old," impart the same vintage aroma to relics and memories. Revived and surviving pasts collapse into a single realm.

The hyped heritage thus acquires a studied air of coherent uniformity utterly unlike the inviolate past's discrepant nature, let alone the ramshackle detritus that unaided time bequeaths us. With "charming and rich effects suitable to . . . today's decorator taste," observed Ada Louise Huxtable, "most restored houses look as if they'd had the same decorator. They are all . . . Williamsburged."[4] New historic sites copy older ones. Present-day demands and techniques impose a uniform gloss on retooled historical structures. The visitor is apt— and expects—to see old-time precincts tricked out in much the same way. Standard display and restoration practices apply today's veneer to relics of all epochs. Like shopping malls, revamped old markets are purposely alike. "Blindfold a tourist and drop him in Canal Square in Washington or Ghirardelli Square in San Francisco or Quincy Market in Boston" and he'd hardly spot the difference, for they "use their histories as an excuse to become more and more like each other, to the reassurance of their tourist audience."[5]

These unhappy outcomes—the valued past homogenized, the disregarded present neglected—are perhaps unavoidable. Yet past/present segregation disserves both past and present. It privileges and deforms the past while depriving the present of pastness. The dichotomy is false. The past suffuses every place, every structure, every artifact. Just as we ourselves are living archives of sempiternal DNA, antique cultural practices, and ancient memories, so all that we design and build, inhabit and domesticate, are storehouses of inherited skills, precepts, dreams, and follies. We must learn to heed that palimpsest, in line with Helen Santmyer's "shabby, worn, and unpicturesque" childhood Ohio town. "The unfastidious heart makes up its magpie hoard, heedless of the protesting intelligence. Valentines in a drugstore window, the smell of roasting coffee, sawdust on the butcher's floor—these are as good to have known and remembered as fair streets and singing towers and classic arcades."[6] Like Adam Nicolson's ancestral Sissinghurst, "a place consists of everything that has happened there; it is a reservoir of memories and a menu of

DAVID LOWENTHAL

possibilities. Any place that people have loved is drenched both in belonging and in longing to belong."[7]

"There's no there there," Gertrude Stein memorably dismissed her vanished childhood Oakland, California. Her dismay co-opted the old Podunk canard of a place between Hick Town and Nowheresville. Such put-downs rightly backfire; a real little old lady from Dubuque spun the famed *New Yorker* slur into local Iowa glory. Two hundred unheralded Springfields and Salems, Clintons and Chesters, Madisons and Marions, Greenvilles and Georgetowns grace their denizens with a haloed "here." No aficionado of Walden Pond or Yosemite should gainsay America's twenty-seven Fairviews their cherished idiosyncratic prospects.

DAVID LOWENTHAL, emeritus professor of geography and honorary research fellow at University College London, is a fellow of the British Academy, and honorary D. Litt. Memorial University of Newfoundland. Among his books are *West Indian Societies* (1972); *Geographies of the Mind* (1975); *Our Past Before Us: Why Do We Save It?* (1981); *The Past Is a Foreign Country* (1985); *Landscape Meanings and Values* (1986); *The Politics of the Past* (1989); *The Heritage Crusade and the Spoils of History* (1996); *George Perkins Marsh, Prophet of Conservation* (2000); *The Nature of Cultural Heritage and the Culture of Natural Heritage* (2005); *Passage du temps sur le paysage* (2008); and *The Past Is a Foreign Country—Revisited* (2015).

NOTES

1. David Lowenthal, "Marsh's *Man and Nature* at 150," *George Wright Forum* 32, no. 3 (2015): 227–37, at 235.
2. Reyner Banham, "Preservation Adobe," *New Society* (April 2, 1981): 24, quoted in David Lowenthal, *The Past Is a Foreign Country—Revisited* (Cambridge: Cambridge University Press, 2015), 439.
3. John Ruskin, "Of the Turnerian Picturesque," *Modern Painters* 4 (1856): n.p., cited in Lowenthal, *Past*, 439.
4. Ada Louise Huxtable, "The Old Lady of 29 East Fourth St," *New York Times*, June 28, 1972, section 2, 22, and *The Unreal America: Architecture and Illusion* (New York: New Press, 1997), chapter 1, both cited in Lowenthal, *Past*, 572.

5. Andrew Kopkind, "Kitsch for the Rich," *Real Paper* (Cambridge, MA), February 19, 1977, 22, republished in his *The Thirty Years' Wars: Dispatches and Diversions of a Radical Journalist, 1965–1994* (New York: Verso, 1995), 297; Charlie Haas, "The Secret Life of the American Tourist," *New West* 5, no. 16 (1980): 22–24, both cited in Lowenthal, *Past,* 572.
6. Helen Santmyer, *Ohio Town* (1962; repr., New York: Harper & Row, 1984), cited in Lowenthal, *Past,* 94.
7. Adam Nicolson, *Sissinghurst: An Unfinished History* (London: Harper, 2008), cited in Lowenthal, *Past,* 94.

DAVID LOWENTHAL

Preservation Demands Interpretation

STEVEN LUBAR

Historic markers and the plaques on historic houses remind us that there's a past to what we see around us, that history happens everywhere, that things were once different, that change is possible. They do important work. The historic house raises questions, and the plaque answers them. The marker on an otherwise ordinary street corner takes us to a moment when some event happened, right where we stand.

Interpretation is an important part of preservation, but it is often an afterthought. It's hard enough to save buildings, and for those primarily interested in architecture, a well-preserved building speaks for itself. Further, it's difficult to provide historical depth on a historic marker, let alone on a building plaque. But we should try.

New perspectives and new technologies offer new ways to make interpretation a more prominent part of preservation. Doing so will allow us to not only offer information and perspective to a wide audience but also strengthen the cause of preservation. We can add a new cultural dimension to the built environment and a new material dimension to our understanding of history. "The ICOMOS Charter for the Interpretation and Presentation of Cultural Heritage Sites" suggests the importance of this work. By making cultural heritage sites "places and sources of learning and reflection about the past," the charter suggests, they become "valuable resources for sustainable community development and intercultural and intergenerational dialogue."[1]

The Providence Preservation Society (PPS), which provides plaques in the area where I work, has typical standards. They award markers

"to buildings that retain integrity of their original design, are appropriately and well maintained, and are at least 50 years old." The markers serve "not only to identify buildings of historical and architectural significance, but also to encourage, through heightened community awareness, the continuing care and preservation of individual buildings and neighborhoods."[2]

How might we call attention to what has disappeared?

Plaques provided by organizations such as PPS answer a very narrow range of questions. Most offer the name of the first owner of the house and the date of the building's construction. A few offer additional information: the date of an addition or when the house was moved. A very few mention famous people who lived in the building.

But they could do so much more.

They could tell a story—or, more accurately, provide some details from which the passerby might construct a story. Knowing the date a building was constructed is useful, but it barely begins to capture its history, and it rarely makes us want to know more. Adding even one small additional fact ("Home to 6 slaves in 1765" or "Used as apartment building, 1931–49" or "Racially restrictive covenants prevented people of color from living here, 1920–1948" or "Preserved after long battle in 1987") would provide a perspective otherwise invisible. It would offer some context for the building. It would make the building more interesting. It might even provoke the dialogue that the ICOMOS charter calls for. Drop the name of the first owner and use the space to offer up a tidbit of history instead.

Something else is missing from our historic house plaques, because something is missing from the landscape. That's the built environment that no longer exists. History has taken its toll, and the buildings that remain are usually a small and not always representative sample of what was once there. We are missing big pieces of history. I'm not just talking about vacant lots, or new construction. Those lovely Victorian houses replaced something: Can we find out what? Can we use our preserved properties to tell us about those that are lost?

Michel-Rolph Trouillot, in *Silencing the Past,* warns us of the necessity of understanding the history of the archive, and not taking it for granted. He urges that we look for the silences, for what is left

STEVEN LUBAR

out.[3] The built environment is an archive, shaped like all archives by time and power, and with lacunae that can tell stories as profound and important as what remains. We need to interpret our entire history, moving our focus beyond just those lucky buildings that survive. Indeed, it may be even more important to tell the stories of those buildings that, demolished because they were no longer of value, speak directly of change over time.

How might we call attention to what has disappeared? It might occasionally be possible to add a layer of signage to the landscape, to describe no longer extant structures. Historic markers sometimes do this: "On this spot once stood. . . ." Perhaps it would be better, though, to recreate these past worlds in a new virtual world. Almost every city uses a geographic information system to keep track of its infrastructure, zoning, and property records. More and more, these systems are open to the public, part of the movement toward open civic data. Might it be possible to add a layer of history, of historic maps and historic records, to that system? Property records, rich historical sources with present-day use, are often already publicly available; might we make these more easily available, and with an interface that lets us tell historical stories, not just track ownership for real estate transactions? There are often photographs online; can we link them to locations in these systems? And once this historical information is available in city GIS systems, can we write mobile apps to bring it back into the real world? Utility crews access details on phone poles and sewer lines on their mobile devices. Why can't we access historical data as well?

The National Historic Preservation Act of 1966 offered this rationale for preservation: that "the historical and cultural foundations of the Nation should be preserved as a living part of our community life and development in order to give a sense of orientation to the American people." Preservation was to be, in part, a means to an interpretive end. We preserve the past, in part, so that we can understand it, and so that we might use it to provide direction for the future. Increasing our emphasis on interpreting the built environment would help us toward that worthy goal.

STEVEN LUBAR is a professor in the departments of American studies and history and the John Nicholas Brown Center for Public

Humanities and Cultural Heritage at Brown University. Before joining the faculty at Brown University, Lubar chaired the Division of History and Technology at the Smithsonian Institution's National Museum of American History. He is the author or coauthor of several books on the history of museums and material culture, and consults actively with a wide range of museums and history enterprises.

NOTES

1. The charter can be read at www.icip.icomos.org.
2. See Providence Preservation Society at www.ppsri.org.
3. Michel-Rolph Trouillot, *Silencing the Past: Power and the Production of History* (Boston: Beacon Press, 1995).

A New Ownership Culture

Concepts, Policies, and Institutions for the Future of Preservation

RANDALL MASON

The received wisdom in historic preservation practice is that the best way to preserve something is to own it. Before the twentieth century, this was the model of practice: owning and preserving were intimately linked. Wealthy individuals or governments bought valuable places as the first measure of preserving them—witness the classic historic house museum or national parks. Later in the twentieth century, the role of regulation was ascendant in historic preservation (government control of what others owned), as part of the field's professionalization (largely following models set by the evolution of city planning) and as an extension of preservation's assertion as a basic public good.[1] One could fairly say that preservationists (and their opponents) have become obsessed with regulation as the principal culture of preservation.[2]

In the light of the current dominance of regulation—and the antiqueness of ownership—as preservation strategies, it may strike the reader as very unlikely to be advancing "ownership" as an innovative idea for the future of the field. But that is exactly what I'd like to do.

My twofold proposal calls for: (1) a more expansive ownership culture transcending narrow conceptions of property rights (without overthrowing them); and (2) corresponding innovation in creating institutions (trusts, conservancies, corporations) that apply notions of shared ownership and public-private benefits of preservation to built heritage—especially in the forms and places in which it is most endangered today.

I hope to provoke *new* ideas, forms, and means of ownership, to

rethink and redeploy the politics of ownership (along collective and collaborative, less competitive and maximizing, models), and to imagine new institutions and new methods of financing, all in order to meet the evolving demands of preservation.

A few more or less fixed principles need to be laid down as assumptions. First, built heritage is a mixed good in economic terms, meaning that private and public values flow from it and that ownership is often a matter of negotiation (financial and political). In other words, there is no a priori best way to own heritage—private and public interests have to share. Second, in our current neoliberal moment, when politically regulation is delegitimized or ineffective, ownership needs rethinking. The basic structure of American society is not going to change any time soon—private property ownership will remain central to American society, culture, and politics, and the need to defend the commons remains (harkening back to Garrett Hardin's classic essay).[3] To assert the public good aspects of historic preservation, *as well as* manage its legitimate private good aspects, the preservation field needs to build the right kinds of institutions. This highlights the need to innovate in the legal/administrative/managerial realm as well as in the technological, interpretive, and design realms of preservation.

There is no a priori best way to own heritage.

The next stages in the development of the preservation field will be marked by a shift toward a more performance- and experience-based notion of historic preservation practice: What effects do we want preservation to have on society? What will be our social impact? How do we measure and monitor effects? Fabric-centered, regulatory notions of preservation will be de-emphasized though certainly won't disappear. (The outlines of this are already being mapped out by cultural landscape theory,[4] in stakeholder-centered and multiple values theory; these innovations are imperfect, but they hold the promise of greater contemporary relevance and responsiveness). Realizing and taking advantage of this shift will require new modes of policy, monitoring, advocacy, and research/education, as well as somehow less-fixed notions of ownership.

RANDALL MASON

What will these new institutions and ownership cultures look like? For pragmatic help, we need only look to other fields dealing with aspects of the built environment that possess both private and public good qualities—especially housing and open-space conservation.

Clearly, the affordable housing sector has accomplished a lot along these lines, using community development corporations and other nonprofit institutional vehicles to apply mixtures of private, philanthropic, and government funding to the production and maintenance of social housing. These serve a great variety of constituencies and social goals. In open space and parks (bastions of traditional, public-sector ownership), an ecology of hybrid institutions and ownership arrangements has grown over time, multiplying the types of stewardship and ownership arrangements such as trusts available to satisfy public goods while maintaining property rights and markets.

In these and other sectors, public-private partnerships (PPPs) have proliferated. Public-private partnerships are an important arena of innovation directly addressing ownership and financing but are usually tasked with repackaging market-led development or providing public space. Both are important goals but somewhat different from the typical preservation challenges of white elephant, community landmark buildings, redundant factories, or housing in need of rehabilitation.[5] Public-private partnerships are being applied to urban redevelopment problems and will continue to be an area of innovation for preservation—directed, one hopes, to structures or districts distinguished by cultural, aesthetic, or environmental values but for which no market or existing PPP arrangement exists. The preservation field has reached such a point of maturity that existing ownership processes and institutions don't address current problems, for instance, the growing problem of redundant churches with extraordinary cultural, artistic, and social value—sites of conscience for which the cultural "ownership" of the site's stories is quite disconnected from property ownership.

Innovation in the future might look like the tools pioneered in sister fields—such as land trusts or other forms of non–public sector, community ownership—reimagined to buy and hold heritage properties. It might come from the philanthropic sector—whether

the current movement toward "program-related investing" (in which philanthropies such as the Ford Foundation invest in longer-term partnerships with programs and organizations, as opposed to making traditional grants), or historic ideas such as the nineteenth-century "5 percent solution" housing projects,[6] or, who knows, maybe an honest-to-goodness utopian community? Whatever old ideas are transformed or new ideas are invented, the measures of the preservation field's progress will be experimentation as well as social impact.

Looking ahead fifty years from now, the preservation field will hopefully have pioneered new models of ownership mixing the most effective and resonant aspects of historical private and public ownership models, innovated new institutions to manage ownership and stewardship processes (and fiscal and public accountability), and created new cultures of heritage ownership in the broad and progressive sense.

RANDALL MASON is associate professor and chair of the Graduate Program in Historic Preservation at the University of Pennsylvania's School of Design, and executive director of PennPraxis. He earned a PhD at Columbia, has worked at the Getty Conservation Institute and in private practice, and was a Rome Prize fellow at the American Academy in Rome in 2012–13.

NOTES

1. Ratified by the Penn Central case, among other developments. See Penn Central Transportation Co. v. New York City, 438 U.S. 104.
2. The policy tools available for preservation, however, range much more widely, as Mark Schuster and John de Monchaux, for instance, elaborated in their extremely useful 1997 book *Preserving the Built Heritage* (Lebanon, NH: University Press of New England, 1997).
3. Garrett Hardin, "Tragedy of the Commons," *Science* 162, no. 13 (December 1968): 1243–48.
4. Touchstone works in cultural landscape theory applied to historic preservation include Robert Cook, "Is Landscape Preservation an Oxymoron?," *George Wright Forum* 13, no. 1 (1996): 42–53; Dolores Hayden, *The Power of Place* (Cambridge, MA: MIT Press, 1995); and Dell Upton, "Architectural History or Landscape History?," *Journal of Architectural Education* 44, no. 4 (August 1991): 195–99.
5. See, for instance: important work by Lynne Sagalyn and other scholars of real estate development; and the recent book by Susan Macdonald and Caroline

Cheong, *The Role of Public-Private Partnerships and the Third Sector in Conserving Heritage Buildings, Sites, and Historic Urban Areas* (Los Angeles, CA: Getty Conservation Institute, 2014).

6. The "5 percent solution" was an approach to philanthropic housing development in the early twentieth century premised on limiting investment capital returns to just 5 percent.

Changing the Paradigm from Demolition to Reuse—Building Reuse Ordinances

TOM MAYES

Many cities and communities compete to be green, encouraging LEED-certified buildings, bike-friendly transportation policies, walkable streets, and energy-efficient public and private buildings. Yet few cities actively promote the reuse of existing buildings as a green strategy. The result is that many older buildings are discarded, with the materials ending up in landfills and the new buildings constructed from materials that have been obtained through the environmentally damaging extraction and transportation of new materials.[1] It's a double whammy—throwing materials away and destroying the earth to extract more. The result is a wasteful and unsustainable cycle of construction, demolition, and reconstruction.

At the same time, people crave continuity as their communities change, and they lament the loss of the stories, memories, and identities embodied in the existing buildings. These stories, memories, and identities surface even in places that are only a generation old, such as the 1970s Eastland Mall (Charlotte, North Carolina) of my childhood.

In order to promote greener and more sustainable communities, and to give people a greater capacity to ensure continuity and to manage change, I envision communities implementing a new tool tentatively titled a "building reuse ordinance." As I conceive it, a building reuse ordinance would establish a community policy that promotes the reuse of existing buildings. Demolition would be prohibited unless the community determined that the existing building and the proposed new building met specified requirements. The requirements would be assessed through a review process that determined

whether the demolition was beneficial for the community. If the building did not meet the test for demolition, the community would have the authority to prohibit demolition and require reuse.

The factors considered in the review process would vary from community to community, but could include: (1) the environmental impacts of demolition and new construction; (2) the potential energy efficiency of the existing building compared to the new building, including the number of years that it would take to recoup the environmental cost of the demolition and new construction; (3) the historic significance of the building; (4) the architectural significance of the building; (5) the cultural significance of the building to the community, including the collective memory and community identities associated with the building; (6) consistency of the old and the proposed new building with the zoning ordinance and comprehensive plan of the community; and (7) the character and quality of the proposed replacement building.

Building reuse ordinances would represent a fundamental paradigm shift.

From a preservation perspective, the implementation of a building reuse ordinance would fundamentally change the default in most communities from a presumption that demolition is acceptable to a presumption of reuse. If implemented, building reuse ordinances would represent a fundamental paradigm shift in preservation practice, and this paradigm shift would pose both opportunities and challenges.

First, the opportunities. Currently, even though preservation is widely accepted as a value in the United States,[2] protection is the exception rather than the norm. Historic landmarks and historic districts must be specifically designated, often an expensive, cumbersome, and controversial process. In many communities that have put historic preservation ordinances in place, few districts or buildings are designated. In addition, in many states, the enabling laws do not permit the community to prohibit demolition, but only delay demolition by a year or two. The result is that we have historic preservation commissions reviewing specific changes to a building, such as window replacement, when they cannot ultimately protect the building from

being demolished. Property owners can simply wait the commission out and then demolish. Implementing a building reuse ordinance that is enacted on the basis of environmental sustainability may encourage the survival of many more buildings than could be currently protected with existing historic preservation ordinances.

The challenge. As proposed, the building reuse ordinance would not impose any review of changes to the building other than those required by the building code or other ordinances. There would be no historic area work permit, no certificate of appropriateness, no approval from the architectural review board or historic preservation commission.[3] People could change the siding, change the windows, construct additions, or make other alterations so long as they were consistent with the community's other ordinances. Yet the building would itself would likely survive.

A building reuse ordinance also would not distinguish between "contributing" and "noncontributing" buildings, and there would be no need for a "period of significance." All buildings of all eras would be covered by the ordinance. From a community continuity point of view, the ordinance would therefore "protect" buildings that the community may have become attached to that are not yet officially "old," such as, for example, New York City's American Folk Art Museum building, which was only twelve years old when it was demolished, or Eastland Mall or other buildings of the recent past that may be significant for their architecture or their cultural meaning.

Many may find the idea of not regulating changes to buildings to be troubling if the buildings are historically or architecturally significant (although I want to be clear that I view a building reuse ordinance as an additional tool that could be used in conjunction with existing preservation ordinances, and not only as a substitute). Certainly owners could make what trained preservation professionals would consider to be inappropriate changes to buildings—changes that are not consistent with "The Secretary of the Interior's Standards for the Treatment of Historic Properties" or other comparable standards. But the trade-off is that more buildings would likely survive, even if they survived in a greatly altered state. And there would be no regulation of small changes to older buildings (window replacements, siding changes, roof material changes, solar panels) that many

TOM MAYES

people in the public find difficult to understand. Buildings would not be "frozen in time" (not that they ever were under existing preservation ordinances and "The Secretary of the Interior's Standards for Rehabilitation").

Currently, there are some similar ordinances to look to as partial models, such as teardown or mansionization ordinances, conservation district ordinances, and ordinances that require a surcharge for construction or demolition landfill material.

Is this preservation? It keeps existing buildings and encourages their sustainable reuse, which retains a broader range of community values, right up to the present day. Seems like preservation to me.

THOMPSON (TOM) MAYES is deputy general counsel at the National Trust for Historic Preservation. A recipient of the National Endowment for the Arts Rome Prize in Historic Preservation from the American Academy in Rome, Tom recently published a series of essays about why old places matter to people. He has written and spoken widely about historic house museums, preservation, and preservation law.

NOTES

1. "The Greenest Building: Quantifying the Environmental Value of Building Reuse," National Trust for Historic Preservation, www.preservationnation.org.
2. Sandra Shannon, "Why Old Places Matter: A Survey of the Public," Preservation Leadership Forum Blog, May 7, 2015, blog.preservationleadershipforum.org.
3. The building reuse ordinance would not replace a historic preservation ordinance. Communities could have a building reuse ordinance as well as a historic preservation ordinance, so that specific historic districts and historic landmarks could still be designated and subject to review where appropriate.

Did Martha Washington Sleep Here?

Feminism, Power, and Preservation

MICHELLE L. MCCLELLAN

As we approach the fiftieth anniversary of the National Historic Preservation Act, we also mark a half century since the rise of second-wave feminism, among other social movements of the 1960s. Advocates for historic preservation have accomplished many things: protecting buildings and landscapes, communicating the importance of history, cultivating a sense of place, and highlighting untold aspects of American history. In light of these achievements, the confluence of anniversaries prompts these questions: How, if at all, has historic preservation advanced the cause of gender and sexual equality? And how might it do so in the next half century?

In the United States, women have played important roles in historic preservation; indeed, genealogies of the field begin with the rescue of Mount Vernon by the Mount Vernon Ladies' Association (MVLA). The women of the MVLA, like many others involved in social and political movements, leveraged common beliefs about women's nature to gain moral authority—but at a cost. Not surprisingly given the nineteenth-century context, the MVLA worked to preserve a resource associated with a famous man. What is surprising is how long-lasting that template has proven to be: today, historic sites and interpretive practices still implicitly tend to favor a "great man" theory of history, even as historical scholarship has been transformed as it relates to the histories of women, gender, sexuality, and the family. The codification of standards of "significance" at the federal level represented a critical success for preservationists. But fifty years on, those criteria have had unintended consequences in determining what counts as important, even as preservation has become more inclusive.

A more robust engagement with insights from feminism and from women's history would enrich both the theory and practice of historic preservation. It would help us see women where they have been hidden in plain sight; it would encourage women's historians to pay more attention to place and space; and it would remind preservationists that our field is not immune to forces of power and inequality. Ultimately, such feminist engagement should help us move beyond a simplistic division between men's sites and women's sites, men's stories and women's stories, as we recognize that any site contains a multitude of narratives, experiences, and power relations.

"Women Worthies." One common approach in interpretive practices (and in history education more generally) is called "add women and stir." Find a prominent woman—sometimes the wife of a famous man—and tell her story as emblematic of all women if only they had tried a little harder. This model resonates with an individualized model of achievement common in American life, is easily grasped by the public, and fits into National Park Service criteria. Indeed, the importance of including women in this way is not to be overlooked; asserting that women belong in the national narrative is critical. But this framework can perpetuate privilege within a marginalized group, plucking out a few "women worthies" and leaving the rest unmarked because anonymous. Historians of women have successfully proven the obvious point that women have been virtually everywhere on the historical landscape; ensuring that preservation practices do not recapitulate discriminatory forces should be a best practice for women's history, and "men's" history too. For example, statements of significance and interpretive frameworks should recognize that individual achievement almost always depends on dense networks of support and the labor of others, even if we do not know their names.

Hidden in Plain Sight—Historic Houses and House Museums. As the single most common type of historic site, house museums and historic houses (places documented in the National Register of Historic Places, for instance, or marked with a plaque but not necessarily open to the public), are incredibly influential in shaping public perceptions of history. Innovative survey methods and updated naming practices (simply supplanting references to the "John Smith House," for example, with "the John and Mary Smith house or the "Smith House"

is one small, easy step) enable us to acknowledge the presence and contributions of women in new ways.

But we can do more, because dwellings offer tremendous potential to invigorate interpretation of gender roles, sexuality, and how "family" has changed over time. We can take advantage of visitors' curiosity about the details of everyday life by emphasizing how girls and women, and boys and men, would have moved through these private spaces and enacted their gender roles through their clothes, voices, chores, and interactions. Bedrooms and other interior arrangements can also illustrate intimate relationships, including sexual and erotic connections, in ways that encourage visitors to see beyond their presumption that "historic" means "traditional" and thus heterosexual. Homes are ideal spaces in which to demonstrate central insights of women's history scholarship: that gender is a system that shapes the behavior and social position of men as well as women, and that a "family" is a cultural creation as much as a biological one.

Maybe it's time for "historical consciousness-raising groups."

You've Come a Long Way, Baby. Historic preservation has changed a great deal since the days of the MVLA: advanced degrees and credentialing bodies, federal laws, conferences, professional associations and journals, trade groups—all of these show the maturation of the field. But some things have not changed very much after all. Many preservation efforts remain volunteer and local. Dovetailing these grassroots efforts with federal criteria and standards is not always a smooth process. Moreover, in our attempts to tell more inclusive stories, we sometimes overlook the distinction between preservation and interpretation. Even when a resource is saved and designated, there may be no mechanism for the government or the public to influence its meaning. It is worth remembering that power does not flow only from the top down, as if all preservation practice conformed to federal criteria. Instead, while we recognize the gains realized through professionalization, we should also reconsider preservation as a social movement that can be energized from multiple directions simultaneously. Maybe it's time for "historical consciousness-raising groups" that would tour local landscapes in search of the women's history that was there all along.

MICHELLE L. MCCLELLAN

Preserving and interpreting women's history illuminates a central tension that informs all historical analysis: that between continuity and change. Women's history is just as old as men's, yet truisms about what constitutes "family" and "gender" and "sexuality" are not timeless facts at all, but rather contingent, messy, and always-changing aspects of human experience. For many individuals, awareness of that changeability in the past is empowering in the present—just one of many reasons why bringing more women's history into historic preservation will enrich preservation theory and practice and historical scholarship alike.

MICHELLE MCCLELLAN is an assistant professor in the Department of History and the Residential College at the University of Michigan. Much of her current work focuses on how landscapes, buildings, material culture, and even family memories influence our sense of history. Complete with sunbonnet, Michelle is now writing a book on heritage tourism at sites related to the "Little House" books by Laura Ingalls Wilder, to be called *Looking for Laura: In Search of the Authentic "Little House."*

NOTE

I thank Susan Ferentinos and Marla Miller for contributing ideas to an earlier version of this essay.

Become a "Movement of Yes"

STEPHANIE K. MEEKS

As the diverse essays in this volume attest, historic preservation in the twenty-first century is an amazingly vibrant and dynamic field. We are working in a host of ways to revitalize cities and communities, capture the contours of our shared past, address the challenges of today, and bring people together.

And yet, despite this current flourishing of ideas, innovation, and creativity, we suffer from a perilous public image, even among our own cadre. Americans tend to think we are out of touch, obstacles to change and progress—in a phrase, that we are a "Movement of No." To bury that stereotype for good and draw more allies into the preservation orbit, we need to break away from old habits and become a "Movement of Yes."

One doesn't have to travel far to encounter the typical perception of our field. "The historic preservation community seems to be living in its own chamber," wrote one journalist in 2008. "To the rest of us it looks like preservationists want to preserve for preservation's sake, rather than for any larger community good."[1] This view is also captured in a joke by historian David Lowenthal: "How many preservationists does it take to change a light bulb? Four—one to insert the bulb, one to document the event, and two to lament the passing of the old bulb."[2]

Sometimes this stereotype takes on even uglier resonances. Preservationists, wrote an urban design blogger, are "busybodies, mostly. . . . It really is the urge to tell the neighbors how tall their grass should be, or what color to paint the windows."[3] This unfortunate perception of preservationists as the "paint police" is partly rooted in the

fact that, for too many Americans, their only direct experience with our work is through their local historic preservation review board. While these boards often have the best intentions, the sorts of archaic rules and intrusive "box-checking" interventions that are HPRB's (Historic Preservation Review Board) bread and butter have conspired to give preservation a bad reputation.

Instead of trapping buildings in amber, we need to keep them in active service to today's families.

As Catherine Buell, former chair of Washington, D.C.'s HPRB, said of how their work is viewed, "The two worlds are still completely apart. Longtime preservationists are getting really uncomfortable with how unpopular they've become, and they haven't gotten traction with more and more audiences that are important."[4]

Buell is right. Our research shows that sixty-five million Americans believe that saving historic places is fundamentally important, and nearly a quarter of those are already taking action in their communities to preserve places that matter. The millennial generation—both the largest and most diverse generation in our history—is also more interested in America's past than any generation before it. And yet, much more often than not, these Americans do not think of themselves as preservationists.

We've made it a priority at the National Trust to tackle this lingering perception problem. We're commissioning new research, reaching out to new partners, engaging diverse communities, and working to present a more dynamic face for our movement. But to really change our public impression, and draw more attention to the innovative work preservationists do, we also need to put our best foot forward.

In short, preservation needs to be about more than simply stopping bad things from happening to old buildings. The primary focus of our movement cannot just be telling people they can't have a deck on their historic home. Of course, there is still an important place for local preservation controls—New York, for example, would have lost much of its character without its Landmarks Preservation Law. But all too often, laudable policy goals are experienced by the public as impersonal exercises in the picayune and the impractical. We should

explore less-rigid and more community-driven tools, such as conservation districts and eco-districts.

Similarly, just working to cordon off historic places behind plaques and velvet ropes "because they're there" will only ensure these buildings remain sterile, desiccated, shut off from communities, and, soon, in need of ever more support. At the National Trust, we are working hard to make our historic sites centers of local community engagement—and, when appropriate, places where commercial and non-profit enterprises can together engage the public in a "shared use" environment.

Instead of trapping buildings in amber, we need to keep them in active service to today's families. We need to work with communities to reconceptualize historic places, so they meet the needs of neighborhoods and reflect the energy and diversity of their environment. We should partner with preservation-minded developers, property owners, real estate agents, city officials, and civic organizations to modernize regulations, help existing communities to thrive, and make it easier to breathe new life into older buildings.

Most of all, instead of being the ones who hold back change, and say "No, you can't do that," we need to lead by example and find more ways to adapt and reuse historic buildings. Preservation has come a long way over the past fifty years, and our neighborhoods and cities are much more livable and lovable because of the many successes we have achieved. As we move forward, we need to keep innovating, adopting new tools, and crafting new partnerships—all in support of becoming a Movement of Yes.

STEPHANIE K. MEEKS has served as the president and CEO of the National Trust for Historic Preservation since 2010. She previously served as director of RARE and in several executive positions with The Nature Conservancy.

NOTES

1. Cavan Wilk, "Has Preservation Become an Echo Chamber?," Greater Greater Washington, December 16, 2008, www.greatergreaterwashington.org.
2. David Lowenthal, "The Heritage Crusade and Its Contradictions," in *Giving Preservation a History,* ed. Max Page and Randall Mason (New York: Routledge, 2004), 9.
3. Nic Musolino, "Whenever Anyone Says 'Historic Preservation' I Reach for My Hoary Clichés," Miss Representation, May 23, 2007, www.missrepresentation.com.
4. Lydia DePillis, "The Future of the Past," Washington City Paper, September 29, 2011, www.washingtoncitypaper.com.

Critical Place-Based Storytelling

A Mode of Creative Interaction at Historic Sites

TIYA MILES AND RACHEL MILLER

Anthropologist Keith Basso's work with Western Apaches points to a fundamental reason why human beings save places. "Wisdom sits in places," Basso writes, pinpointing the role of place in the construction of self and community.[1] We preserve places because we seek wisdom: knowledge, understanding, and ethical growth. And Basso's research shows that a most effective route to accessing wisdom intrinsic to places is through story. Basso's revelation and the living role of storytelling in many communities of color point to the idea of channeling the power of story to preserve historic sites. We therefore propose deliberate engagement with sophisticated stories in order to diversify, enliven, and strengthen historic preservation and public participation, especially at sites that mark difficult social histories. We urge the adoption of critical place-based storytelling as an ethos and practice.

Critical place-based storytelling uses carefully selected stories grounded in historical research with a clear relevance to historic sites to explore the historical, cultural, and social meanings of places; it unfolds in a conscious, responsible manner that channels the affective force of skillful narrative to connect visitors to historic sites and foster reflection as well as critical engagement. The selected narratives would be multiperspectival, foregrounding a range of voices and highlighting suppressed historical experiences to encourage a mobility of standpoint that compels visitors to imagine all of a site's former residents across racial, gender, class, sexuality, and ability categories. The visitors who engage these narratives would become more than tourists. A multilayered process of reading and reflecting on a curated story or stories before and after seeing a site creates a sense of what it was like to

inhabit imagined subjectivities as well as material places as members of various social groups. Through imaginative connection with people of the past, as well as through participatory exchanges with others, visitors would develop an intellectual and emotional investment in historic places.

To find stories that foster this critical engagement, historic preservationists need not necessarily craft their own narratives. Instead, they can draw on existing historical fiction that can be read dialogically to illuminate the complex histories of preserved (as well as unmarked) places. With an empathetic ear to the past, creative writers have already forged pathways through fragmented evidence and lost memories. We focus here on works that tunnel through the challenging terrain of American slavery that vexes both staff and guests at historic sites.

Novels can reinvigorate interpretation at historic sites

Toni Morrison's *Beloved* (1987) is a well-known testament to the collective healing of enslaved people and their descendants. It is also a novel of places that are both extant and disappeared, and provides a mode for confronting the presence of absence at historic sites. By traditional definition, a historic site is a place that still exists. But what if only a story is saved, and what if those who passed the story along were denied the ability to consecrate property through historic preservation? There is no historic trail for Margaret Garner, the historical figure whose life inspired *Beloved,* no meticulously restored home to teach us about her, or even to allow us an affective connection to the past she inhabited. Instead, the home where Garner was arrested is now Cincinnati's Mill Creek Waste Treatment Plant.[2] Drawing on the work of fiction writers such as Morrison allows historic preservationists to grab hold of, and richly interpret, even that which is gone.

Newer works such as Dolen Perkins-Valdez's *Wench* (2010), a story of enslaved African American concubines, can also help visitors think about the social geography of enslavement. The novel suggests that a single historic site—the hotel retreat where slave owners take black women for sexual recreation—contains distinct and meaningful places in which the past happened. Readers must weigh the complex interconnections between different kinds of spaces, balance the secret solidarities between enslaved women fostered in the tall grasses

at the resort's boundary against the cruel exposure of the hotel's dining room. For some enslaved women in the novel, routine acts of cleaning and cooking are invested with new meaning away from the plantation. "Inside the cottage," we are told about the protagonist, "Lizzie felt human."[3] But at what cost?

Novels can both reinvigorate interpretation at historic sites and inspire challenging conversations.[4] Thinking seriously about the intricate intimacies of enslaved women requires more than the recounting of facts and figures, as many plantation tours still do when describing slavery.[5] Discussion of these novels could help docents and visitors experience place in multiple ways: as rooms, homes, neighborhoods, and natural environments. Because these novels focus on interior as well as exterior spaces—plantation homes and cottages, outbuildings and fields—they raise a productive counterpoint to the default mode of privileging beautifully preserved homes over other kinds of places.

In Practice

There are multiple ways to enact critical place-based storytelling, each grounded in dialogic site visits, reading groups, and reflective creative writing. Tour creators should think carefully about whose story is told in which place. For instance, bedrooms can provoke contests for power and the edge of a field can be the headquarters for political strategies. Resort cottages and plantation cabins can help visitors rethink the second term in "historic home."

We imagine historic sites anchoring community-wide conversations grounded in both the history of a specific place and an imaginative work of fiction.[6] Because our vision of preservation casts a wide net, we suggest looking beyond standard partners such as humanities councils and public libraries to reading groups and social service or faith organizations. Community reads could take place simultaneously in multiple locations. In the case of *Wench*, multiple sites with links to Tawawa House—from Wilberforce, Ohio, to Cairo, Illinois, to Shelby County, Tennessee—might host local events, as well as collaborative web-based programs such as video conferencing and creative writing exchanges between sites. Both components would encourage visitors to create responsive writing to their experience at sites,

TIYA MILES AND RACHEL MILLER

thereby deepening engagement and increasing critical reflection of places of the past.

As *Beloved* suggests, critical place-based storytelling does not require extant buildings. Margaret Garner's life could be imaginatively re-placed through organized visits to the churches and plantations in Kentucky where Garner and her family lived, as well as to the waste treatment plant. We imagine that visitors would create a plethora of responses both to Garner's story and to the history of the place she thought offered shelter, to connections between marginalized people and marginalized places, and to visions of a future that bring historical thinking to bear on social as well as environmental justice.[7]

In the historic preservation endeavor, people steward places. We steward places to recall who we were, who we wish we had—or had not—been, and who we hope to become in the future—as individuals, families, communities, nations, and larger social formations that stretch across the globe. And we can further the promise of our stewardship into the future through the thoughtful use of storytelling.

TIYA MILES is the Mary Henrietta Graham Distinguished University Professor in the Departments of Afroamerican and African studies, American culture, history, Native American studies, and women's studies at the University of Michigan. She is the author of two prize-winning works of history, *Ties That Bind: The Story of an Afro-Cherokee Family in Slavery and Freedom* (2005) and *The House on Diamond Hill: A Cherokee Plantation Story* (2010); as well as a novel, *The Cherokee Rose* (2015); the 2015 volume *Tales from the Haunted South: Dark Tourism and Memories of Slavery from the Civil War Era;* and various articles on women's history and black and Native interrelated experience.

RACHEL MILLER is a PhD candidate in the Department of American Culture at the University of Michigan and a participant in the Museum Studies Program. She is a former employee of the Wadsworth-Longfellow House in Portland, Maine, and is currently at work on a dissertation titled "Capital Entertainment: The Invention of Creative Labor, 1860–1930."

NOTES

1. Keith Basso, *Wisdom Sits in Places: Landscape and Language among the Western Apache* (Albuquerque: University of New Mexico Press, 1996).
2. Steven Weisenburger, *Modern Medea: A Family Story of Slavery and Child-Murder from the Old South* (New York: Hill & Wang, 1998), 62–63.
3. Dolen Perkins-Valdez, *Wench* (New York: Harper-Collins, 2010), 18.
4. Our understanding of the history in both *Beloved* and *Wench* is drawn from scholarship that could be useful to sites with a related past. These include Weisenburger, *Modern Medea,* and Mark Reinhardt, *Who Speaks for Margaret Garner?* (Minneapolis: University of Minnesota Press, 2010), for *Beloved;* for *Wench,* we recommend Sharony Green, "'Mr. Ballard, I Am Compelled to Write Again': Beyond Bedrooms and Brothels, a Fancy Girl Speaks," *Black Women, Gender and Families* 5 (Spring 2011): 17–40; and Sharony Green's *Remember Me to Miss Louisa: Black and White Intimacies in Antebellum America* (DeKalb: Northern Illinois University Press, 2015).
5. E. Arnold Modlin Jr., Derek H. Alderman, and Glenn W. Gentry, "Tour Guides as Creators of Empathy: The Role of Affective Inequality in Marginalizing the Enslaved at Plantation House Museums," *Tourist Studies* 11 (Apr. 2011): 3–19.
6. This reciprocal relationship exists at Seattle's Panama Hotel, a National Historic Landmark and a key setting in Jamie Ford's novel *Hotel at the Corner of Bitter and Sweet* (New York: Ballantine Books, 2009). Linked through literal common ground, the novel could be used in conjunction with the hotel's robust preservation efforts to bring contemporary reader-habitants into imaginative touch with the city's Chinese and Japanese American past.
7. In Andrew Hurley, *Beyond Preservation: Using Public History to Revitalize Inner Cities* (Philadelphia: Temple University Press, 2010), Hurley makes a powerful argument for linking public history, preservation, and environmental activism through a shared commitment to place, conservation, and a collective future informed by the past. As the subjects of preservation expands, public historians are wise to use natural landscapes; they build historical narratives linking the past to the present, as many challenges facing current urban populations also involve water, soil, air, and plant and animal life.

TIYA MILES AND RACHEL MILLER

Digital Reconstruction as Preservation

*Alternative Methods of Practice for Difficult and
Lost Histories of the African American Past*

ANGEL DAVID NIEVES

The value and veracity of historical reconstructions have long been
debated among preservationists, archaeologists, and historians.
Ethical considerations regarding the reconstruction of historical
buildings at heritage sites, although still vigorously discussed, con-
tinue to benefit the general public as surveyed by historical site
workers. Although methods of preservation practice concerning
reconstruction changed after the 1926 reconstruction of Colonial
Williamsburg, by the 1970s critics including Richard Sellers and
Dwight Pitcaithley believed that the National Park Service must avoid
reconstructions. Sellers and Pitcaithley argued that reconstructions
might illustrate how the past may have appeared but "not how it did
look," that these reconstructions take away from the historic locations
or buildings on site, and that the "structures are not historic."[1] By
1981 the NPS Cultural Resources Management Guidelines removed
reconstruction from its approved activities; NPS-Director's Order
28 (NPS-28) stated that "the Service does not endorse, support, or
encourage the reconstruction of historic structures."

After several more years of debate, and arguments that placing
a reconstruction on-site of the original building or structure was
unethical, many archaeologists concluded that any reconstruction
requires the destruction of archeological resources and therefore
should not be undertaken without careful contextual assessment.
Finally, in 1995, the NPS published updated preservation standards
concerning reconstructions, allowing them only if documentary
and physical evidence exists to allow for "minimal conjecture, and
[if] such reconstruction is essential to the public understanding of

the property."[2] Reconstruction, according to "The Secretary of the Interior's Standards for the Treatment of Historic Properties," is defined as "the act or process of depicting, by means of new construction, the form, features, and detailing of a non-surviving site, landscape, building structure, or object for the purpose of replicating its appearance at a specific period of time and in its historic location."[3] The alternative to physical reconstructions, particularly given the financial limitations of many community- based organizations committed to documenting the past, could be through 3-D reconstructions of historic sites showing change over time.

Can digital reconstructions be used to harness the tools of restorative social justice?

The pervasive natures of digital reconstructions of historical environments "seem to be everywhere," notes architectural historian Diane Favro—who has for two decades now argued for the use of 3-D models in helping researchers to understand ancient Rome.[4] Popular films with hyperrealistic CGI (computer-generated imagery) of buildings and landscapes have also helped to increase public interest in digital reconstructions. Much of this work, however, fails to provide the public with a more complex understanding of a building's history over time or its symbolic or material importance to a variety of constituencies.

With the above in mind, I pose this question: can digital reconstructions of difficult histories be used to harness the tools of restorative social justice in a preservation-based practice that combines both tangible and intangible heritage? My vision for the next fifty years of preservation is one in which minority communities across the United States can harness digital technologies to tell their difficult histories through collaborative and grassroots-based forms of restorative social justice.

The American landscape is replete with hidden histories of the nation's turbulent racial past, but reconstructing the history and landscape of sites such as Rosewood, Florida; Tulsa, Oklahoma; or even Harlem in New York City pose unique challenges. Fragmentary historical and archaeological records—and willful erasures of these difficult heritage sites—complicate research into the historical record. However, virtual reconstruction practices that archaeologists, cultural heritage practitioners, art historians, and classical studies scholars

ANGEL DAVID NIEVES

have used to document canonical sites over the past thirty years are now being employed to illustrate and illuminate sites claimed by once marginalized African Americans. These digital technologies are now providing alternative venues to present and curate the histories of African Americans across the United States and elsewhere. As such, within the past decade virtual technologies have enabled the introduction of a profound process of witness and testimony into these vanished landscapes of America's history of racial violence as well as resistance among the disenfranchised.

My experience documenting memory and the built environment in postapartheid South Africa suggests a model that could animate practice in the United States as well. The Greenwood area of Tulsa, Oklahoma—almost completely destroyed in the race riot of 1921—offers visitors little extant evidence of the African American community once well established there. All that remains is a block of redbrick storefronts and an extensive exhibit of the race riot at the Greenwood Cultural Center, which is constantly under threat of closure due to a limited budget. However, through maps, photographs, and oral histories of survivors previously unavailable to the public, the Tulsa Race Riot Memorial Commission and the Oklahoma Historical Society have sponsored an exhibit at the Greenwood Cultural Center.[5] Sadly, in 2011 the center lost all of its state-sponsored operating budget, putting at risk existing exhibits that provide both survivor testimony and any sense of the lived experiences of the over three hundred people killed in Greenwood or the eight thousand left homeless there. The 2010 Black Wall Street Memorial, although a prominent reminder to the public, does not provide a tangible heritage asset or a long-term solution to recovering the site's history. With little to no extant physical evidence, the costs of any physical reconstruction of Greenwood remain prohibitive; however, a digital reconstruction—a 3-D model and an accompanying oral history of Tulsa's Greenwood community—could provide former residents with a window into this tragic cultural erasure of early twentieth-century African American life.

The recent work of Edward Gonzalez-Tennant, assistant professor at Monmouth University in New Jersey, provides another example of efforts to "utilize new media to open (digital) spaces thus encouraging candid reflection on the connections between historical, face-to-face

Prototype of the Soweto Historical GIS (SHGIS) Project website, with 3-D content viewer and embedded video player. Oral histories of local residents are linked to a 3-D reconstruction based on witness testimony. COURTESY OF GREGORY LORD AND ANGEL DAVID NIEVES.

violence and present inequality."[6] Again working from maps, and survivor testimony, Gonzalez-Tennant has used a 3-D geographic information system (or GIS) to recreate both the historical development and the 1923 massacre and destruction of Rosewood, Florida, providing a deeper contextualization of the area's complex history. The absence of extant physical remnants of the past does not suggest that communities must follow the "Secretary of the Interior's Standards," but digital reconstructions could provide viable alternatives for the preservation and documentation of sites with difficult histories for marginalized communities.

The link between "human rights" and the preservation of cultural heritage resources—particularly those in the built environment—is often misunderstood. If we are seeking social justice for communities such as Tulsa's Greenwood or Rosewood, Florida, we must remember these historical injustices and recognize how they continue to shape identities today. Cultural heritage resources must be understood as a part of peoples' efforts to maintain and construct identity. Historic sites are critical elements in the struggle for equality and democracy, and new technologies can be used to increase access to the information held in these important spaces. Digital reconstructions are

ANGEL DAVID NIEVES

essential to any reconciliation process because they allow communities where no physical sites remain intact because of acts of racial violence to provide narrative testimony concerning the destruction of their cultural heritage.

ANGEL DAVID NIEVES is an associate professor at Hamilton College in Clinton, New York, and director of the American studies and cinema and media studies programs. He is also codirector of Hamilton's Digital Humanities Initiative (DHi), which is recognized as a leader among small liberal arts colleges in the Northeast. Nieves's scholarly work and community-based activism critically engage with issues of race and the built environment in cities across the Global South.

NOTES

1. Richard Sellers and Dwight Pitcaithley, "Reconstruction—Expensive, Life Size Toys." *CRM Bulletin* 2, no. 4 (1979): 6–8.
2. "Technical Preservation Services, Standards for Reconstruction," National Park Service, U.S. Department of the Interior, www.nps.gov.
3. Anne E. Grimmer and Kay D. Weeks, *The Secretary of the Interior's Standards for the Treatment of Historical Properties: Guidelines for Preserving, Rehabilitating, Restore and Reconstructing Historical Buildings* (Washington, DC: U.S. Department of the Interior, 1995), 168; "The Secretary of the Interior's Standards and Guidelines [As Amended and Annotated]," National Park Service, www.nps.gov.
4. Diane Favro, "Se non èvero, èben trovato (If Not True, It Is Well Conceived): Digital Immersive Reconstructions of Historical Environments," *JSAH: Journal of the Society of Architectural Historians* 71, no. 3 (2012): 273. Other historic sites in the United States that have used 3-D reconstructions and related technologies include Mesa Verde National Park, Colorado; the Presidio, San Francisco; Tudor Place, Washington, DC; Colonial Williamsburg, Virginia; and Historic Jamestown, Virginia.
5. Ronni Michelle Greenwood, "Remembrance, Responsibility, and Reparations: The Use of Emotions in Talk about the 1921 Tulsa Race Riot," *Journal of Social Issues* 71, no. 2 (2015): 340. The Tulsa Race Riot Commission to Study the Events of the Riot (TRC) examined the historical record and recommended reparations payments for survivors of the riots and their descendants in 2001. The TRC concluded "that reparations to the historic [Black] Greenwood community in real and tangible form would be good public policy and do much to repair the emotional and physical scars of this terrible incident in our shared past." The Oklahoma state legislature responded by establishing scholarships, a memorial, and economic development for Greenwood, but declined to offer reparations.
6. Edward González-Tennant, "Intersectional Violence, New Media, and the 1923 Rosewood Pogrom," *Fire!!!* 1, no. 2 (2012): 65.

Race and Historic Preservation

The Case for Mainstreaming Asian American
and Pacific Islander American Historic Sites

FRANKLIN ODO

Important places marking historic events or people in American history are listed in the National Register of Historic Sites (NR) or the National Historic Landmarks (NHL). But, although inexact, National Park Service estimates suggest that only about 3 to 5 percent of all such designations reference the experiences of all peoples of color in the United States.[1] For peoples of color, these experiences include regular encounters with race and racism. Nonetheless, the U.S. government has apologized for egregious race-related policies only five times in our history. One such apology referenced African Americans; another off-handedly noted the ill treatment of Native Americans. The others were directed at Asian Americans or Pacific Islanders (AAPIs). In 1988, president Ronald Reagan signed H.R. 442, apologizing on behalf of the nation to Japanese Americans (JAs) who had been forcibly and wrongfully removed from their homes and incarcerated in dozens of military sites, local prisons, immigration holding areas, and internment and concentration camps between December 7, 1941, and spring 1946. About one half of those 120,000 JAs were still alive on August 10, 1988, and received official letters of apology and checks in the amount of twenty thousand dollars. Then, in 1993, President William Jefferson Clinton announced that the United States formally apologized for the "illegal overthrow" of the Hawaiian Kingdom in 1893. Finally, in 2011 and 2012, the Senate and House of the U.S. Congress apologized for enacting the 1882 Chinese Exclusion Act, which declared people of Chinese descent unwelcome and ineligible for citizenship. Three of the five apologies, therefore, have involved racist and discriminatory actions directed at

people of Asian and Pacific Islander descent. Given the significance of these apologies, the critical underrepresentation of AAPI historic sites on the National Register and the National Historic Landmarks is disappointing, even disturbing.

Many possible sites could raise critical questions, such as "How did our current immigration policies emerge and evolve?" and "What does the historical record say about our nation's ability to adhere to constitutional principles in, say, the Bill of Rights, when questions of national security become pre-eminent?" Preservation should help consider how well organized labor has managed issues of diversity when faced with threats to jobs, and how the nation has changed its definition of who is fit to be or become an American. Importantly, such efforts should be designed to ask "What should be the roles of diasporic immigrant or refugee groups in the U.S. with regard to American foreign policies directed at their former home-lands—and will these patterns change as these communities become increasingly African, Middle Eastern, Muslim, Latino, Asian, and Pacific Islander?" Or "How does the history of AAPIs in educational systems inform our understanding of segregation or quotas or caps and affirmative action?"

> *Many possible sites could raise critical questions.*

But before we can ask such sites to address such complex questions, we need to know where these places are. A number of excellent examples point the way to identifying significant sites for designation on the lists of the National Register of Historic Places and the National Historic Landmarks. The Japanese American Confinement Sites (JACS) Program currently being implemented in the National Park Service was established by Congress in 2009 for the purpose of "the preservation and interpretation of U.S. confinement sites where Japanese Americans were incarcerated during World War II." The law authorized up to $38 million for the life of the grant program to identify, research, evaluate, interpret, protect, restore, repair, and acquire historic confinement sites so that present and future generations may learn and gain inspiration from these sites and so that these sites will demonstrate the nation's commitment to equal justice under the law.[2] The program funds proposals from historical societies, museums,

foundations, and organizations that directly address these goals and has disbursed over one half of the authorized budget.

Another important project—led by Stanford University professor Gordon Chang—is the first large-scale, sustained, effort to uncover or discover records about Chinese workers who were employed on America's railroads in the mid- to late nineteenth century, from archives and archaeological sites in North America and China. Chang convinced Stanford's administration to fund the project. Leland Stanford, the Stanford University's founder, had made his fortune as one of four men who built the Central Pacific Railroad. Stanford led efforts to recruit the thousands of Chinese workers who were essential in building the western half of the transcontinental railroad. The completion of the transcontinental railroad, providing the first major transportation link between the East and West Coasts, was famously commemorated in Utah with the symbolic golden spike. The iconic photograph of the ceremony shows builders, workers (especially Irish immigrant laborers), and Native Americans but completely excludes the Chinese. Current archaeological projects are uncovering numerous sites where the Chinese lived and worked. Further, many of them used the railroad stops to establish restaurants and laundries. These are also potential sites for NR or NHL designation.

On a more grassroots level, Asian and Pacific Islander Americans in Historic Preservation (APIAHiP) is a national network of preservationists, historians, planners, and advocates focused on historic and cultural preservation in Asian and Pacific Islander American communities. Since its 2007 inception, APIAHiP has hosted two biennial National APIA Historic Preservation Forums, convening over four hundred preservationists, historians, urban planners, architects, community leaders, policy makers, and others involved in preserving and sustaining historic and cultural resources that are important to Asian and Pacific Islander Americans. APIAHiP has also been involved with national advocacy and policy issues, including increasing participation and visibility of APIA historic and cultural resources.[3]

Finally, there are a number of National Park Service (NPS) theme studies. "American Latinos and the Making of the United States: A Theme Study" was launched in February 2013; another study, focusing on LGBTQ history, is scheduled for publication in 2016. The

FRANKLIN ODO

Asian American Pacific Islander Theme Study has an advisory group of distinguished academics and preservation activists and will include eighteen essays from senior scholars. It, too, is expected to be available in 2016. Contributions designed to provide examples to inspire consideration of historic sites that illuminate the depth and breadth of the AAPI presence in North America will explore encounters between Asian and Pacific Islanders caught in the conflicts between American and Japanese imperialisms as well as labor activism, popular culture, agriculture and innovation, architecture and landscape, World War II, the Cold War, Asian American Pacific Islander studies, new immigration, and community development.

There are many ways to include more AAPI stories in the NPS and American historical narrative. Whether they be Congressionally mandated and funded like the JACS project, federally initiated like the NPS theme studies, university-inspired research like with the Stanford Chinese railroad workers project, or citizen- and grassroots-led like the APIAHiP venture, we must bring more stories into the NPS pantheon. The examples cited here should inspire NPS personnel, from superintendents to rangers and outreach staff, to consider diverse communities within their own purview and to embark on some fascinating journeys. Increasing the number of stories about AAPI communities will be important because they now comprise an important part of the national political, social, and cultural fabric.[4] Equally important, this volume may energize scholars, students, and community leaders to imagine the potential to enrich our appreciation of our nation's history and culture through the designation of sites significant to AAPI experiences.

FRANKLIN ODO is a Japanese American author, scholar, activist, and historian. As the director of the Asian Pacific American Program at the Smithsonian Institution since the program's inception in 1997, he has brought numerous exhibits to the Smithsonian highlighting the experiences of Chinese Americans, Native Hawaiians, Japanese Americans, Filipino Americans, Vietnamese Americans, Korean Americans, and Indian Americans. After his retirement from the Smithsonian, he became chair of the National Park Service Asian American and Pacific Islander Theme Study.

NOTES

1. This statistic was offered by Secretary of the Interior Ken Salazar in 2011; see Ed O'Keefe, "Ken Salazar Urges More Latino-Themed National Parks, Sites," *Washington Post,* October 11, 2011.
2. See "Japanese American Confinement Sites," www.nps.gov.
3. In addition to forums, APIAHiP has two major projects: "East at Main Street," a national APIA history mapping project, and APIA Endangered Sites.
4. On this population growth, see "2010 Census Shows Asians Are Fastest-Growing Race Group," press release, United States Census Bureau, March 21, 2012.

FRANKLIN ODO

Preserving the History of Gentrification

SULEIMAN OSMAN

No field of study has immaculate origins. Whether anthropology, psychology, or American studies, all disciplines begin with terminology, central assumptions, and practices that later practitioners find dated and even troubling. Grappling with thorny origins is important for a field as it raises questions about contemporary and future practice. For preservationists in the twenty-first century, this will mean confronting the complex connection between "second wave" historic preservation and the gentrification of American cities.[1]

If gentrification has a history, how does one preserve and document it?

Gentrification is a well-worn topic in American preservation circles. Since the 1980s, a "third wave" of historic preservation scholars and activists in the United States has diversified what was once a largely upper-middle-class field and made great strides to fight the displacement of the poor from revitalizing urban districts. Yet earlier years have left their impact. Preservationists still face mistrust from the public and an unfair perception that the field is elitist. Furthermore, gentrification has now transformed cities for decades, which raises new questions for preservationists. If gentrification has a history, how does one preserve and document it?

The goal here is not to diminish the heroic accomplishments of historic preservation's "second wave." Dedicated activists in cities after World War II saved irreplaceable nineteenth-century and early twentieth-century housing from urban renewal bulldozers and slum clearance. Preservation activists in the 1960s and 1970s had progressive

goals and links to the emerging environmentalist movement. In a postwar era in which most middle-class Americans were fleeing urban areas and government officials were championing their demolition, historic preservation was unquestionably a boon for cities.

But even the most heroic of movements has complex sides. While the bulk of "second wave" historic preservationists in American cities had the best of intentions, they were also participating in an early form of gentrification avant la lettre.[2] Whether in New York's Greenwich Village in the 1920s, Charleston's Old City District in the 1940s, Providence's College Hill in the 1950s, or Brooklyn's Park Slope in the 1960s, historic preservation was championed by a new white middle class migrating into declining inner-city districts and buying up old homes and townhouses that sat abandoned or were subdivided into rooming houses and low-income rental apartments. As they restored houses and returned them to single-family use, they often displaced the poorer and often nonwhite renters and roomers who lived in them.[3]

By the 1970s, historic preservationists at conferences and in publications described themselves explicitly as a new "back-to-the-city" movement. By the end of the decade, historic preservationists had convinced once indifferent city growth machines and federal officials to support the movement with new zoning and tax incentives in part by emphasizing how historic architecture could revitalize cities by attracting the white middle class back to poorer areas. By the 1980s, historic preservation entered into an uncomfortable partnership with downtown developers, who discovered the potential profit of historic architecture and the adaptive reuse of older buildings. To the dismay of some preservationists, developers converted old industrial lofts and townhouses into expensive condos and superficially retained the facades of old buildings with historic ambience to market new office buildings and festival marketplaces.

As historic preservation moved from the margins to the center stage of urban policy in the 1980s, scholars within the field began to ask provocative questions about whether preservation had become a victim of its own success. Scholars ranging from Pierce F. Lewis to Robert Bruegmann offered sharp criticism of preservation's preoccupation with restoring aristocratic private homes and its blind eye

SULEIMAN OSMAN

toward the displacement caused by restoration efforts.[4] Critics also accused preservation activists of striking a Faustian bargain with developers. By marketing historic preservation as a profitable urban revitalization strategy, the field was now thriving. But critics argued that it had unleashed a "Frankenstein's monster" of bowdlerized history, Disneyfied architecture and high-priced, monotonous historic districts.[5]

Since the 1990s, a "third wave" of preservationists has pushed the field in new and exciting directions. Scholars such as Daniel Bluestone have implored preservationists to abandon their obsession with architectural categorization and to treat buildings instead as palimpsests with complex layers of historical memory. Richard Longstreth has pushed preservationists to consider a richer and more democratic range of buildings beyond Victorian private homes, such as public housing, Brutalist architecture from the urban renewal era, Levittown Cape houses, parking garages, and even gas stations. Dolores Hayden and Gail Dubrow have championed a more inclusive and bottom-up approach to preservation that draws from African American, Latino, Native American, and other voices neglected by the previous generation.[6] All of this has resulted in a "third wave" preservation movement that stands on the shoulders of the previous generation but is more diverse and dynamic. The era of preservationists leading prospective buyers on historic home tours in impoverished inner-city townhouse districts seems long ago.[7]

Gentrification will present new challenges for historic preservation in the coming decades. Citizens around the country are passionately debating the merits and drawbacks of gentrification, but few can say what it is or why it happens. Gentrification is now part of public memory, and preservationists need to document and preserve a nuanced history of the process. Yet preservationists themselves are now also key historic actors who in the past century had a hand in producing the gentrified cityscape that surrounds us. "Fourth wave" historic preservation projects thus will need to be more self-reflexive. A plaque erected in Columbus, Ohio, in the 1970s identifying "Historic German Village" not only provides a glimpse into the nineteenth century but is now also an artifact of a contested era of the historic preservation movement. A row of brownstones may be historically significant today

not only due to the date they were originally built but also because of the debate about displacement and local heritage that was sparked in the 1960s when they were restored.

The task for "fourth wave" preservationists will be to tell not only the history of gentrification but also the complex history of historic preservation itself.

SULEIMAN OSMAN is associate professor of American studies at George Washington University. He is the author of *The Invention of Brownstone Brooklyn: Gentrification and the Search for Authenticity in Postwar New York*, which was awarded the 2012 Hornblower Award by the New York Society Library. He is currently working on a comprehensive history of gentrification in the United States from 1880 to the present.

NOTES

1. I am distinguishing historic preservation's "second wave" starting in the 1920s and burgeoning into a national movement supported by the state in the 1970s from a "first wave" lasting from 1890 to 1920, linked to Progressivism and described by Randall Mason, *The Once and Future New York: Historic Preservation and the Modern City* (Minneapolis: University of Minnesota Press, 2009).

2. British sociologist Ruth Glass coined the term "gentrification" in the 1960s to describe a similar process in London. In the United States, the term first gained currency during the late 1970s.

3. Andrew Dolkart, *The Row House Reborn: Architecture and Neighborhoods in New York City, 1908–1929* (Baltimore: Johns Hopkins University Press, 2009), 128–30; Briann Greenfield, "Marketing the Past," in *Giving Preservation a History*, ed. Max Page and Randall Mason, 163–84 (New York: Routledge, 2004); Robert R. Weyeneth, "Ancestral Architecture" in Page and Mason, eds., *Giving Preservation a History*, 257–81.

4. Peirce Lewis, "The Future of the Past: Our Clouded View of Historic Preservation," in *Controversies in Historic Preservation: Understanding the Preservation Movement Today*, ed. Pamela Thurber, 11–30 (Washington, DC: National Trust for Historic Preservation, 1985); Robert Bruegmann, "What Price Preservation?," in Thurber, *Controversies in Historic Preservation*, 31–35.

5. Pamela Thurber, ed., *Controversies in Historic Preservation: Understanding the Preservation Movement Today* (Washington, DC: National Trust for Historic Preservation, 1985).

6. Dolores Hayden, *The Power of Place: Urban Landscapes as Public History* (Cambridge, MA: MIT Press, 1995); Gail Lee Dubrow, "Restoring Women's History Through Historic Preservation: Recent Developments in Scholarship and Historical Practice," in *Restoring Women's History through Historic Preservation*, ed. Gail Lee

Dubrow and Jennifer B. Goodman, 1–14 (Baltimore: John Hopkins University Press, 2003).

7. Max Page and Randall Mason, "Rethinking the Roots of the Historic Preservation Movement," in Page and Mason, *Giving Preservation a History*, 9.

Pollution

..

JORGE OTERO-PAILOS

Nothing lasts forever, except of course pollution. From radioactive dust clouds to coal soot, the durability of pollution is so great that it is now measured in geologic time: the Anthropocene. Of all our products, the great feats of architecture, of art, of engineering, of digital technology, the most enduring will have been pollution. Preservation, as a discipline concerned with the endurance of things, is well poised, and might be well served, to rethink pollution more deeply and precisely.

..
Preservationists were among the first to notice the environmental damage of pollution.
..

Preservation is, in some ways, ahead of many other disciplines in this rethinking. Pollution is, after all, one of the enabling elements of decay—the other major one being water—and it is by extension a central concern of practice. Preservationists know a great deal about pollution, its makeup and effects. Historically, we have been at the forefront of the production of knowledge about pollution. Preservationists were among the first to notice the environmental damage of pollution, partly because of their aesthetic refinement and attunement to the visible effects of time on art and architecture. As early as the 1860s, preservationists' reports invoked the imperative to protect cultural objects from pollution.[1]

The interesting thing is that the focus on pollution ended up helping to reorganize what was considered relevant knowledge in the field. It slowly upturned preservation as a field that had, up till then, been built on knowledge derived primarily from aesthetic appreciation. A

{ 194 }

Jorge Otero-Pailos's *The Ethics of Dust: Trajan's Column* (2015). Commissioned by the Victoria and Albert Museum. The installation is made of conservation latex that has been used to "clean" the hollow inside of the cast of Trajan's Column, the largest object in the V&A. Hanging in the space next to the cast, it shows the pollution accumulated over decades in the usually unseen interior of the column. PHOTO BY PETER KELLEHER, COURTESY OF THE VICTORIA AND ALBERT MUSEUM.

Pollution

new form of knowledge was deemed necessary, and preservationists began to open up to new scientific methods of inquiry, such as chemistry's laboratory-based experimentation, and eventually developed dedicated materials conservation laboratories, without which the discipline today would be inconceivable.

For much of the nineteenth and twentieth centuries, pollution was thought to be a localized and ephemeral phenomenon, contained mostly in and around industrial cities. If only the chimneys could be turned off, pollution would disappear, at least in theory. Ebeneezer Howard could image "smokeless and slumless cities," not only because industry could be relocated downwind from cities, but also because air and water, that is nature, was thought to be self-cleansing and self-regenerating. The atmosphere and the sea were, as Joel Tarr has documented, conceived of as "ultimate sinks."[2]

By the 1960s however, preservationists had discovered the action of pollution in objects far away from industrial centers, proving that nature was not regenerating and that pollution traveled far greater distances and remained noxious for far greater time spans than previously thought. At the same time, Rachel Carson showed natural landscapes, once thought pristine, to be deeply contaminated.[3] The public learned that pollution was causing insects and other animals to die, and even go extinct. The simultaneous economic collapse of Western industry in the Bretton Woods era made city skies clearer—pollution continued to haunt cities, but its major sources shifted from the coal used in heavy nineteenth-century industry to gasoline for cars and oil for building boilers, making the particulate matter in the emissions smaller and less visible. Urban politicians, desperate to take symbolic actions that could stem the flight of the middle class from historic centers, seized the opportunity to rebrand cities as depolluted, clean, desirable places to live. They ordered preservationists into a massive cleaning campaign, unprecedented in scale, to eliminate pollution from historic buildings. Paris under André Malraux is the most famous example, but London, Milan, New York, Pittsburgh, Chicago, and countless other Western cities were also visually rid of pollution.

I say visually, because we cannot make pollution disappear. We can only push it around. The pollution that preservationists removed

JORGE OTERO-PAILOS

from monuments in the 1960s and 1970s was flushed into sewers and is now somewhere in a riverbed or in the ocean. It is worth pausing and asking: why was it a problem to have pollution on monuments, but perfectly fine for it to be in rivers and streams? Anthropologist Mary Douglas offered a clue when she famously defined pollution as matter out of place, as that for which we cannot, indeed must not, find a place in culture.[4] Monuments are overdetermined as places of culture, and as such we expect them to be free from pollution, whereas rivers and oceans are natural realms that most people consider outside of culture, where the existence of pollution is less troubling, even if not entirely agreeable either. In other words, pollution is as much a material as an idea. It is something that we imagine belonging to the conceptual realm of chaos, of the incomprehensible, of dirtiness, of danger, of evil. It is the negation of culture and everything it represents: order, understanding, purity, and security—among, needless to say, so many other "good" things.

We accept pollution as the cost of producing and having culture, so long as the two are not mixed. In preservation we draw the line strictly: we care about cultural objects, not the pollution they bear. We remove pollution from the surface of significant cultural objects, and we discard it, thus affirming the idea that it is, that it must be, insignificant. Capitalism operates the same way: it considers pollution as an "externality" of production and the economic system, a cost that is not accounted for in the company balance books and is borne by the environment and the general public. But as Marx pointed out, pollution is a constitutive externality, that is to say, we cannot make industrial products without making pollution. Culture and pollution are two sides of the same coin. That is why environmentalists have long been arguing that polluters must pay for polluting.

We have come to a point in human history when the so-called educated classes across the world are beginning to grasp that there is no ultimate sink. Pollution is everywhere, and will be for the foreseeable future. It will have been the most enduring monument constructed by our civilization. The old dyad of culture versus pollution is ceasing to make sense, and a new understanding of these concepts and their relationship is desperately needed. As stewards of culture, preservationists have a central role to play in this broader rethinking of our

environment and ourselves. But to play that role we must begin by questioning our presuppositions of what culture is, of what a cultural object is, of what is intrinsic and extrinsic to it, and dare to understand pollution differently: not as the outside of culture, but rather as itself an enduring cultural object worthy of preservation; not as a nonmaterial, but rather as a specific material; not as an ahistorical dust, but rather as microscopic matter that is a new measure of time (the Anthropocene) and therefore an invitation and a key to rethinking historiography. We are, in sum, at a moment when preservation must open up to a new form of knowledge that has yet to coalesce: it cannot be learned, it must be produced. We need a new experimental preservation conceptually willing and technically able to move into realms of uncertainty.

But how to think of pollution as an object of preservation? The question is only radical inasmuch as the only way to arrive at the thought of pollution as an object of preservation is to move beneath the surface of how we have become accustomed to thinking about cultural objects, beneath the now accepted conventions of theory and practice, to the doubts from which the idea of these cultural objects sprung. Take for instance historic districts, which we take for granted today as cultural objects worthy of preservation. When the idea of historic districts first emerged at the end of the nineteenth century, there was a great deal of uncertainty about the legitimacy of the claim that cultural objects—as we now call them, or "monuments," as they were called then—could be larger than individual buildings. That idea emerged in a dialectic between theory and practice. Schematizing this rather complex history for the sake of brevity, the construction of the historic district was made possible by theoretical advances, such as Aloïs Riegl's notion of the unintentional monument (which put cultural significance on par with artistic achievement), and Camillo Sitte's theorization of the monument's surrounding buildings as integral to the monument. In practice, the introduction of infrastructure in old cities, combined with the rise of nationalist revivals in the late nineteenth century, led to historicizing urban beautification projects in cities such as Brussels, Barcelona, and Bologna—to pick only those starting with the letter *b*. These projects allowed architects to move beyond designing buildings and to operate at a new and

larger urban scale, allowing them to think of the city as a collection of urban ensembles. There was of course great resistance to the budding idea of historic districts from building owners and others who saw it as a form of illegitimate control over their property. All this is to say that the notion of a historic district was, at one point, a radical preservation idea that fundamentally transformed how urban dwellers everywhere now think of cultural objects. To think of pollution as a cultural object will require a similarly daring claim on reality, a similar expansion of how we think and practice, and collaborations with disciplines, such as the health and data sciences, that are beginning to exert new influence over the environment. Governments are already, although perhaps unwittingly, thinking of pollution in preservation terms when they frame policy as returning the atmosphere to what it was at the start of the twenty-first century by midcentury. Regrettably, these proposals seem to wash over something preservationists know all too well: just how hard restoration is, the methodological rigor it requires, and the cultural sensitivities that must be negotiated. It seems critical that preservationists help rethink pollution as a cultural and historical issue and not just a technological problem, for no technology can solve climate change unless there is a mainstream culture there that is not only willing but desiring to adopt it—and judging from the minute market share of hybrid and electric vehicles (currently shy of 3 percent in the United States), that mainstream culture has yet to arrive. There is no better place to start shaping the culture that will reverse climate change than in places of culture, that is, in precisely the places that preservationists shape and help interpret for the interested public. To rethink pollution as part of our heritage is also to set in motion a new broad-based culture of preservation capable of addressing the major environmental, social, political, and technological challenges of the next fifty years.

JORGE OTERO-PAILOS is an artist, architect, and theorist specializing in experimental preservation. He is associate professor and director of historic preservation at Columbia University GSAPP, and the founder and editor of the journal *Future Anterior*. His artworks have been exhibited in major museums and biennials such as the Victoria and Albert Museum (2015), Louis Vuitton La Galerie (2015), Venice

Art Biennial (2009), and Manifesta Art Biennial (2008), as well as art galleries internationally. His work has been published in journals of reference such as Art in America, *Artforum, Modern Painters, DAMn, Architectural Record, AA Files, Places, Quaderns, Volume,* and others. He is the author of *Architecture's Historical Turn* (2010) and contributor to a number of scholarly journals and books, including Rem Koolhaas's *Preservation Is Overtaking Us* (2014).

NOTES

1. See, for example, Augustus Voelcker, "On the Injurious Effects of Smoke on Certain Buildings Stones and on Vegetation," *Journal of the Society of Arts* (January 22, 1864): 146–53. Also see "Report on the Decay of Stone at Westminster," *Builder,* no. 5 (October 1861): 677–80.
2. Joel A. Tarr, *The Search for the Ultimate Sink: Urban Pollution in Historical Perspective* (Akron, Ohio: University of Akron Press, 1996).
3. Rachel Carson, *Silent Spring* (New York: Houghton Mifflin, 1962).
4. Mary Douglas, *Purity and Danger: An Analysis of the Concepts of Pollution and Taboo* (London: Ark Paperbacks, 1966–84).

Culture as the Catalyst

*Broadening Our History, Intangible Heritage,
and Enlivening Historic Places*

JULIANNE POLANCO

Historic preservation, like many movements, began as a grassroots effort to save and celebrate our nation's built heritage. Now, fifty years later, preservation is mainstream. Most people know something about our tangible historic resources: that they exist, that there are processes for listing them on state and federal registers, that alternatives must be considered before the historic resource can be adversely effected.

But what about our intangible heritage? As the country matures, layers of history are present in place—what I refer to as the stratigraphy of communities—and we are compelled not only to expand the stories that are told but to do so in a way that honors each layer of a place and includes its current inhabitants. There is richness and depth in these stories, these gems of understanding that create and unite.

Not all places that are listed are architecturally significant; their importance may lie beneath observable surfaces. But invisible integrity, too, deserves recognition. Forever etched in my memory is one such site, the Maravilla Handball Court (1928) and El Centro Grocery (1946) in East Los Angeles. Having little to no architectural significance, these ordinary buildings exist in what is today a predominately Mexican American community. Although the grocery has had a series of owners, among its most compelling stories is that of its management and ownership by the Nishiyma family, Japanese Americans who settled in the area following World War II—and their internment—to start a new life and family.

During their tenure, the store and court were known as a makeshift community center, and served as a place to post announcements, have parties, and connect with neighbors. The handball league used

the site as a focal point that invited neighborhood youth to gather, learn, and stay off the streets. As part of the process to list a property on the California Register of Historic Places in 2013, a hearing before the California State Historical Resources Commission took place. Generations of neighborhood community members testified to the site's importance, sharing stories of hope and family and of lives saved through sport. This multicultural site of great significance to the community was successfully listed on the California register; and, in doing so, the property owner has ensured that it will stand and be recognized as the important neighborhood beacon it is. These stories from our past require telling in our present to be preserved for the future.

We must find ways to add new sites representing a broader history.

The National Register of Historic Places directs practitioners to evaluate significance and integrity when considering whether a resource is historic—criteria that may be useful and important in the context of the built environment but that fail when applied to intangible heritage, the layers of culture that exist at a place, and the many people connected to that shared history. This is the next frontier in historic preservation.

The next step toward that frontier is for those responsible for state and federal registers to review existing historic resources. Many of the places listed on state and federal registers are sites of multicultural experience. While such sites may not have been built by members of the many groups who migrated to the United States throughout our history, they were inhabited, experienced, and transformed by them, and these later stories are just as important as those of the builders and first occupants. There is a lot to be gained by reassessing how stories are told, and by adding to the dialogue so that the stories are more complete. For instance, the narrative description of the Presidio of San Francisco, a National Historic Landmark, tells of a site inhabited by Native Americans, Spanish settlers, and the U.S. Army before becoming a national park. The narrative, however, should also include the great love story between a Russian captain located to the north, at Fort Ross, and the daughter of a Spanish commandant stationed at the Presidio—two military camps, each established to

JULIANNE POLANCO

stop the advancement of the other. It could recount the story of general John J. Pershing's launch from San Francisco to the Texas–New Mexico border to stop Pancho Villa's raids on U.S. citizens and their holdings, an effort that included the first use of airplanes in a military exercise. Other histories, including the use of Japanese Americans to translate Japanese military communications during World War II and the groundbreaking directive to create the present-day sustainable urban park reveal yet other layers of story. Building on the richness of existing sites is critical to a successful articulation of the broader importance of the past.

On a practical level, we must find ways to add new sites representing a broader history to state and federal registers of historic places. Increased use of documentation tools, such as contextual studies and multiple property submissions, could do just that. These documentation tools place the history of a grouping or theme in a broader historic setting, illuminate defining themes, and provide a framework for sites of cultural and social significance to be rightfully understood for their contributions to our shared history. These documentation tools, once completed, provide the basis for a shortened nomination form to the state and federal register, thereby removing financial barriers associated with the cost of creating individual nomination forms. The "American Latinos and the Making of the United States" National Park Service theme study and the "Latinos in Twentieth-Century California" National Register context statement by the California Office of Historic Preservation provide such a framework. Because these studies are organized around events or activities, and not just the physicality of the built environment, the types of resources considered eligible for state or national register listing become less about architecture and more about cultural attributes, increasingly honoring intangible heritage.

UNESCO has created an "intangible cultural heritage" list that includes cultural attributes such as tapas, mariachi, flamenco, and communication by whistling (a practice in the Canary Islands), to name a few. These are traditions passed on from generation to generation, and represent active culture. Their preservation provides connectivity between the past and the present that gives a community a stable foundation to honor the past and carry it forward into the

future. The United States should challenge itself to participate in this worldwide effort while at the same time considering these types of cultural patrimony in its state and local registers. Intangible heritage can be a means to activate historic spaces in new ways. At the local, state, and national levels, government and nonprofit organizations alike can use intangible heritage to enliven historic spaces through celebration, teaching, and storytelling. Once the themes of our collective history are brought into the contemporary memory, intangible heritage becomes the nexus between our past and our present. Expanding the narrative of our past has great potential to give people, especially youth, a sense of pride, dignity, and understanding. Culture, then, is a catalyst for knowledge, empowerment, and peace.

History should be told in a way that reflects the collective contributions of all of its members. We are a nation of immigrants who came to this country through struggle and with hope of a better life. Our ancestors dared to dream, endured, and succeeded. It is our responsibility to tell their stories, to inspire our youth to have the courage to dream for themselves. Our cultural heritage can, and should, do all of this and more.

JULIANNE (JULI) POLANCO is the California State historic preservation officer and former chair of the California State Historical Resources Commission. Among her roles in cultural resources, Juli served as the director of cultural resources for Lend Lease Americas and as federal preservation officer at Presidio Trust. She has held several environmental and natural resources positions at the California Environmental Protection and Resources Agencies, and staffed four California governors and a member of Congress. She received a BA in political science from University of California, Santa Barbara, and M.S. from Columbia University, Graduate School of Architecture, Planning, and Preservation.

A City Visible to Itself

RICHARD RABINOWITZ

For a century following the American Civil War, United States cities grew by developing functionally and demographically distinguishable districts: a civic center, a financial district, downtown shopping streets, an entertainment area, parks and beaches, zones for heavy and light industry, waterfronts and rail yards near warehouses and distribution routes, residential sections defined by race, class, and ethnicity, and so on. Every city had more or less the same roster. Each area had its distinctive architecture, its own decorum, its particular clock and calendar.

In the late 1960s, things began to be jumbled up, and by 2000, every sort of use could be found in almost any part of any city. Artists began to colonize disused industrial space as production facilities, and turned parks and streets into exhibition and performance spaces. Places like Times Square lost their monopoly on nighttime attractions. Inner-city row houses, often converted during the Depression and war years into boarding and rooming houses, were restored to single-family domiciles or condominiums. Developers and local civic associations slapped new names on old neighborhoods, often evoking preindustrial landscapes: Soundview, Boerum Hill, Carroll Gardens.

Now these areas of the city have become distinguishable chiefly by their narratives. New York's Soho, Dumbo, Williamsburg, Meatpacking District, Red Hook, and Flushing were once important sites of industrial production and labor, but now their stories are mostly invitations to consumption. Their images as used in "lifestyle" advertisements connote "stroller moms," cricket matches, "Smorgasburg," ethnic festivals, and so on. The preservation of historic—or better,

"historicized"—districts advances this transformation of places into commodities.[1] In New York City, the carefully researched historic district reports that supported designation by the Landmarks Preservation Commission of the city's 114 districts (plus twenty extensions of previous designations) focus almost invariably on only one story: how this particular local landscape came to be dominated by a consistent and coherent architectural form.

The result of the commission's work is reflected in the brown signs posted high on streetlamps within the historic district. There is one across the street from my house. It has a map of the Park Slope Historic District on one face, impossible to decipher from ground level. The reverse side explains the value of the district:

PROSPECT PARK, LARGELY COMPLETED BY 1873 AS THE MASTERPIECE OF FREDERICK LAW OLMSTED AND CALVERT VAUX'S LANDSCAPE DESIGNS, DEFINED PARK SLOPE AS A DESIRABLE RESIDENTIAL NEIGHBORHOOD. PRINCIPALLY BUILT BETWEEN THE MID-1880S AND WORLD WAR I, PARK SLOPE RETAINS ITS 19TH CENTURY PROFILE OF THREE AND FOUR-STORY BUILDINGS, PUNCTUATED BY CHURCH STEEPLES, RECALLING BROOKLYN'S CHARACTER AS THE CITY OF HOMES AND CHURCHES. THE MONTAUK CLUB, A VENETIAN GOTHIC PALAZZO, BUILT IN 1891, AND MONTGOMERY PLACE, A BLOCK-LONG STREET, MUCH OF WHICH WAS DESIGNED BY ARCHITECT CASS GILBERT, ARE THE MOST DRAMATIC OF THE NEIGHBORHOOD'S ARCHITECTURAL CREATIONS. VICTORIAN GOTHIC, QUEEN ANNE, ROMANESQUE REVIVAL, AND OTHER STYLES ABOUND HERE.

(I give the wording in capital letters here because that it how it appears, to the detriment of legibility, on the sign itself.) In the world of this sign, only Architecture matters: it alone has the power to "define" neighborhoods, "recall" urban character, and "dramatize" places ten or twelve blocks away. In this neutron-bombed landscape, "styles abound," but there are no people. How Park Slopers made a living, chose their houses of worship, supplied themselves with food and clothing, responded to wars and depressions, welcomed or resisted waves of immigrant incomers, or experienced anything of

RICHARD RABINOWITZ

daily life—or even went about the highly relevant processes of gen-trifying, rehabilitating, and celebrating their residences—is not the concern of the commission. Nothing of note has happened here for over a century.

As with most markers of this type, it's great if you already know all this stuff—if you can tell Queen Anne from Romanesque, if you recognize the architects' names, and if you know how to find the nearly moribund Montauk Club. If not, you're out of luck. Your history counts for naught. Ada Louise Huxtable famously claimed that preservation ensured that "the meaning and flavor of those other times and tastes are incorporated into the mainstream of the city's life."[2] But the idea that the only con-duit connecting the past to the present is architecture is nonsense. As long as we define our communities only as properties, we disas-trously narrow the dimensions of our shared history. This erasure of the everyday lives of ordinary New Yorkers goes on and on. We have recently made lovely, highly praised parks out of two major chunks of our industrial and commercial past—the High Line and Brooklyn Bridge Park. Neither acknowledges the slightest link between these landscapes and the historical circumstances or populations that cre-ated them.

Historical awareness cannot be achieved through the preservation of individual buildings.

Historical awareness cannot be achieved through the preservation of individual buildings and districts. Conventional markers that recall "famous" events—the birthplaces of celebrities, the sites of Indian massacres, and so on—are not sufficient. We need a "One Percent for History" program that will tell locals and their guests where they are in the flow of time. New construction and adaptation projects should be asked to annotate the social archaeology of their sites. Our cities are flush with new public amenities, but these are more often plat-forms for commercial advertising than for locational identifiers. Bus shelters could easily tell us how transport routes constitute a palimp-sest of urban journeys over many decades. Street benches can help us recall the folk wisdom of those who lingered on the sidewalks of earlier generations. Bike racks, street lamps, playground furniture, subway information kiosks—rich with interpretive images, texts, and

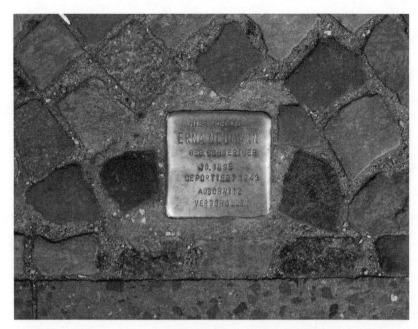

Stolpersteine ("stumble stones") in Rome. These brass markers, first installed in Germany by Gunter Demnig and now numbering almost fifty thousand across all of Europe, mark the homes of the victims of fascism. In Rome, these *stolpersteine* mark sites of Jewish and non-Jewish victims of Nazi occupation in 1943. PHOTO COURTESY OF MAX PAGE.

other media—can enliven the cityscape with the memories of the artistry, voices, and struggles of the past, rather than pretend that they sit in a tabula rasa. We want interpretive devices to tell us something about the ground and air we occupy: "This was the tallest structure in the city when it was built." "In the 1850s you would have seen piles of merchandise six times higher than this sign." "The bricks for this house came down the river and were unloaded at the pier just west of here." "Every World War II sailor passed down this street." And so on. Then a marker would operate like a well-informed sidekick and not an old-fashioned busybody droning on about trivia.

Stumble stones, like those now reminding Europeans of the individual tragedies of the Holocaust or Argentines of the "disappearances" of the 1970s, restore human presence to the mechanical efficiencies of urban life. Best of all, wholly new designs can remind us of topographies, patterns of life, and biographies obscured by "progress." The

RICHARD RABINOWITZ

splendid North End Park in Boston, for example, brilliantly evokes in its design the crossing of the low "saddle" between the North End ethnic neighborhood on Copps Hill and the downtown business district. Details of the park remind us that this was once a wetland, then a canal and millpond, a street between the city's two railroad stations, an elevated expressway, and finally the tunneled roadway of the Big Dig.

Some of this, surely, can be accomplished by producing apps linked to GPS for mobile devices. But implanting our collective memory in the physical landscape pays important dividends for our current citizens. That one travels to work in the "groove" formed decades ago by market gardeners and shipyard workers dignifies the passage. It is doubly refreshing to know one can fill a water bottle at the site of a well where enslaved women gathered, secretly, to share gossip and ways of resisting oppression. By respecting our forebears, these humble insertions make the contemporary city visible to itself.[3]

RICHARD RABINOWITZ, as president of American History Workshop, has led creative teams in over five hundred history museum planning and exhibition projects around the United States. His book, *Curating America: The Past as Storyscape*, is forthcoming in 2016.

NOTES

1. David Hamer, *History in Urban Places: The Historic Districts of the United States* (Columbus: Ohio State University Press, 1998), ix, 145–50.
2. Ada Louise Huxtable, "Where Did We Go Wrong?" *New York Times,* July 14, 1968.
3. Karilyn Crockett, "A City Invisible to Itself," *ArchitectureBoston* 17, no. 1 (Spring 2014): n.p.

I Want You to Run for Office

BERNICE RADLE

I want you to run for office. Pick a political office that makes the most sense to you and run. Run hard and don't be afraid. You're an activist! A change maker! You stand up for preservation every day! Your years of creating and building successful campaigns to save buildings will help you WIN.

Campaigns are hard work, but you are more equipped to handle a hard campaign than anyone else. At the end of the day, being a decision maker to drive preservation-related policy is the single most effective thing you can do. The future of preservation needs you— you can do this!

Here is why we need you to run for office. Typically preservation efforts are driven by one of two major issues, and policy plays a critical role in each scenario: economic or population decline, leading toward demolition by neglect, or, just the opposite, so much success in a concentrated area that historic buildings become targets for redevelopment.

Being a Buffalo girl, I'm going to talk Buffalo.

Cities across the United States are making a giant comeback these days. For the first time in fifty years, Buffalo is seeing an increased number of people wanting to live, work and play in the city—the excitement surrounding the Nickel City is remarkable! Real estate is booming—with over five billion dollars in economic activity now under way or recently completed. Much of this development can be credited to the success of New York State's historic tax credit program, which has been so successful in focusing investment in the urban core that we're running out of vacant historic buildings to rehabilitate downtown.

However, despite our recent growth and insatiable Buffalove, we have areas of the city that have lost nearly 90 percent of their population since 1950, and over 50 percent of our children are living in poverty. The vacancy crisis is very real. Many important buildings remain at risk of demolition, including our Central Terminal, Buffalo's beloved art deco train station.

You may ask—why is this happening? Why would we tear buildings down when there is huge demand for these buildings? In my experience, it comes down to the vacancy vortex, the need for policy changes and the need for YOU.

The Vacancy Vortex. The Vacancy Vortex is a nightmare for our neighborhoods. It is a spinning tornado that sucks the life out of buildings and rarely spits them out alive. It is an invisible force of "reasons" as to why our buildings become vacant and stay that way. The worst part is that 90 percent of the time the vacant house is wanted by someone, but once it's trapped in the vortex, the process of acquiring the vacant building is so daunting that even the most determined folks with the best intentions and financial situations find it nearly impossible to navigate or understand.

Why do properties become vacant? There's a plethora of reasons. A home owner dies and the house goes into estate hell. The neighborhood has declined and thus the value of the property isn't worth what it costs to maintain it. Abandonment. Fire. Crime. Slumlords. Housing inspectors are overloaded with calls and cannot handle cases quickly, so they rot in the process. An owner owes thousands of dollars in back taxes and liens. The owner owns way too many properties and cannot maintain them. And the list goes on and on.

The worst part is what happens when the house becomes vacant. It immediately means that it no longer qualifies for a bank loan. If you can afford to buy it with cash, good luck getting insurance as you renovate it. If it is vacant during the winter without proper heat and mothballing techniques, the water pipes freeze and burst and within a day the entire house is flooded, adding thousands of dollars in necessary repairs. In the springtime, that water melts and you're left with giant mushrooms, mold, and extreme water damage. In Buffalo, we have thousands of properties in this state. Thousands. See why the vacancy vortex is an absolute nightmare?

How do you change this? It all comes down to policy. Let's look at a few examples that can be applied to almost any city.

Mothballing. Here in Buffalo, you're required to keep the first floor of your vacant building secure, but nothing is said about the second floor. Broken windows let in rain, snow, and vandals, and pretty soon you have rot, fires, and crime issues. A simple change in the language to mothball the ENTIRE building properly could easily result in saving thousands of dollars in damages!

..

I challenge you to get involved in politics.

..

Moratorium on Demolitions. One of the coolest things a politician can do is impose a moratorium. A moratorium on demolition can temporarily halt demolitions in an area, giving you time to study the issue more deeply, initiate a positive community conversation, or find the right investor to buy and renovate a property.

Housing Court. Our housing court handles thousands of housing violations each year. They are overworked and backed up, meaning that buildings stay vacant or in disrepair even longer. It would be amazing to have more staff and support for housing court—which is a policy decision!

Zoning. In Buffalo, we are about to launch the largest preservation initiative in history—the Buffalo Green Code. It is a complete overhaul of our existing zoning code. While this may sound boring to some, this new code will put the focus on walkable, dense neighborhoods that promote transit-oriented development, sustainability measures, and historic preservation. It will remove barriers to adaptive reuse and infill development, helping prevent vacancy before it starts. It will promote high-quality design that promotes sustainable neighborhoods, rebuilding property values and helping reverse the forces that have led to decline. When it is implemented later this year, it will be the most progressive zoning code out there. This policy is a game changer!

I will leave you with this:

I challenge you to get involved in politics. Run for office. Be at the table. Change policies and promote preservation in your community! And if you're scared, reach out to your friends here in Buffalo, because we are here to help, always.

BERNICE RADLE

BERNICE RADLE is a sustainable neighborhood maker in Buffalo, New York. She is the owner of Buffalove Development, a real estate development company focused on rejuvenating vacant spaces and places. She is a leader in Buffalo's Young Preservationists and was awarded the Peter H. Brink Award by the National Trust for Historic Preservation in 2014. She is the creator of the "heart bomb," a nationally known preservation initiative, and you can find her work highlighted in the *New York Times, Citylab, Huffington Post, Deadline Detroit,* and TedxBuffalo!

Preservationists Must Be Anti-Gentrification Activists

GRACIELA ISABEL SÁNCHEZ

Contemporary historic preservationists recognize that much preservation work in the past was informed by race, class, and gender bias.[1] Leading preservationist organizations now express commitment to greater inclusiveness.[2] To achieve this important goal, preservationists must become anti-gentrification activists.

Preservationists must become anti-gentrification activists.

I grew up in San Antonio's Westside, a center of Mexican American life since the late 1800s. For most of the twentieth century, it was one of the few areas in San Antonio where Mexicans were permitted to live and own property. Today it remains the corazón of San Antonio's Mexican American community, which makes up over 67 percent of the city's population.

It is difficult to describe the layers that comprise the culture of Mexican Americans living for generations in San Antonio's Westside. I learned this culture from my abuelitos, my parents, and neighborhood sabias (wise ones). Today, children are still taught to respect and care for others. We learn the values of cariño, compasión, living simply, and being humble. Each of us is part of a family and neighborhood—if food is available, it is to nourish all. For generations, we have learned to challenge the powerful who hurt our people, pollute our environment, and steal our land. We march and demand civil and human rights, risking injury and retaliation. These are lessons about racism and power, but also about culture and identity. Through them, we learn to survive in a hostile world without losing the ability to love. Our survival depends on remaining grounded in our

cultural roots, and this depends on being able to live in an inter-generational, interconnected neighborhood. Recognizing all that we have survived, we see how easily our lives and culture can be destroyed.

In the 1970s, urban renewal devastated our community. Our homes and tienditas were bulldozed, replaced with cheaply made homes and vacant lots. My family, for example, lost two sturdily built wooden houses, approximately 2,400 square feet—made with long-leaf pine, a wonderful wood that is now largely extinct—and was moved one half block north to a cement house built by a powerful local developer, with 900 square feet of living space that is now permeated by mold. The fruit trees were uprooted, medicinal herb gardens paved over, roosters and hens outlawed. Traditional neighborly bonds were severed and the wise ones—curanderas, sobadoras, hueseras, all of the healers—were driven out. Many families were forced to move, placated by the hope of a middle-class lifestyle, only to find themselves isolated and unwelcomed in their new neighborhoods.

In the 1980s and '90s, changes in public housing policy led to further disruption of our communities. The Housing and Urban Development's HOPE VI policies decreased the amount of truly affordable housing in the inner city and led to mixed-income buildings designed to resemble gated communities, shut off from our neighbors and isolated behind tall fences.[3] These projects cause parts of the Westside to feel alien, like the suburbs.

Fortunately, much of the Westside survived both urban renewal and HOPE VI. Significant portions of the Westside remain coherent, tightly knit neighborhoods, sharing a distinct Mexican American language and culture. The Esperanza Peace and Justice Center, of which I am the executive director, is working together with its allies to preserve these areas and to restore the community's historic stability and interconnection. Current residents must be given the resources we need to rebuild our homes and revitalize our community life. Homes, transportation, and jobs must be made available for our displaced parents, children, herman's, ti@s, and abuel@s who long to return to the Westside.[4]

Sadly, the current plans for Westside "neighborhood improvement," "economic development," and even "historic preservation" adopted by the city government and its development partners threaten the final

destruction of this nationally important historical and cultural community. The central goal of these plans is to create upscale housing and other amenities attractive to middle- and upper-class buyers. The vision is to transform the Westside into an "economically integrated" and "culturally diverse" community populated by educated and affluent young families. In this view, the goal is "positive gentrification."

The Esperanza Peace and Justice Center is a multi-issue cultural organizing and activist center serving San Antonio and South Texas. Since 2000, the Esperanza has focused a significant part of its work on the historical and cultural preservation of San Antonio's inner-city communities of color. This experience has led us to believe that if historic preservationists are serious about the desire to preserve the history and culture of communities of color, they must find ways to prevent the gentrification of inner-city communities. In San Antonio, the struggle to prevent gentrification is going to have to take on some of the most formidable economic interests in the city because inner-city redevelopment promises huge profits and historic preservation is at risk of becoming mere "value added" for the developers. Inner-city communities of color throughout the nation are facing similar threats.

To preserve these irreplaceable communities and the cultures that thrive within them, historic preservationists have to stand with us not only as preservationists but also as anti-gentrification activists. We must aggressively advocate for increased public spending to improve the quality of life for current residents in historically marginalized inner-city neighborhoods, including individual home improvement grants, well-maintained and improved parks, accessible sidewalks, and public arts and cultural programming. We must fight for renters' rights, including the right to prevent displacements through property sales. We must support historic designation for whole neighborhoods under laws giving those neighborhoods the power of self-regulation. And we must demand property tax caps that will protect current residents from rising property values.

Anti-gentrification preservationists must resist the empty lure of "economic development" promoted by developers and the local officials who support them. It is not enough to say that developers will bring investment or that short-term construction projects will employ

GRACIELA ISABEL SÁNCHEZ

our people. That is not "economic development"; that is "economic exploitation." To paraphrase environmental activist Vandana Shiva, we are not those being "left behind" by gentrification and economic development, we are the ones being robbed.[5]

To be good allies, preservationists will have to listen, to learn, and to support the leadership of local residents of color. Many communities of color have long-standing practices of cultural and historic preservation. Preservationists who have not worked in inner-city communities may find these practices strange or unfocused. Indeed, our practices differ from mainstream preservation work in many ways, and yet they offer important insights for our allies.

To do this work, we must be passionate. Remember: when we get dismissed, demonized, or jailed, we are preservationists, as well as activists. We are people who do the research, think and analyze, and follow the rules. Yet when all else fails, we take to the streets and, if necessary, disobey civil authorities. Stay with us. Don't go home when one of our historic buildings or neighborhoods is slated for imminent demolition. Don't expect us to make noise so that you can step in as the grown-ups. It is hard on our bodies and distressing to our families when we have to resist at that level. You can join us and put your lives, jobs, and reputations on the line too.

Finally, remember that this fight is critical. Without effective preservation of inner-city neighborhoods, a huge part of our national legacy will be lost forever. Historic preservationists have a critical role to play in averting this disaster. Please heed the call.

GRACIELA ISABEL SÁNCHEZ, after graduating from Yale University in 1982, returned to her childhood neighborhood on the near west side of San Antonio, where she remains a dedicated community organizer. As an organizer in the queer community, she became a founding board member of the San Antonio Lesbian Gay assembly, the San Antonio Lesbian/Gay Media Project, and ELLAS, a state and local Latina lesbian organization. In 1987, Sánchez joined other women in founding the Esperanza Peace and Justice Center, which she continues to direct. In 1992, Sánchez received the Stonewall Award in national recognition of her work in promoting lesbian rights.

NOTES

1. One measure of this bias can be seen in the National Register of Historic Place, which contains a total of 95,153 entries, of which only 3,081 (less than 3.24 percent) are protected because of their association with communities of color.
2. See, for example, "Preservation Priorities," National Trust for Historic Preservation, www.preservationnation.org.
3. The HOPE VI Program was originally developed as a set of policies adopted in 1992 by the Departments of Veterans Affairs and Housing and Urban Development. It was named HOPE VI, connecting it to the five HOPE (Home Ownership for People Everywhere) programs enacted in 1990. The HOPE VI program funded the demolition of existing public housing to be replaced by new "mixed income" neighborhoods. HOPE VI has been widely criticized. A report of the National Low Income Housing Coalition (NLIHC) includes these observations: "Under HOPE VI, tens of thousands of public housing residents have been displaced. Old public housing has been replaced with mixed income neighborhoods with far fewer units that are affordable to the original residents. Most have not been able to return." NLIHC report, *Affordable Housing Dilemma: The Preservation vs. Mobility Debate*, May 2012, at 24–25.
4. This is one of the conventions adopted by some progressive writers to avoid the patriarchal practice of signifying both genders with male pronouns or, in Spanish, to use the male form of nouns to signify both genders.
5. See Vandana Shiva, "Two Myths That Keep the World Poor," *Ode Magazine*, November 2005, n.p. Dr. Vandana Shiva is a physicist and prominent Indian environmental activist. She founded Navdanya, a movement for biodiversity conservation and farmers' rights.

GRACIELA ISABEL SÁNCHEZ

Riding Preservation's New Wave

How to Build on Movements for Memoria

LIZ ŠEVČENKO

Over the last few decades, a shadow preservation movement has stolen across the world. It's wildly successful, yet rarely recognized. In Argentina, for example, historic preservation was traditionally tied to *patrimonio,* the national heritage maintained by a few government offices. But starting in the 1990s, a massive social movement to hold the military dictatorship of the 1970s and '80s accountable for its crimes birthed a campaign for *memoria;* thousands of people took to the streets to mark and preserve places and traces of state terrorism so that they would be remembered by future generations. Both *memoria* and *patrimonio* preserve places from the past to integrate them in popular understanding of the nation. But they occupy radically different spaces in policy, practice, and public consciousness: one is elite, static, and rooted in cultural institutions; the other is populist, urgent, and part of current social movements.

> A shadow preservation movement has stolen across the world.

Parallel problems—and possibilities—have arisen in many other countries undergoing dramatic political transitions since the 1990s. New governments from South Africa to Sierra Leone have responded to popular insistence that the society as a whole must confront the most difficult and violent pieces of its past in order to build a democracy with any hope of lasting. A new framework has emerged in law and governance, known as transitional justice, encompassing a variety of tools societies can use to pursue justice and accountability for mass crimes. For many, this includes remembering and preserving

sites and stories of struggle, in order to open a new dialogue about how to confront new struggles today. That's historic preservation at its best—and it's happening in spectacular ways around the world, with popular support most preservationists could only dream of. But it's happening using different approaches and different skills than preservationists typically use; and outside the fold of traditional preservation apparatuses.

This is not to say that these are exclusively grass roots movements: while many emerged from civil society efforts, they have since generated new state apparatuses and legal frameworks. Reports emerging from truth commissions and other investigations often include recommendations for "symbolic reparations," which include everything from formal apologies to memorials. These state mandates to remember can translate into significant state support for *memoria*-type preservation. For example, the justices of the first democratic South African Constitutional Court constructed the new court building on the site of the Old Fort Prison, where Nelson Mandela, Mahatma Gandhi, and countless others had been jailed under apartheid. The result was a multi-use complex called Constitution Hill that preserved a significant portion of the Old Fort as a museum (undertaken by a new Heritage, Education, and Tourism state entity). Responding to calls from civil society groups like Memoria Abierta, President Nestor Kirchner created a government commission to preserve Argentina's most infamous center for disappearances, the Escuela Mechanica de la Armada, as a Space for Memory and Human Rights; and municipal offices across the country oversaw forensic archaeological projects to uncover hidden sites of detention. Spain instituted a "Law of Historical Memory" to confront, among other things, sites of dictator Francisco Franco's victims; on an international level, the United Nations' Joint Principles establish "a right to know the truth" about past human rights violations. These memoria policies explode traditional definitions of heritage and history. But they have not yet developed coherent approaches for treating historic fabric.

Preservation practice in the next half-century can be reinvogorated by bringing together the approaches and organizational structures represented by *memoria* and *patrimonio*. To do so will develop four specific new areas:

Research and develop memoria policies and the structures to support it. A flexible but applicable international language of *memoria* preservation could be of tremendous value to preservation efforts in the United States and around the world. In some places, where the traditional *patrimonio* preservation structures are deemed inappropriate for certain sites (perhaps because of their history of preserving the narratives of the former repressive regime), but there is no *memoria* structure to replace it, vitally important projects can fall between the cracks. In Kenya and Turkey, for example, the responsibility to preserve prisons that stood as iconic symbols of a former conflict initially fell to the ministries that managed security, since they technically governed the property. But in other places where the *"memoria"* preservation movement has had decades to mature, such as South America and South Africa, it has established new regulatory frameworks and practices, and the formal structures to support them. Further research into what offices, codes, and processes now exist to preserve sites associated with state terrorism or apartheid, how well they are working, and whether and how they are working in concert with the *patrimonio* preservation structures that preceded them could provide an extremely valuable resource.

Deliberately look for faultlines. Seek out places that are lighting rods for intense feelings and opinions on a raw or unresolved history that may deeply divide people. Mainstream preservation standards and practices have evolved greatly to be much more inclusive of more diverse histories, especially those remembering marginalized communities. But most places win the right to be preserved only when—and because—there is a broad consensus around their historical importance. This consensus framework will always limit the diversity of histories to be preserved, as nearly all histories of subaltern peoples are histories of conflict—and most of these conflicts remain unresolved today. It's at these places that the work of next-generation preservationists is most needed.

Train in dialogue. Playing a central role in civic life means moving beyond community consultation and its framework of rubber-stamping. To do so, preservationists need intensive training in a variety of forms of dialogue. This must include training in how to recognize what forms of exchange and engagement are required to pursue

which goals. For example, if a situation requires that parties in conflict come to a specific decision, preservationists need to employ specific consensus-building strategies; for situations that require building long-term understanding and empathy between divided groups, open-ended dialogue may be better.

LIZ ŠEVČENKO is director of the Humanities Action Lab, a consortium of twenty universities across the United States, led from The New School in New York City, whose students and stakeholders collaborate on projects remembering the histories of contested contemporary issues. She was founding director of the Guantánamo Public Memory Project and the International Coalition of Sites of Conscience, a network of historic sites that foster public dialogue on pressing human rights issues. Before launching the coalition, she was vice president for programs at the Lower East Side Tenement Museum, where she developed exhibits and educational activities that connect the stories of the neighborhood's immigrants past and present. She has a BA from Yale University and an MA in history from New York University.

Preserving People

..

MICHAEL SORKIN

New York's most important piece of preservation legislation was passed in 1942: our rent regulations. These laws were designed to offer tenants additional security during wartime, to protect them from economic travail and dislocation as they bent themselves to a collective—and urgent—good. In 1947 the regulations were institutionalized in their current form. What was literally "protected" were rent levels, but what was effectively secured was tenure. Although winnowed, our rent controls continue to be bulwarks of community, cementing diversity and thwarting destruction of human habitat: these laws landmark lives.

Our architectural landmark laws don't. Even district-wide styles of preservation are enabled almost entirely by purely formal criteria and by a preference for memory over vitality. Ancillary impacts remain a matter of dispute. Developers and owners resent the implicit "taking"—seizure of property without "just" compensation—when the law forbids them to demolish or alter their buildings. Others argue that these protections have the opposite effect, serving as fulcrums for gentrification. The law itself—and the commission that extends it—are little interested in the lives currently led or the fragility of the human ecologies that inhabit these places. Indeed, a recent attempt by a group from my own, heavily landmarked, neighborhood to argue for the enlargement of the district based on the prospective inclusion of a large number of long-standing rent-regulated tenants whose buildings would be saved from demolition met only with indifference.

But the law, in its conception, does offer some slack for extra-architectural considerations. One of the most recent landmarkings in New York was the Stonewall Inn, a little building of no special

architectural quality that was the scene of the Stonewall Rebellion, a heroic moment in the struggle for gay rights. Here, the commission held that the *events* that had taken place at the inn were so consequential that it deserved protection. In effect, the Stonewall was accorded the status of a battlefield (which, indeed, it was)—the setting for "great" human occurrences. And the commission has also been ready to extend the mantle of consequence to scenes that are more generally emblematic. Tenement buildings have been preserved. The Garment District—where remnant manufacture is under the squeeze of a rent gyre—is up for discussion and the arguments for its importance already far exceed the architectural.

But how to measure such nonarchitectural significance?

But how to measure such nonarchitectural significance? Clearly, one key to an expansive view is that what's commemorated is often collective: the Stonewall triumph or the Triangle Shirtwaist fire tragedy were about groups of people. We readily preserve the homes of seminal individuals and the sites of their accomplishments, transferring the auras of both lives and events to the material settings in which they unfolded and the principle is easily expanded to embrace both larger cultural forms and expressions: New York already preserves districts found beautiful or "historic" in ensemble. Landmark laws celebrate nonarchitectural human accomplishments by protecting the physical environments that sheltered—even nurtured—them. Even when their design is ordinary, certain classes of buildings are held, via this transference, to possess rights, principally the right to remain, itself an enshrined *human* right. This enfranchisement of the inanimate might disquietingly remind one of the weird outcome of the Supreme Court's *Citizens United* decision and its conclusion that, from a legal standpoint, corporations are people. While this surely seems to be a promiscuous category error in its sinister displacement, it's not an entirely unfamiliar one. The standard of venerability, for example, is a widely felt, even reflexive, source of respect for both people and objects, and the idea that a collective entity should have some of the privileges of an individual is not bizarre.

However, the nuance in the distinction between preservation and

MICHAEL SORKIN

conservation (the latter understood as the tool that enables the former) suggests that national parks are a better model than battlefields for thinking about the application of landmarking to neighborhoods that are still dynamic but threatened by other (mainly market) forces. I can recall a trip to Krakow, where the Jewish quarter is "preserved"—including kosher restaurants (with ersatz "Jewish" waiters)—in the virtually complete absence of Jews. The conservation of the ghetto is both a form of guilty redress and a particularly grotesque example of the meaning-stripping, neutron-bomb approach of traditional architectural preservation. The real question is not whether preservation laws can cast the past in amber but whether they can help protect real neighborhoods without looting them of life.

Although the original intent behind the national parks may have been couched in a combination of cultural, scopic, and romantic regimes, it has secured these territories not simply for spectatorship but as *ecologies*. We defend them in this complexity via the extent of their space, via the prohibition of activities thought inimical, and via various practices of "conservation"—some of which (like firefighting) are arguably forms of interference with "natural" processes. But the very size of the parks—their real vastness—surely suggests that much of what they preserve is quotidian, that they are fields of diversity with an ark-like aspiration to taxonomic comprehensiveness for all of the nature within them, something that was, at the time of their founding, conceived as fundamentally other than human and required protection from our instinctual rapaciousness (the meaning and intent of contemporaneous Indian "reservations" is another subject). But people are organisms too and the city is our increasingly predominant habitat.

The exteriors of approximately thirty-three thousand buildings are landmarked in New York City, but only slightly more than one hundred interiors are protected. This divide is clarifying, reflecting not simply a reticence to interfere with private activities (and an attempt to divorce architecture's public, civic, face from them) but also a useful means of exclusion of their *current* uses from the preservation agenda. It's time to re-understand the remit of landmarking in a way that embraces far more than artistic criteria and to give it a robustly sensitized role in how we plan, making it part of the toolkit of

techniques we use to cultivate and protect our indigenous urban life-forms. That is, we must make preservation alive to the "internalities" of its too purely architectural preoccupations.

Which brings us back to rent regulations. New York—like the rest of the planet—is caught up in a radical and growing inequality, which manifests itself as, among other things, a crisis in housing affordability. Our municipal administration is struggling to expand opportunities both by increasing supply and by preserving existing sites and strategies. In too many ways, though, our landmarks policy contradicts this larger policy of social preservation. Is it absurd to think that these two ambitions might be harmonized? Alas, the opposite seems to be happening as the city deploys the blunt instrument of increased density to create added real estate value that it will then attempt to capture as trickle-down to fertilize its social programs. Meanwhile, precious buildings are saved, but the benefit to the environment is more and more reduced to mere prestige, camouflage for the cruel cleansing of gentrification. It is time to link architectural preservation to human preservation. Neighborhoods are people too!

MICHAEL SORKIN, an American theoretician and critic, studied architecture at Harvard and MIT. For a decade he wrote about architecture in the well-known New York weekly the *Village Voice*. At the same time he taught at several universities, including Yale, Harvard, Columbia, and Cornell. His many writings focus primarily on the social aspects and political implications of architectural and urban planning projects.

Teaching Landscape Literacy

Historic Preservation and Community Knowledge

ANNE WHISTON SPIRN

Landscape, in the original sense of the word in Old English and the Nordic languages—the mutual shaping of people and place—links the population of a place with its physical features: its landforms, highways, buildings, and gardens. Individuals and societies inscribe their values, beliefs, ideas, and identities in the landscapes they create, leaving a legacy of stories: natural and cultural histories, and landscapes of poetry, power, and prayer. These stories are

The language of landscape is a powerful tool.

told and read through a language of landscape with its own elements, pragmatics, and poetics.[1] The language of landscape is a powerful tool. To read and shape landscape is to learn and to teach: to know the world, to express ideas, and to influence others. Landscape permits people to perceive pasts they cannot otherwise experience, to anticipate the possible, to envision, choose, and shape the future. Historic preservation has a critical role to play in conserving the tangible history and cultural memory that landscape represents.

Since 1987, West Philadelphia's Mill Creek watershed and neighborhood (among the poorest in Philadelphia) has been my laboratory to test and generate ideas about landscape language, landscape literacy, and how to restore urban ecosystems and rebuild community in synergistic ways. Learning landscape literacy enabled Mill Creek residents to read the environmental, social, economic, and political stories embedded in their local landscape and gave them a way to formulate new stories, to envision how to transform their neighborhood. Just as verbal literacy was a cornerstone of the American civil rights

movement of the 1950s and '60s, landscape literacy empowered Mill Creek residents to recognize and redress injustices embodied in their landscape, to build pride and self-confidence.[2]

When I first started working with middle school students in the Mill Creek neighborhood, I was stunned by their conviction that nothing could change. They were living in an eternal present. They could not imagine that the neighborhood had ever been different, and they did not believe that it could ever become different. And yet the landscape of their neighborhood embodies dramatic changes: from forest to farms and rural retreat to streetcar suburb to inner-city neighborhood.

Two blocks from the school, at the bottom of a valley at the corner of 46th Street and Haverford Avenue, one can read this history in a large block that slopes up toward the northeast. Once split up into multiple blocks and covered by homes, it was a grassy meadow with a grove of trees (a resurgence of the original forest) in the late twentieth century and is now a ball field, church, and apartment complex. At the northwest corner is an open lawn, a right-of-way for the sewer below, which was built in the 1880s on Mill Creek's former stream- bed. The open lawn is contains a trace of the homes once constructed directly over the sewer and demolished in the mid-twentieth century. A high stone wall runs along the south side of Haverford Avenue, east to 42nd Street and west to 49th; it was built in the mid-nineteenth century to enclose Pennsylvania Hospital's buildings, gardens, and psychiatric patients. The western branch of the hospital still functions as a psychiatric facility, but the eastern property was sold and its build- ings demolished in 1959 to make way for the towers of West Park, a public housing project. Uphill to the east, behind the stone wall of the old hospital, the roof of an eighteenth-century mansion is visible (but does not appear on maps of Philadelphia's historic houses!). Once part of Mill Creek Farm, a country retreat established in the 1790s, then sold to the hospital in the 1830s, it is now surrounded by ball courts and is a public recreation center. Downslope, in the valley where the creek once flowed through the farm and hospital grounds, is an elementary school that was built in the 1960s and an enclave of townhouses constructed in the 1990s.

Over the course of six weeks, the middle school students learned to

ANNE WHISTON SPIRN

read this landscape. My students from the University of Pennsylvania brought in historical documents—maps, photographs, newspaper reports, and plans. Together, in a succession of weeks, each week representing a different time period, they traced how the neighborhood developed over time: William Penn's letter describing his first meeting with Native Americans, maps depicting the creek and mills along it photographs of the sewer and subsequent cave-ins, the 1930s Home Owner's Loan Corporation map that provided a basis for redlining, and the Mill Creek redevelopment plan of 1954. From this experience, it was a short step to reading the surrounding landscape, which is itself a primary document. Landscapes are public history made tangible.[3]

Learning to read the history of their neighborhood gave these kids a sense of the future. Before they learned to read their landscape more fully, they had read it partially. Without an understanding of how the neighborhood came to be, many believed that it had always been the same, that the poor conditions were the fault of those who lived there, a product of incompetence or lack of care. Learning that there were other reasons for present circumstances, such as public policies and decisions made by outside institutions, sparked a sense of relief. The students began to see their home in a more positive light, came to consider the possibility of alternative futures, and brimmed with ideas. Understanding their own landscape also opened wider vistas. It introduced them to broader social, political, and environmental issues and promoted other kinds of learning. And it transferred to their own lives. They could imagine their own lives being different.

The scope of historic preservation must extend from the individual building to the larger landscape. It must address environmental, as well as cultural, history. It must identify and treat historical resources in the poorest neighborhoods, as well as in the more affluent. Historic preservation must not only curate and conserve buildings and landscapes but also teach landscape literacy to the communities whose histories are embodied there. The domain of historic preservation should encompass all of these dimensions. If the field claims such a role, it could transform not just the built environment but the lives of those who reside there.

ANNE WHISTON SPIRN is professor of landscape architecture and planning at MIT and director of the West Philadelphia Landscape Project. For more information on WPLP and landscape literacy, see www.annewhistonspirn.com and www.wplp.net. She is the author of *The Language of Landscape* (1998) and "Restoring Mill Creek: Landscape Literacy, Environmental History, and City Planning and Design," in *Nature's Entrepôt: Philadelphia's Urban Sphere and Its Environmental Thresholds,* ed. Brian C. Black and Michael J. Chiarappa (2012).

NOTES

1. Anne Whiston Spirn, *The Language of Landscape* (New Haven, CT: Yale University Press, 1998.
2. Anne Whiston Spirn, "Restoring Mill Creek: Landscape Literacy, Environmental History, and City Design and Development," in *Nature's Entrepot,* ed. Brian Black and Michael Chiarappa (Pittsburgh, PA: University of Pittsburgh Press, 2012).
3. Dolores Hayden, *The Power of Place: Urban Landscapes as Public History* (Cambridge, MA: MIT Press, 1995).

ANNE WHISTON SPIRN

To Expand and Maintain a National Register of Historic Places

JOHN H. SPRINKLE, JR.

After all of the inspirational language found in the preamble to the National Historic Preservation Act, the very first activity delegated to the Secretary of the Interior in 1966 was "to expand and maintain a National Register of Historic Places." In the last fifty years, half of that goal has been achieved. The other half needs work.

Given where it started in the mid-1960s, the national preservation partnership has done an impressive job expanding the scope of the National Register. The criteria first published in 1969 were primarily based on a thirty-year track record of administrative review and historical evaluation by a National Park Service program whose mandate was to deter, deflect, and discourage the acquisition of new parks proposed for addition to a system already burdened with maintenance backlog issues. But the goal of the "new preservation" of the 1960s was never to acquire and interpret a comprehensive panorama of the American experience; its mission was to ensure that due consideration was given to historic places in managing the change that was to come in the last decades of the twentieth century.

Expansion of the register did represent the liberalization of preexisting recognition criteria. Frank Lloyd Wright's widely regarded residential masterpiece, the Robie House, was designated as a National Historic Landmark in 1963, but only after a five-year review period. The Park Service adopted "historic districts" as a property type only in 1965. Traditional resistance to the recognition of living persons, manifested in the little-remembered "twenty-five-year rule" that restricted historical evaluation until a generation after a person's death, was not adopted by the new preservation.[1]

By the 1970s, American historic preservation had been transformed from "an odd and harmless hobby of little old ladies in floppy hats who liked old houses" into an "integral, administrative part of city government dealing with an essential part of the city's fabric." It had become, noted Ada Louise Huxtable, an "environmental necessity."[2] *National Register Bulletins* helped expand the program by addressing a variety of historic places, including suburbs, battlefields, shipwrecks, landscapes, archaeological sites, and traditional cultural properties. Guidance for the recognition of the "recent past" has been updated three times since 1979. Since 2000, the inherently flexible criteria for evaluating historical significance and describing physical integrity were used to recognize sites as diverse as Elvis Presley's Memphis home, Graceland; New York's Stonewall Inn; and the Fresno (California) Sanitary Landfill. Despite this extensive guidance, over the years the National Register program has endured cycles of criticism for being too restrictive in the kinds of properties that are afforded official recognition. Current complaints focus on statistics that appear to indicate a lack of ethnic diversity reflected in the kinds of places listed—which is an unsustainable argument when considered in light of the register's information maintenance backlog.

The National Register can be seen as 1.5-million-page history textbook that illustrates the kinds of places that more than two generations of Americans have thought worthy of preservation. The documentation reflects the time and administrative context in which nominations were prepared and processed, and thus it is often out-of-date or incomplete. For example, the official name of Thomas Jefferson's Virginia State Capitol building is the "Confederate Capitol" because it was designated as a National Historic Landmark in 1961 during the centennial of the American Civil War. Many properties that have important associations with historical events or persons were listed only under Criterion C for their architectural qualities because it represented the easiest path to official recognition.

No one would expect a history textbook from the 1960s to reflect the current narrative of American history without significant revision, but the fact is that only 3 percent of the ninety thousand listings on the National Register have ever been updated for content. This backlog in the maintenance of the information contained within the National

JOHN H. SPRINKLE, JR.

Register is primarily the product of increasingly parsimonious funding for the federal preservation partnership and reflects the impact of a predominantly compliance-driven process in which the vast majority of sites evaluated using the criteria are never considered for nomination. At present there is little regulatory or fiscal incentive to update existing listings, which means the National Register will always be found wanting in terms of its comprehensiveness and can never achieve its full potential as a public archive. For anyone interested in recognizing the panorama of the American experiment, addressing the informational

No one would expect a history textbook from the 1960s to reflect the current narrative of American history.

maintenance backlog at the National Register is a worthy goal; it can empower our students through research projects, reconnect our work with our neighbors and communities, and ensure that decision makers are fully informed about historic places in our communities.

If the Smithsonian Institution is "the nation's attic," then perhaps the register is our national storage locker—one that we have been filling for nearly fifty years. To organize our unit, we have adopted and adapted criteria and conventions that have shaped which places we have decided to save and which places we have let go. To some the National Register might appear to be a cluttered, disorganized collection, but, with a little reorganization and some long-neglected repacking and relabeling of boxes, there is plenty of room in our national storage unit to include a new generation of historic properties that illustrate our collective past. Perhaps some rebranding is in order to address the National Register's maintenance backlog: let's imagine an interactive, widely accessible, authoritative, and crowd-sourced guide to our historic places and their stewards—a.k.a., "Placebook."

The views and conclusions in this essay are those of the author and should not be interpreted as representing the opinions or policies of the National Park Service or the United States government.

JOHN H. SPRINKLE, JR., after a decade of private sector experience in historic preservation, has served as a historian at the National Park

Service headquarters for more than fifteen years. He holds a PhD from the College of William and Mary and is currently working on his next book, which traces the interaction of the land conservation and historic preservation movements during the second half of the twentieth century. He is the chair of the Alexandria, Virginia, Historical Restoration and Preservation Commission.

NOTES

1. John H. Sprinkle, Jr., *Crafting Preservation Criteria: The National Register of Historic Places and American Historic Preservation* (New York: Routledge, 2014).
2. Quoted in "New York City's Landmarks Law at 50," *New York Times,* April 17, 2015.

Historic Un-Preservation

JOHN KUO WEI TCHEN

A key moment of the U.S. historic preservation movement occurred over one hundred years ago, not fifty. It was narrated as a pulp melodrama in which citizens of "character" gathered to stem "the first menace," which was "hatched" in fetid lofts spawning "the invasion." So began the campaign to "Save New York." The Fifth Avenue Association (FAA) mobilized its troops. If as Richard Hurd, the chief theorist of U.S. urban property value, has asserted, cities emerged as a "defence against enemies," this was the Anglo-Protestant call to arms.[1]

> We need to unravel historic preservation's foundational logics, its mystified origins.

We need to unravel historic preservation's foundational logics, its mystified origins. Real property values have "always already" been linked to hierarchies of status value globally. It was, however, the merchants, lawyers, and financiers of Manhattan who transmuted the logics of the Protestant work ethic into the spirited capitalization of square footage.

The enemy? The insurgent needle trades, which deployed thousands of Italian and Jewish workers, who flooded into the streets on their way to work, at their lunch breaks, and after work. This was the "invasion of the garment industries." The first battle? The notorious fire at the Asch Building of the Triangle Shirtwaist Factory, "on the outskirts of lower Fifth Avenue in 1911." The tragedy of the fire became an opportunity for the FAA to wage a moral campaign "heading off the threatened destruction of Fifth Avenue." The foe? Not the horrid fire, the 146 garment worker deaths, nor the locked exit

doors, but that the FAA targeted the independent manufacturing shops the purported foreign immigrant enemy had erected in their midst. "Fifth Avenue was a sudden industrial fetish," argued colonel William J. Pedrick. "New buildings were hastily thrown up. There was a great increase in traffic. There was confusion."[2]

The saviors? The Fifth Avenue Association took credit in their version of NYC history. "To direct this trade expansion and to prevent permanent injury to the section, the Fifth Avenue Association was organized in 1907": so reads the culminating essay, "Fifth Avenue— Old and New," by Colonel Pedrick, the general manager of the FAA, in *Fifth Avenue Old and New, 1824–1924* (1924), who described this organizational publication as a "Commemoration of the One Hundredth Anniversary of the Founding of Fifth Avenue." The 1824 beginning date was designated because of the date the city began constructing Fifth Avenue from Waverly Street.

Henry Collins Brown, the founding director of the Museum of the City of New York, wrote the first essay in *Fifth Avenue Old and New.* It was a historical retrospective piecing together what constitutes a genealogy of Fifth Avenue as the golden city within Manhattan Island. Ignoring the British, the Dutch, and the Lenni Lenape peoples, Brown's history of Fifth Avenue, isolated from the rest of the history of NYC, begins with a romantic gloss of 1824 Washington Square that asks 1924 readers to picture a rural setting of "land retain[ing] traces of its primeval loneliness."[3] The Washington Square arch, like the gate of a castle, serves as the entry into a fabricated white Protestant genealogical story, a tale of Fifth Avenue Land. Brown's narrative, lavishly illustrated with maps, high-resolution photographs, color reproduction prints, and commissioned full-color illustrations, is that of a patrician tour guide showing selected fragments of an extended family heritage of movers and shakers, business gatherings and gala balls, all as if Fifth Avenue were a sovereign city state, the epitome of American civilization.

The second essay, "Fifth Avenue To-day," authored by Colonel Pedrick, begins with a chart titled "A Century of Realty Values" that shows the arbitrarily drawn territory from the Washington Square Arch up Fifth Avenue to 110th Street, from Lexington to Sixth Avenues. In upholding real estate values and civilizational standards

JOHN KUO WEI TCHEN

against the barbarians at the gate, Colonel Pedrick evokes modernity, Greek civilization, and republican virtue. Here we come to the FAA's foundational rationale of the Anglo-American preservationist social contract: "It is well to read our history in the light of the fact that the growth to higher standards is a direct product of civic pride, and civic pride is as efficient a check on the wrong kind of commercialism as is historical sentiment. It is part of our task, therefore, to rewrite our building story in civic terms"—so defines the purpose of this centennial commemorative publication.[4] This is the branding of the antigilded age in which "progressives" sought to "rewrite" their claim to New York City amid the massive growth of what, for them, became a wild, dangerous urbanscape.

As their lead soldier, Colonel Pedrick organized antibegging laws, resulting in 1,074 arrests in 1923 alone.[5] In 1928, he led the troops to defend Fifth Avenue from the "invasion of the parasitical sidewalk vendor" at Christmastime. And the FAA also installed six "signal towers" high above the chaos, with sentries to keep order at key crossroads. Pedrick declaimed, "The Avenue thus became cosmopolitan and dedicated itself not to a single city or a single state, but to the country at large."[6] Yet social historians have understood that this modernist, worldly claim is always fraught with unresolved contestations dividing the soul of the American experiment.

Henry Pratt Fairchild, a New York University sociologist and active in the American eugenics movement, was closely associated with the FAA and part of a generation of policy-minded Protestant men who sought to control laissez faire growth through intelligent regulatory bureaucracies organized by city, state, and federal legislatures. "Progressives," with their networks of individuals and cultural organizations, organized to push through a series of laws premised on the dangers of social intermixing and "racial degeneration."

The year 1924 also saw the passage of the National Origins Act, which classified Europeans into three racial groups. Patrician, lawyer, and leading eugenicist Madison Grant coined the term "Nordics." He considered Nordics naturally superior, and thought they should be maximized in numbers and protected from "racial suicide."[7] Those deemed unfit, the so-called Alpines and Mediterraneans (notably Italians and Jews) became effectively banned from immigration. The

FAA's 1924 publication should be understood within this larger cultural context.

These elite Protestant men linked their notions of civilization to real estate value. Richard Hurd, author of the classic *Principles of City Land Values* (1903), espoused a single-minded profit logic of increasing square footage value. He linked his economic laws to Herbert Spencer's Social Darwinism. "The life of value in land," said Hurd, "bears a close analogy to all other life . . . by a small beginning, gradual growth and increased strength, up to a point of maximum power, after the attainment of which comes a longer or shorter decline to a final disappearance. . . . Underneath all economic laws . . . and the land values resulting therefrom, turn on individual and collective taste and preference."[8] To stem the disappearance of Fifth Avenue, the symbolic space of wealth and value for all NYC and U.S. Protestant elites, crusading individuals would have to organize and fight to survive.

In this more open era, a more pluralist approach to landmarking holds sway in NYC. However, simply adding the Stonewall Inn, for example, as another site to the foundational FAA logics of historic preservation is not enough. Such a pluralist approach, though eminently practical, makes for shoddy history. More rigorous facts, archives, stories, and histories of those historically disenfranchised have to be understood in relation to those doing the disenfranchising. Historic preservation in the next fifty years must preserve more than white Anglo-American Protestant patrimony. An add-on pluralism approach is not enough. A truly public-committed scholarship must also unpack the relational valuation of one group over the devaluation of its "others." A concrete future-minded suggestion? Let's follow the lead of Charles Robert Ashbee, the arts and crafts architect and social practitioner, in creating a *Survey of New York City* documenting the often neglected everyday built environment and growth of the city but with a keener forward edge. The relational historical process of spatial othering has to be included. And it must be accessible online and by smart devices as a walking app with full sensate effects.[9]

Hurd and Pedrick were correct. Those outside Fifth Avenue Land are the barbarians. And once again we need to fight for a more democratic, more informed public culture. Truly meaningful, rigorous,

JOHN KUO WEI TCHEN

and fun public histories must un-preserve the past, while engaging in the ongoing fight for historic reconstruction for a just society.

JOHN KUO WEI TCHEN is the founding director of the A/P/A (Asian/Pacific/American) Studies Program and Institute at New York University and part of the original founding faculty of the Department of Social and Cultural Analysis, New York University. He cofounded the Museum of Chinese in America in 1979–80, where he continues to serve as senior historian.

NOTES

1. Richard M. Hurd, *Principles of City Land Values* (New York: The Record and Guide, 1903), 19.
2. Henry Collins Brown, *Fifth Avenue Old and New, 1824–1924,* with an additional essay by Colonel William J. Pedrick (New York: Fifth Avenue Association, 1924), 111.
3. Brown, *Fifth Avenue Old and New,* 9.
4. Ibid., 104.
5. Kerry Segrave, *Begging in America, 1850–1940: The Needy, the Frauds, the Charities and the Law* (Jefferson, NC: McFarland & Co., 2011), 137.
6. William J. Pedrick, "Fifth Avenue To-day," in Brown, *Fifth Avenue Old and New,* 121.
7. Lombardo, Paul, "Eugenic Laws against Race Mixing," Image Archive on the American Eugenics Movement, www.eugenicsarchive.org.
8. Hurd, *Principles,* 17–18.
9. Professor Andrew Saint of the Bartlett School of Architecture, University College of London, has carried on the "Survey of London" admirably. Thanks to Mosette Broderick for the core of this suggestion. See the Bartlett School of Architecture at www.bartlett.ucl.ac.uk.

Can Preservation Destigmatize Public Housing?

LAWRENCE J. VALE

Few aspects of the American built environment have lingered on the land with as much stigma as public housing projects. Correspondingly, few places have been imploded or knocked flat with as much relish. From the iconic 1972 demolition of St. Louis' Pruitt-Igoe project (1954) to the hundreds of thousands of public housing units that were torn down after 1993 under two decades of the United States Department of Housing and Urban Development's HOPE VI program (which aimed to revitalize the nation's worst public housing projects), many of the largest and most notorious public housing projects have disappeared from the urban landscape—most often without a trace. More than four decades after its demise, the Pruitt-Igoe site has gradually turned into a fenced-off forest, while other once infamous projects, such as Chicago's Cabrini-Green and Robert Taylor Homes, have been flattened in anticipation of slow-to-emerge mixed-income housing and other more upscale ventures. Even these most vilified towers have had their defenders, however. Former residents have found venues for their oral histories to be recorded; filmmakers have documented the complex community support that existed even in violent places; and academic studies have added alternative readings to simplistic accounts of "decline and fall."[1]

Much of the negative hype, though, has focused on the largest or most violent of the big-city projects, whereas most of the remaining public housing is spread across more than three thousand smaller housing authorities, where it continues to supply more than a million affordable apartments that usually have long waiting lists. Conditions continue to decline—in large part due to persistent underfunding

that that has led to decades of deferred maintenance—but the broadly shared ruinous public reputation of "the projects" has largely been driven by the intense media coverage of the most troubled places—many of which no longer exist. Now that these places have been largely removed from the media landscape (as well as from the neighborhood landscape), is there still a chance that the reputation of public housing can be restored? And, if so, is there a role for historic preservation in changing public opinion?

Sometimes preservation has been used to instigate engagement with the most troubled aspects of our shared past.

Preservation is typically associated with efforts to retain and celebrate significant cultural assets. Sometimes, however, preservation has been used to instigate engagement with the most troubled aspects of our shared past (such as the restoration of slave cabins and slave markets), or to remind ourselves about the place specificity of certain deeply unsettling historical events. Less common has been a third challenge for preservationists: altering a narrative in ways that can rehabilitate the reputation of once vilified places, while also promoting a corresponding reassessment of their inhabitants.

As the recent volume *Public Housing Myths* makes clear, numerous misconceptions could be, at least partially, debunked by a fuller analysis of the pluses and minuses of the projects: modernist architecture has not necessarily failed public housing; public housing does not "breed crime"; high-rise housing is not always unmanageable; mixed-income alternatives are not the only way to "fix" public housing; and public housing residents are not powerless, police-hating troublemakers who contribute little to their neighborhoods.[2] How might preservation assist in this myth busting about places, policies, and people?

In a few cases, public housing has been actively preserved on the basis of architectural merit. In Chicago, for instance, architect Bertrand Goldberg's Raymond Hilliard Homes, built between 1963 and 1966 (and on the National Register since 1997), still stand as evidence that high-modern high-rises can sometimes work for the poor just as well as Goldberg's Marina City did for their wealthier

counterparts. Located on the city's Near South Side, where most nearby public housing has now been torn down, Hilliard's two sixteen-story round towers for seniors and two eighteen-story curved towers for families have been preserved and converted into a privately managed mixed-income housing Chicago Housing Authority development, following a $98 million renovation carried out between 2002 and 2007.

In most other places, however, historic preservation has been little more than an unwanted stepchild in the urban redevelopment family. Preservation—typically encompassing no more than a few remnant structures—has either been half-heartedly invoked by developers as a marginally useful extra source of funding (through tax credits) for projects otherwise centered on demolition, or has been strategically espoused by housing activists seeking one additional stopgap argument against fears of displacement.

In Atlanta's Techwood development—placed on the National Register in 1976 primarily due to its role as the country's first public housing project, inaugurated by Franklin Roosevelt—redevelopment into Centennial Place during the mid- to late 1990s had little room for preservation. Compliance with a Section 106 review happened belatedly and grudgingly, and only after residents had complained that no parts of the original structures were to be retained. As Atlanta Housing Authority director Renée Glover put it, "If something gets on the National Register, that's painful. We spent probably a million dollars in all the consultation and the HABS [Historic American Buildings Survey] documentation." The developers ended up keeping the cupola building as a sop to the history of FDRs visit and the heady days of Public Works Administration optimism. Yet, unable to sort out a way to turn the building into housing or use it for other purposes due to "restrictions on reconfiguring," the developer decided to "let it sit." The result is disheartening: a (quite literally) dehumanized, locked-up, empty shell.[3]

In New Orleans, during the conversion of the historic St. Thomas project into the new urbanist River Garden, preservationists faced—and lost—a double battle. Developers wished to minimize the number of original structures (courtyard-style brick buildings with wrought iron details, dramatically shaded by Katrina-surviving live oaks) and flesh

LAWRENCE J. VALE

Destigmatizing public housing through preservation. The last remaining building of Chicago's Jane Addams Homes; after renovation (scheduled to begin in 2016), part of it will become the National Public Housing Museum. PHOTO COURTESY OF LAWRENCE VALE.

out their financing by attracting an adjacent Walmart supercenter. They ultimately preserved one courtyard (though it was too beautiful to be left to low-income occupancy), but once again public housing was preserved with reluctance rather than fervor, a defensive action to gain extra development funds or to appease disgruntled constituencies.

In this context, the ongoing effort to convert the last-standing building of Chicago's Jane Addams Houses (completed in 1938) into the National Public Housing Museum deserves full support. Much as the Lower East Side Tenement Museum in New York City has enabled a more complex understanding of habitability, immigrant history, and rich material culture—as counterpoint to a merely dismissive view of slums and overcrowding—so, too, a future National Public Housing Museum might deliver a more nuanced assessment of what public housing has meant to its residents over the last eight decades. Without such a museum, the vital sociocultural legacy of public housing will ultimately be left to disembodied books and films. However

valuable, these fail to preserve remnant microcosms of the built world that once existed—to remind Americans that access to public housing could be seen as a reward rather than a prison sentence. Ultimately, the value of a museum inheres in its capacity to do two things simultaneously: first, provide a physical space that can enable visitors to understand the ambiance of another person's home-place, and second, shape the narrative frame that helps visitors understand what they are seeing in ways that prompt new questions and shatter simplistic stereotypes. For those who have not previously entered public housing, or for those who know it only in its more recent degraded and denigrated state and have no memory of its earliest successes, this combination of place making and programing just might be transformative. In the case of public housing, preservation of a stigmatized place may, paradoxically, contribute to the easing of that very same stigma.

LAWRENCE J. VALE is Ford Professor of Urban Design and Planning at MIT, where he directs the Resilient Cities Housing Initiative (RCHI). His prize-winning books include *Architecture, Power, and National Identity* (1992, 2008); *From the Puritans to the Projects* (2000, 2007); *Reclaiming Public Housing* (2002); and *Purging the Poorest* (2013). Most recently, he is coeditor—with Nicholas Bloom and Fritz Umbach—of *Public Housing Myths: Perception, Reality, and Social Policy* (2015).

NOTES

1. See, for example, Audrey Petty, ed., *High Rise Stories: Voices from Chicago Public Housing* (San Francisco: McSweeney's, 2013); Sudhir Venkatesh, *American Project* (Chicago: University of Chicago Press, 2000); and films such as *The Pruit-Igoe Myth, Voices of Cabrini, 70 Acres in Chicago*, and *Pomonok Dreams*.
2. See Nicholas Dagen Bloom, Fritz Umbach, and Lawrence J. Vale, eds., *Public Housing Myths: Perception, Reality, and Social Policy* (Ithaca, NY: Cornell University Press, 2015).
3. Lawrence J. Vale, *Purging the Poorest: Public Housing and the Design Politics of Twice-Cleared Communities* (Chicago: University of Chicago Press, 2013), 127–28.

We Need to Move the Goal Posts

MAX A. VAN BALGOOY

One way to measure the success of historic preservation is to count the number of listings on the National Register of Historic Places. In its first year nearly 700 properties were registered, and today the National Register has more than 90,000 entries representing nearly 1.8 million buildings, sites, and structures and is growing at a rate of about 1,500 listings annually.[1] We could easily celebrate that as an achievement of the National Historic Preservation Act, however, the sobering truth is that fewer and fewer Americans find historic sites "inspirational" or "beneficial," to use NHPA parlance. In the last thirty years, the number of adults who visited an historic park, monument, building, or neighborhood has dropped, from 39 percent in 1982 to 24 percent in 2012.[2] A similar pattern appears in a study of cultural travelers in San Francisco, which showed that while 66 percent said that historic sites were important to visit, only 26 percent had actually visited one in the previous three years.[3]

Historic preservation seems to have become less, rather than more, relevant.

There are probably several reasons for this decline, including the near-elimination of history from public schools and a decreasing amount of leisure time, but our own field of historic preservation may also be at fault. Over the past fifty years, historic preservation has become more complex, often requiring expertise in legal strategies, real estate development, fundraising, and architectural conservation. It's become more focused around technique, such as how to designate a property, navigate Section 106, or repair a double-hung

window. It's become more intellectual, with battles fought over state-
ments of significance, National Register criteria, and applicability of
the National Environmental Policy Act. It's become an endless circuit
in which we seem to fight the same battles and hear the same objec-
tions: "We can't save everything," "It's not historic," "We can't stop
progress," and "You're taking away my rights." Historic preservation
seems to have become less, rather than more, relevant and meaning-
ful to Americans since the passage of the NHPA.

Maybe we've confused the ends with the means and are chasing the
wrong goals. Preservation is not a destination but a means of reach-
ing a destination. So what is the goal of preservation? According to
the NHPA, it's a "sense of orientation" and a "genuine opportunity
to appreciate and enjoy the rich heritage of our Nation."[4] We need
to rebalance the term "historic preservation" so that there's equal
emphasis on both words, rather than just the latter. We need to move
the goal posts so that historic preservation is not *about* some*thing* but
for some*body*.[5]

As management guru Peter Drucker reminds us, the nonprofit
organization's "product is a changed human being. Non-profit insti-
tutions are human-change agents. The 'product' is a cured patient, a
child that learns, a young man or woman grown into a self-respecting
adults, a changed human life altogether."[6] Historic preservation is not
just about saving buildings; it's about changing the lives of people.

Protecting, preserving, and interpreting are not sufficient. These
are simply methods, tasks, jobs, works, or actions that define a pur-
pose and explain how it will be accomplished. What is needed is a
goal, a destination, a target, an idealized description of the future
that explains "why." To borrow from grammar, we need a transitive
verb—a verb that requires one or more objects. What is the object or
purpose of protecting, preserving, and interpreting?

Every organization will answer these questions differently because
every community is unique, but ultimately, the struggle to answer
them will result in a clear, inspiring, and distinctive vision. A few his-
toric preservation organizations are beginning to make the shift, as
can be seen in the language used in their governing documents:

"To help people understand our shared history and motivate

MAX A. VAN BALGOOY

them to preserve it by providing access to the rich continuity of history and preservation in one community and family over time, and by offering direction and knowledge about preserving our built heritage and its value." (mission statement of Cliveden of the National Trust, Philadelphia, 2012)

"To maintain the cultural vitality that makes San Francisco one of the world's great cities"; "not promote one culture over another, but instead to foster an inclusive narrative of our city's history"; and "preserve the signifiers of neighborhood identity, such as art and culture, family histories, buildings, and community events." (excerpts from *Sustaining San Francisco's Living History* by San Francisco Heritage, California, 2014)

"Citizens deserve a city that is pleasant, safe and well maintained, and residents deserve neighborhoods that foster their sense of wellbeing. We believe these traits of a great city are nurtured by preserving places of architectural and historical significance. Preservation sustains the distinctive cultural histories and unique character of our neighborhoods and downtown districts." (excerpt from the values statement of the Providence Preservation Society, Rhode Island, 2015)[7]

Our goals should not only consider the community as a whole but also the individuals who live and work in it. Too often people see history as merely a collection of names and dates, a ticking clock without an opinion or cause.[8] Instead, we need to demonstrate that knowing history informs our understanding of today, and thinking historically improves our decisions for the future. Historic preservation should also produce thoughtful leaders and advocates, not just consumers and followers.

So how can history become a "living part of our community life," as directed by the NHPA? Here are a few suggestions to get started:

1. Articulate the value of history for you, your organization, and your community. The aim of "historic preservation" is to "preserve history," so what does that mean for you? What are the benefits of knowing history and thinking historically? Is it to

improve the economy, inspire leaders, shape personal identity, develop engaged citizens, build critical skills, or create vital places to live and work?[9] Incorporate these values into your mission statement.

2. What's your vision for your community? List the top three things you'd like to keep and three things you'd like to toss. If you are successful, how will your community be different or better in twenty years? What do you want people to know, feel, or do in the next few years to advance toward that goal? Add this vision to your next strategic plan.

3. Integrate history throughout your programs and activities. If history is so valuable, use it whenever possible to inform decisions, not just to convey facts. Facts explain who, what, when, or how; history explains why.

The National Historic Preservation Act was a remarkable achievement fifty years ago, but we've confused the means with the ends and need to reestablish the goal posts. If we succeed, however, we can achieve Ada Louise Huxtable's vision to "make the city's heritage a working part of the dynamic vitality and brutal beauty of this strange and wonderful town."[10]

MAX A. VAN BALGOOY is president of Engaging Places LLC, a design and strategy firm that connects people with historic places. His clients have included Drayton Hall, San Francisco Heritage, Gamble House, Taliesin West, Molly Brown House, Providence Preservation Society, and James Madison's Montpelier. He has served on historic preservation commissions for the City of Rockville and Montgomery County in Maryland and as the director of interpretation and education for the National Trust for Historic Preservation.

NOTES

1. National Park Service, "National Register of Historic Places" (Washington, DC: U.S. Department of the Interior, 2015).
2. National Endowment for the Arts, "2002 Survey of Public Participation in the Arts" (Washington, DC: National Endowment for the Arts, 2002), 12; National Endowment for the Arts, "How a Nation Engages with Art" (Washington, DC: National Endowment for the Arts, 2013), 22.
3. Destination Analysts, "San Francisco Arts and Cultural Travel Study" (San Francisco: San Francisco Travel Association, December 2010): 16–17, 41.
4. Section 1 of the National Historic Preservation Act, Pub. L. No. 89-665, as amended by Pub. L. No. 96-515 (2014).
5. This idea is borrowed from Stephen Weil, *Making Museums Matter* (Washington, DC: Smithsonian Books, 2002).
6. Peter Drucker, *Managing the Non-profit Organization* (New York: HarperCollins, 1990), xiv.
7. Cliveden of the National Trust, "Mission Statement" (Philadelphia: Cliveden of the National Trust, 2012); San Francisco Heritage, *Sustaining San Francisco's Living History* (San Francisco: San Francisco Heritage, September 2014), 5, 15; Providence Preservation Society, "Vision, Mission, Values" (Providence, RI: Providence Preservation Society, April 2015).
8. To explore this further, see Barbara Tuchman, *Practicing History* (New York: Ballantine Books, 1982).
9. For more ideas, see "The Value of History: Seven Ways It Is Essential," by the History Relevance Campaign (2015), available at HistoryRelevance.com.
10. Ada Louise Huxtable, *Goodbye History, Hello Hamburger* (Washington, DC: Preservation Press, 1986), 62.

Contesting Neoliberalism

..

The Value of Preservation in a Globalizing Age

DANIEL VIVIAN

In the half century since the National Historic Preservation Act (NHPA) became law, the liberalism of the Great Society has given way to the neoliberalism of the post-Reagan era and its faith in free markets, limited government, and individual freedoms. Government interventions and regulations are tolerated only in limited doses; economic considerations are consistently given precedence.[1] These shifts have challenged the cause of preservation while also supplying new opportunities. Preservation's effectiveness in the next fifty years will depend in part on how supporters express arguments based on economic value—a pillar of pro-preservation thought but an imperfectly understood concept as it relates to historic buildings and sites.

Advocates have long emphasized the economic benefits of preservation. The value of state and federal tax credits, increased property values, and stable tax revenues are well known. Moreover, as the concept of sustainability has infused preservation with new vigor, supporters have detailed the cost savings associated with the inherent "greenness" of older buildings and energy-efficient retrofits. Individually and collectively, these data demonstrate the economic value of preservation and its utility as a revitalization strategy. Towns and cities that owe their vitality in part to the committed stewardship of historic buildings—Boston; Savannah; Santa Fe; Saugatuck, Michigan; and Sonoma, California, for example—provide further affirmation.

Convincing evidence alone, however, has failed to win preservation broad-based support. Misconceptions about the requirements associated with financial incentives and regulatory requirements are partially to blame. So is the relative profitability of new construction.

Even where preservation offers significant advantages, the gains to be realized from other options are often attractive in their own right. Moreover, the economic rewards of preservation are typically diffuse. Rarely do individual actors have strong incentives to act on their own. Reaping preservation's greatest benefits requires an elusive and durable consensus among disparate parties, something difficult to achieve under the best of circumstances, let alone in the fragmented, often divisive political culture of our era.

What should committed preservationists do? The beginnings of a more convincing stance lie in revisiting arguments advanced by preservation's early theorists and connecting them with the market-driven imperatives of our time. As concern for the past grew in Western societies during the nineteenth and early twentieth centuries, figures such as Eugène Emmanuel Viollet-le-Duc, John Ruskin, William Morris, and Alois Riegl produced seminal essays about the importance of preserving historic buildings and monuments. These texts outlined rationales for preservation that have remained influential ever since. None emphasized economic value. Rather, they focused on historic, aesthetic, and artistic concerns. They viewed preservation as a moral obligation, a social necessity, and a source of meaning in a rapidly changing world.[2]

In recent decades, preservationists in the United States have shied away from the views of early theorists. In part the aim has been to avoid taste-based debates of the kind that prompted charges of elitism in the years immediately following passage of the NHPA. Efforts to forge broader, more inclusive views of preservation have also played a role. Moreover, experience has shown that economic arguments hold greater sway with elected officials and business leaders. Yet the ideas articulated by Ruskin, Morris, and other thinkers merit revisiting. They form the basis of social and cultural ties that connect people to place. As globalizing processes continue, they offer tools for countering neoliberalism on its own terms.

Human beings are not the purely rational economic actors economists once supposed. Although keenly attentive to financial matters, Americans of the early twenty-first century also make choices based on social relations and beliefs. Connectedness to place is one reason people to stay put amid economic and political upheavals. At bottom,

ties to place are rooted in the perception of authenticity—the accrued characteristics that invest any particular place or object with distinction. Authenticity is admittedly a fraught concept, deeply subjective and prone to debate. Yet in cases where so much as a modest consensus develops it may become a powerful force. In a world where mass production is ubiquitous, authenticity identifies places and objects shaped principally by historical processes. It denotes value in multiple forms, with the depth, texture, and resonances that accrue only over time.

In an increasingly interconnected world, authenticity may be the most valuable commodity of all.

In an increasingly interconnected world, authenticity may be the most valuable commodity of all. Its centrality to tourism, arts and entertainment, and everything viewed as local and genuine is well established. Authenticity has economic value—it enters into market relations. The starting point, however, is history, culture, and aesthetics. Authenticity derives from innate qualities instead of those that are purposefully manufactured. In contrast to everything else that globalization seeks to sell, authenticity cannot be produced. A product of time, it is immediately distinguishable from imitations and kitsch.

As preservation looks ahead to the next fifty years, a new focus on multiple dimensions of economic value offers options for conveying the promise and potential of the cause. Attempts to sell preservation purely as a matter of dollars and cents obscure its full value. Preservation is never simply an economic proposition. If it were, debates would begin and end with square footage, location, and all the other criteria that populate real estate listings. Preservation necessarily involves deeper, more complex forms of meaning. It transcends mere economics to reach to the heart of the reasons people develop commitments to place. Those commitments are themselves valuable. They provide resiliency in the face of social and political distress and community against the fragmenting tendencies of contemporary life. They also encompass an appreciation of the historical, cultural, and aesthetic qualities that only aged buildings possess.

Preservationists will do well to adopt a twofold approach toward economic value. On the one hand, the same criteria used in assessing the value of all real estate applies to buildings and places deemed

DANIEL VIVIAN

historic. These form the basis of the qualities that bear directly on market-based decisions. On the other hand, a host of less apparent but no less important factors also matter. Although difficult to assess and often even more difficult to quantify, they nonetheless weigh on questions of economic viability. They explain why people fight to save seemingly hopeless structures, why historic buildings and places sometimes acquire a cachet that defies logic, and why, at bottom, preservation is always driven in part by emotional and intellectual commitments. The true value of preservation lies in its ability to cultivate durable attachments to place. Ultimately, these are an economic force—and a means of challenging neoliberalism's ruthless reductionism.

DANIEL VIVIAN is assistant professor of history and director of public history at the University of Louisville. He teaches courses on historic preservation theory and practice and is actively involved in several preservation organizations, including the Louisville Preservation Fund, Inc.

NOTES

1. On neoliberalism, see especially David Harvey, *A Brief History of Neoliberalism* (New York: Oxford University Press, 2005); Noam Chomsky, *Profit Over People: Neoliberalism and Global Order* (New York: Seven Stories Press, 1999); Alfredo Saad-Filho and Deborah Johnson, eds., *Neoliberalism: A Critical Reader* (London: Pluto Press, 2005).
2. Eugène Emmanuel Viollet-le-Duc, *Discourses on Architecture*, trans. Henry Van Brunt (Boston: James R. Osgood and Co., 1875); John Ruskin, *The Seven Lamps of Architecture* (New York: John Wiley and Sons, 1886); Alois Riegel, "The Modern Cult of Monuments: Its Character and Its Origin," *Oppositions* 25 (Fall 1982): 21–51. On Morris, see E. P. Thompson, *William Morris, Romantic to Revolutionary* (New York: Monthly Review Press, 1961), chap. 6; Andrea Elizabeth Donovan, *William Morris and the Society for the Protection of Ancient Buildings* (New York: Routledge, 2008).

Human Environment
Conservation in 2066

An Interview

JEREMY C. WELLS

In preparing this essay, I wanted to create a window into the future of a practicing "historic preservation" professional in the year 2066. I have chosen to do this through an interview of "Jimena," who I believe represents the future of our discipline.

Interviewer: Could you tell me a little bit about your profession and what you do?

Jimena: Yes. I work as a place conservation manager, where I help to conserve human environments. I protect the authenticity of place for the benefit of people and to improve human flourishing. Really, what I do is to work as a facilitator to help communities identify heritage places and then devise ways to protect the authenticity of these places. What I call myself is very important in my work because I need to build rapport with my community—we all think of ourselves as equals and try to understand and respect each other's values, although this can be a lot harder than it sounds. In research over the past few decades, we've discovered that people who like old buildings, places, and landscapes don't identify at all with the academic terms "historic," "heritage," or "conservation." Instead, most people use words like "charming" and "quaint" to describe built heritage and landscapes. So, when meeting with the public, I often describe my work as helping communities to identify, protect, and utilize "charming" places and refer to myself as a "charm manager," which I now understand is increasingly being used by the public to describe professionals like me. I think one of the first organized efforts to make this "charming"

connection was in Mexico back in the 2000s when they created their "Pueblos Magicos" marketing campaign for their heritage towns. You know, there's more than a tangential connection between the words "charming" and "magical."

Interviewer: So what do you need to know to do your job?

Jimena: Well, I need to know a little bit about what seems like almost everything, from materials conservation to social science research. A couple of decades ago, heritage conservation degree programs began mandating social science research methodologies in their curricula, a change from which I benefitted immensely when I was in my degree program. I often wonder how professionals before me did their work without understanding the social, cultural, and psychological aspects of the ways people value place. Even when my discipline was called "historic preservation," it focused on valuing place in some way. How universities could produce graduates who had no firm understanding of how to assess people's value of heritage places seems really odd to me, although it might explain why, before this change, there was a lot more hostility toward professionals who worked to conserve the historic environment. A professor from my graduate program referred to this as the "orthodox" versus "heterodox" heritage divide of the early twenty-first century. Apparently too many people were resistant to the idea that the primary beneficiary of conservation of the human environment should be people. The natural conclusion was that to do our work well, we needed to understand people better. Seems pretty simple to us nowadays, but it took decades for the change to happen.

Interviewer: Tell me a little bit more about your work with your community.

Jimena: Sure. While I am employed by my city, technically I work for my municipality's citizens. That's actually the way my contract is worded—that my overall performance is directly assessed, in part, by the community members I work with. A few years back, my town changed from the old-fashioned design review process—you know the heritage commission thing—to an adaptive regulatory framework. Under this new system, I conduct participatory research with my community members—we like to call ourselves "coresearchers"—to

review and make suggested changes to properties that might negatively affect their authenticity. As opposed to the old system, the applicant simply becomes one of the coresearchers and participates in roundtable discussions and storytelling along with everyone else. It really equalizes the power dynamics that used to plague how we did things before. In the end, the group jointly agrees on how the property should be treated. While we were originally concerned that this new system would take more time, we've found that we're actually saving time because there is a lot less staff prep needed. I can tell you that I do not miss writing "staff reports" anymore! I also never liked our old "heritage list," which was not able to adequately accommodate changing community values. I never relished having to tell a member of the community why, for instance, the Smith House's entry on our register only listed its significance as being architectural even though we now know that it's far more important as the home of one of the most significant members of the marriage equality movement. Now we have a simple formula that dynamically assesses the heritage potential of a property, on a case-by-case basis, and all of these properties are then sent to my community group to work on. So no more static lists, because we now assume that the values people attribute to places in our community constantly change.

Interviewer: What's your reaction to those who claim that what used to be known as "historic preservation" has lost its way because nowadays it focuses too much on people?

Jimena: I have a one-word response: trust. I know that some professionals and academics think that we're focusing too much on people to the exclusion of the actual historic buildings and places that people value. The concern, of course, is that the material authenticity of these buildings and places is being compromised. But what we're finding is that by focusing on the intrinsic value of the historic environment, most people are actually conservationists at heart but don't think of themselves as such. There's a lot of good social science research out there on this topic, which I use a lot. It helps me to communicate using the language of most stakeholders—the use of the word "charming," for instance. In my work with communities, I'm finding that more of the actual fabric of buildings and places is being conserved than was

happening with our old heritage commission, but it's happening in a way that more holistically encompasses the cultural and natural environment. This is especially true with landscape elements that our old preservation ordinance and design guidelines pretty much ignored. So, my advice is to trust that most stakeholders will do the "right" thing. But this can only happen in an environment of respect and empowerment, which is why I really like the adaptive regulatory framework that my town

When I look back at how my grandfather practiced preservation fifty years ago, it all seems so lonely.

has adopted, because it accomplishes all of these goals. When I look back at how my grandfather practiced preservation fifty years ago, it seems like he talked only to other historic preservationists, and it all seems so lonely. I couldn't imagine that world today.

JEREMY C. WELLS is an assistant professor in the historic preservation program at Roger Williams University and a visiting Fulbright Scholar at the Federal University of Pernambuco, Brazil. His research addresses the sociocultural and experiential valuation of the historic environment and ways to assess these values, with a focus on participatory research, phenomenology, and mixed-methods, in order to inform planning practice for the historic environment. Wells created the Historic Environment Knowledge Network at the Environmental Design Research Association (EDRA) to help integrate environmental design and behavior research into heritage conservation practice.

Reigniting Stewardship as a Preservation Practice

SUSAN WEST MONTGOMERY

Historic preservation policy and programs should value, incentivize, and celebrate stewardship as highly as they do rehabilitation.

Historic preservation has always been rooted in the concept of "saving" something, whether a building, place, or landscape, or, in its most liberal applications, a story, cultural practice, or tradition. A "save" comes in many forms, but generally we consider something saved when a place, story, practice, or tradition is able to continue to exist for some time to come.

There are nuances, to be sure. Traditionally, "historic sites" have epitomized the idea of preservation by creating an institution and program devoted to tending to a site and opening it to the public to visit and enjoy. A building that is not a historic site might be saved with all of its original fabric intact, usually because it has been conscientiously cared for throughout its life. Another building's interior might be altered beyond recognition, but a lively, economically sustainable reuse may have been accomplished, and we applaud that too. There are also many instances in which historic infrastructures have been preserved, such as the original piers and modest outbuildings of a historic fishing port, but not one commercial fisherman remains to make use of these historic gems. In other cases we may find that the built resource no longer exists, and yet we still honor the site for its associative values and because it provides a place to talk about a particular history—World War II Japanese internment sites are a great example. In this way, and of necessity—given the diversity of resources we are trying to save, the stakeholders we need to engage with, and the economic factors that come into play—historic

preservation, at its best, embraces and allows for a range of outcomes.

It may be surprising then to realize that most public and private funding for historic preservation, almost all of its incentives, and its most visible awards programs, including the National Trust for Historic Preservation's Honor Awards favor the large scale, the high cost, the dramatic rehabilitation over repair and maintenance—over stewardship. We cannot underestimate the value of the historic tax credit program, nor the billions of dollars brought to historic preservation projects through transportation enhancements, the Save America's Treasures program, and a host of what used to be called "federal earmarks." Nor can we turn away the kinds of private brick-and-mortar funding made possible by the likes of the Kresge Foundation, American Express, and countless others. Every project spotlighted through award programs deserves the honor.

The next big new thing should be a return to the best old thing: regular maintenance, consistent repair, and loving upkeep.

Unfortunately, though, in our quest to gain visibility and credibility for our work, we celebrate the big win. We turn again and again to the projects whose before-and-after shots elicit awe. In so doing, I fear, we have failed to notice the steady and true efforts that preserve buildings over time without the need for massive investments. Indeed, instead of holding up the places that have been carefully "saved" through long-term diligence, we look for the places that are "saved" through a single dramatic intervention. We unwittingly give the impression that historic preservation is always an expensive proposition, rather than honoring the role that individual acts and small investments play in saving places.

Home owners are saving places, whether or not they ever take on a big renovation project, because their daily chores and routine maintenance preserve a place. The building maintenance crews of any small or large institution—a school, a hotel, an apartment building— are also saving places by repairing the roof leak before the problem spreads, sealing the windows for winter warmth, or adding a fresh coat of paint. Others may act as "preservationists" by taking over responsibility for a place. A new retail business moves into an old store, making

modest changes to serve the new enterprise yet preserving most of the essential features intact. This starts a new cycle of stewardship that ensures that the building will continue to stand and contribute to its community. Landscapes have stewards too. All across the nation there are places of immense cultural, archaeological, or scenic value owned by individuals and yet, through good management and sometimes through easements, are protected for the benefit of all.

The next big new thing should be a return to the best old thing: regular maintenance, consistent repair, and loving upkeep. We should use awards programs to place stewardship on equal footing with rehabilitation. We should direct more of our grant programs and tax incentives to repair and maintenance. We must create a culture that looks first to taking care of what it already has. In so doing we honor a wider array of individuals, organizations, and businesses participating in preservation. We add a much larger and much more diverse set of resources to the "win" column for preservation and welcome a greater number of individuals and organization into the ranks of preservationists. And maybe, over time, we might just reduce the need for massive investments and dramatic saves and turn instead to steady, slow, and effective stewardship that saves places just as well.

SUSAN WEST MONTGOMERY is vice president for Preservation Resources at the National Trust for Historic Preservation. She holds a BA from the State University of New York at Buffalo. Before joining the trust in 2009, Susan served as president of Preservation Action in Washington from 1997 to 2004, where she led the organization's national grassroots lobbying network and monitored legislative actions affecting preservation. She was the first executive director of the Buffalo Friends of Olmsted Parks, which became the Buffalo Olmsted Parks Conservancy, and is the author of *A Blueprint for Lobbying*.

A Modern-Day WPA

AMBER WILEY

It is time for a modern-day WPA.

The Works Progress Administration, later known as the Work Projects Administration (WPA), was a part of Franklin D. Roosevelt's New Deal legislation. The WPA was designed to create jobs during the Great Depression by employing skilled and unskilled labor in various fields to promote art projects as well as expand infrastructure throughout the nation. A main project of the modern-day WPA would be recording, modernizing and maintaining existing buildings and infrastructure.

Several economists and political pundits have also called for a modern-day WPA.[1] As the election of 2008 approached, the presidential candidate speeches threw into high relief the great divide between conservative and liberal opinions on economic reform. The chorus of voices supporting a modern-day WPA was much louder between 2008 and 2010, an era dubbed the Great Recession. Around the same time, urban policy scholar Greg Hise published a provocative article in the *Journal of the Society of Architectural Historians* titled "Architecture as State Building: A Challenge to the Field" that called for architectural historians to engage with scholars of other disciplines who study state formation, state building, and state regulation.[2] Hise's intent in setting forth this challenge was to create a cross-disciplinary dialogue that could inform how architecture, and design thinking more broadly (including preservation), could be a change agent in the political economy.

My call for a modern-day WPA is oriented toward the formation of a working middle class, and developing new creative projects that put unemployed and underemployed citizens to work. This includes

unskilled labor, as well as highly specific and skilled labor (take, for instance, those countless adjunct architecture professors wasting away in positions that do not take advantage of their complete skill sets). Additionally, partial loan forgiveness could be a recruitment tool with the program, thereby rewarding college graduates for pursuing advanced degrees instead of burdening them with insurmountable debt.

Historic preservation as a modern movement relies heavily on the implementation of federal legislation, from the Antiquities Act of 1906 to the Historic Sites Act of 1935 to the National Historic Preservation Act of 1966. These complicated pieces of legislation require that the survey, inventory, and protection of historic sites and landscapes be implemented across the nation; however, the legislation does not include capacity building mechanisms to ensure there is the manpower to follow through with the charges. It is important that we have policies and guidelines in place that direct our work as preservationists, but at this moment we do not have the personnel to fully address nationwide issues of preservation at the level that the legislation requires.

One way to expand the capacity of the Secretary of the Interior and the National Park Service to fulfill legislation requirements for documentation of historic structures and landscapes is to reinvigorate the original purpose of the Historic American Buildings Survey (HABS). The National Park Service created HABS in 1933 as part of an employment initiative in response to the Great Depression.[3] During the past five years, highly publicized discussions on the perilous future of architecture as a profession have emerged in the *New York Times,* the *Washington Post, Salon,* and *Metropolis.*[4] College graduates with architecture, arts, and humanities degrees have greater unemployment rates than students with other nonliberal arts degrees. Thinking of design, art, history, and the humanities as incubators of culture and state formation would drastically change these numbers. An expanded HABS program that draws on underemployed designers, preservationists, and humanities graduates could easily fit under the umbrella of a modern-day WPA.

The idea of a modern-day WPA also falls in line with the emergent field of public interest design, though it is has not been connected

as such.[5] Steven Bingler, a community-centered planner, and Martin C. Pedersen, editor of *Metropolis* magazine, argue that "reconnecting architecture with its users—rediscovering the radical middle, where we meet, listen and truly collaborate with the public, speak a common language and still advance the art of architecture—is long overdue."[6] In a way, they are calling for the architecture profession to actively engage in a campaign of "winning the hearts and minds" of the people. A modern-day WPA could do just that. It could address many current challenges in design, preservation, and humanities fields by employing the unemployed and underemployed, therefore giving the Secretary of the Interior and the National Park Service the manpower to effectively manage the goals set forth by the legislation of the National Historic Preservation Act. It would also maintain and expand the thousands of aging public institutions and infrastructure projects that were created in the 1930s as a result of New Deal legislation.[7] What could be more pertinent to the public interest than widespread modern-day public works endeavors?

What could be more pertinent to the public interest than widespread modern-day public works endeavors?

AMBER WILEY, PhD, is an assistant professor of American studies at Skidmore College. Her research interests are centered on the social aspects of design and how it affects urban communities. She sits on the board of the Vernacular Architecture Forum and is a member of the National Park System Advisory Board Landmarks Committee.

NOTES

1. See Dave Demerjian, "Note to Next President: Modern-Day WPA Will Save the Economy," *Wired*, October 19, 2008, www.wired.com; Joel Kotkin, "Why We Need a New Works Progress Administration," *Forbes*, March 24, 2009, www.forbes.com; Paul Krugman, "Why Not a WPA?" *New York Times*, blog, November 6, 2009, www.krugman.blogs.nytimes.com; Kate McCormack, "The Case for a New WPA," *Yes! Magazine*, July 12, 2010, www.yesmagazine.org.

2. Greg Hise, "Architecture as State Building: A Challenge to the Field," *Journal of the Society of Architectural Historians* 67, no. 2 (June 2008): 173–77. Another article that engages the issue of architecture as a generative form of policy is Annalisa Meyboom, "Infrastructure as Practice," *Journal of Architectural Education* 62, no. 4 (May 2009): 72–81.

3. Lisa Pfueller Davidson and Martin J. Perschler, "The Historic American Buildings Survey during the New Deal Era: Documenting 'A Complete Resume of the Builders' Art,'" *CRM: The Journal of Heritage Stewardship* 1, no. 1 (Fall 2003): 49–73.

4. Catherine Rampell, "Want a Job? Go to College, and Don't Major in Architecture," blog, *New York Times*, January 5, 2012, www.economix.blog.nytimes.com; Kristina Shevory, "Architect, or Whatever," *New York Times*, January 20, 2010, D1; Scott Timberg, "The Architecture Meltdown," *Salon*, February 4, 2012, www.salon.com; Peter Whoriskey, "Degrees in Architecture Yield Highest Jobless Rate, Study Says," *Washington Post*, January 4, 2012, A13.

5. John Cary, "Why the Death of Architecture May Not Be Such a Bad Thing," *Good*, February 29, 2012, www.magazine.good.is; Thomas Fisher, "Architecture for the Other 99%," *Metropolis*, February 8, 2012, www.metropolismag.com.

6. Steven Bingler and Martin C. Pedersen, "How to Rebuild Architecture," *New York Times*, December 15, 2014, A29.

7. For an understanding of the vastness of the New Deal landscape, see Robert D. Leighninger, *Long-Range Public Investment: The Forgotten Legacy of the New Deal* (Columbia: University of South Carolina Press, 2007).

AMBER WILEY

Put on Your Hipster Hat

CHRIS WILSON

Fifty years is a conventional anniversary to celebrate the past and consider what lessons it might hold for the future. Fifty years is also a metric of eligibility for the National Register of Historic Places, a key provision of the Historic Preservation Act of 1966. In the intervening years, it has become preservation orthodoxy that we should preserve the most significant buildings and districts of every era, regardless of what we otherwise think of that era. As the fifty-year cutoff has now rolled forward to 1966, many argue for the preservation of suburbia and mid-century modernism.

Yet this stance runs counter to the grassroots preservation movement of the 1950s and '60s, a reaction to the rise of modernism and suburbia, and the urban renewal and interstate highway demolitions then ravaging cities. That generation of preservationists, and the resulting National Register, has also expanded the scope of preservation beyond landmark buildings and elite house museums to include the recognition of entire historic districts. This larger scope of districts could encompass all classes and ethnic groups, while also helping to keep urban lifestyles alive as alternatives to suburbia. For the preservationist of 1966, the fifty-year cutoff not only allowed the necessary distance for evaluating historic significance but also meant that they envisioned the preservation of pre-1916 urbanism just before the automobile and modernism initiated unprecedented transformations of the built environment.

This presuburban, premodernism assumption is still at work today when we enumerate the sustainability advantages of historic preservation. Historic buildings use less energy to operate, we say, because

they are adapted to the local climate, and to the opportunities for natural heating, cooling, ventilation, and lighting. They are well constructed and easily adapted to new uses. Historic districts tend to be dense, mixed-use, pedestrian- and transit-oriented, and, therefore, consume less energy.

It is time to reassert the traditional alliance between preservation and urbanism.

None of these arguments applies to the typical mid-century building or neighborhood, which rely on fossil fuel to operate automobiles, air conditioning, and other climate control systems. Accelerated depreciation in the tax code after the mid-1950s and modernist functional expression in building design similarly mean that these buildings tend to be both less well made and less easily adaptable to new uses. Suburban neighborhoods, with their dependence on the automobile and dispersion into single-use districts, also typically lack the necessary density to support public transit.

Facing the contemporary challenges of sustainability, resilience, and global climate change, we can no longer simply preserve the most significant remainders of every era that has passed the fifty-year cutoff. It is time to reassert the traditional alliance between preservation and urbanism by once again putting on a hipster, or more to the point, an urbanist hat. We can do this by becoming conversant with the principles of urbanism and looking for ways to reconcile them with preservation practices. Among the patterns of traditional urbanism that have been revived and updated by New Urbanism, Smart Growth, LEED-ND (the Neighborhood Design standards of Leadership in Energy and Environmental Design) and the Sustainable Communities initiative are Traditional Neighborhood Design, Transit Oriented Development, and the transect. These have been reinforced through figure-ground analysis, form-based codes, and the study of building and street typologies—all techniques for understanding the historic fabric of cities. What light can these shed on the challenges of preserving the recent past?

One insight of the reurbanization movement—encapsulated in the concept of the transect—holds that historically cities developed with varying densities in different areas, ranging from a very dense urban core to the compact downtowns of satellite communities to suburban,

CHRIS WILSON

rural, and natural areas. A set of appropriately scaled building types in each zone coordinated with similarly scaled streets and public spaces. To this way of thinking, suburbia is one appropriate part of a region. But a very great problem arose when the automobile allowed the suburban scale to colonize every other zone. Single-family houses invaded agricultural and natural lands, while service stations took over downtown street corners, and urban renewal clearances produced surface parking lots around those downtowns.

Making our cities more sustainable depends in large part on reestablishing the traditional hierarchy of zones within each metropolitan region. In downtowns, it is an easy matter to see surface parking lots as good sites for mixed-use infill. But we may also want to let go of out-of-place suburban buildings in the heart of the city and instead focus our desire to preserve the recent past on auto-oriented buildings located more appropriately in the suburbs.

Efforts to retrofit suburbia for greater sustainability today often coordinate new bus rapid transit (BRT) lines with land use rezoning for higher densities around transit stops. This establishes new urban nodes favoring the reconfiguration of suburban superblocks into finer-grained street grids, and the construction of mixed-use infill buildings over historic preservation. If it was a good idea in the 1950s to expand the focus of preservation from individual landmarks to historic districts, it is an equally good idea today to reverse this equation by contracting the focus of preservation from entire, unsustainable suburban subdivisions to a few iconic auto-oriented and modernist structures to serve as reminders of the mid-twentieth century.

With the ongoing reurbanization of city centers, the pressures of infill redevelopment pose different challenges to historic neighborhoods, especially because the consolidation of finance means that these new projects are large-scale—both taller and occupying larger sites than historic buildings in most instances (but smaller lots and very tall buildings in a Manhattan). It helps to think less in terms of the style of historic buildings than to take an inventory of the historic building types of a district—to know, for instance, that an area boasts a mix of business block on the main streets and row houses, four-flats, and double-loaded corridor apartments on the side streets. With such knowledge, preservationists can help craft appropriate

public policies, zoning, and form-based codes to ensure that infill construction reinforces the historic fabric. The most common urban infill building type across the United States and Canada today, for instance, accomplishes this with a setback residential elevator tower atop a mixed-use podium of two to five stories that holds the sidewalk's edge like a business block, with parking tucked or under the building at the rear.

I hold with the antiscrape preservation sensibility, which cares less for establishing a single period of significance than for relishing the successive layers of taste and initiative that write the true, complex history of a city up to the present. Learning and applying the lessons of urbanism, while also preserving select reminders of mid-century modernism and suburbia, can contribute to more sustainable and vibrant cities.

CHRIS WILSON is J. B. Jackson Professor of Cultural Landscape Studies at the University of New Mexico, and founding director of that institution's Historic Preservation and Regionalism program. He is author of *The Myth of Santa Fe: Creating a Modern Regional Tradition* (1997) and lead author with Stefanos Polyzoides (author) and Miguel Gandert (photographer) of *The Plazas of New Mexico* (2011). He is at work on *A Field Guide to Cool Neighborhoods*, which will provide a taxonomy of historic and contemporary mixed-use and multifamily buildings, and street, public space, and district types in the United States and Canada.

Index